KYOTO
SIGHTS

DISCOVER THE "REAL" JAPAN

John Dougill

photography by Patrick Hochner

TUTTLE Publishing

Tokyo | Rutland, Vermont | Singapore

Contents

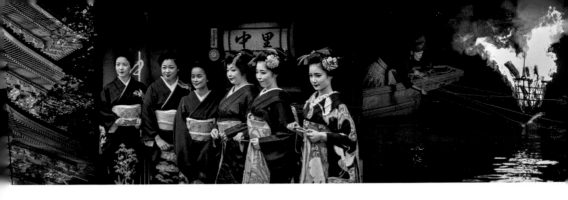

Part Three
EXPLORING NORTHERN & WESTERN KYOTO

Part Four
EXCURSIONS AROUND KYOTO

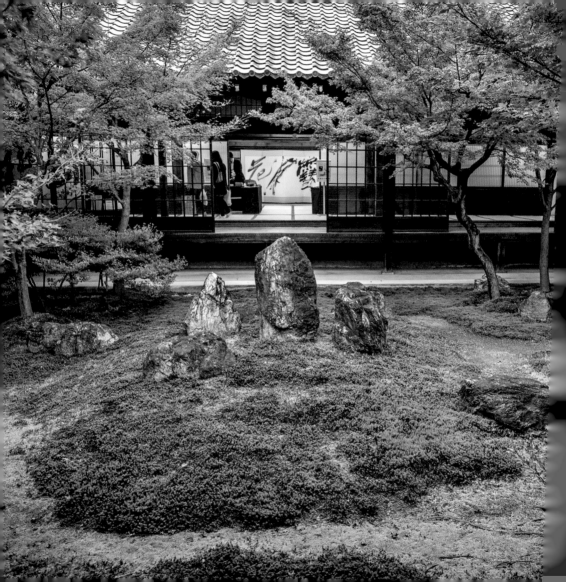

An Unforgettable City of Wonders

Kyoto is a city of 1.5 million people, making it the 8th biggest in Japan. It is compact, set in a river basin and restricted in size by the surrounding hills. This makes it a pleasant place to live, for it is not only easy to get around but the wooded fringes and river banks give quick access to hillside and greenery. There is an abundance of underground water, too, with wells and springs throughout the city, and the flourishing flora once gave rise to the epithet, "the flowering capital."

Yet, for those arriving at the modern JR station, the first impression is altogether different. There are shopping malls, business hotels, convenience stores, traffic jams, overhead wires and high-rise apartment blocks. How can this be? The city is, after all, the "soul of Japan," and regularly voted by travel magazines as amongst the most beautiful in the world. In literary terms, it was immortalized as *The Ancient Capital* by Yasunari Kawabata's nostalgic novel. The contrast of modernity and tradition, of image and reality, is so striking that manga writers like to depict

LEFT The inner garden of the Zen monastery of Kennin-ji exemplifies the traditional aesthetics of Japanese arts and architecture.

ABOVE RIGHT One of the delights of wandering around Kyoto is discovering curiosities, such as this garden guardian at Enko-ji.

Kyoto Timeline

794 Foundation of Heian-kyo by Emperor Kammu
1186 Samurai shogunate rules from Kamakura
12th c Heian-kyo becomes known as Kyoto
1333 Ashikaga shoguns rule from Muromachi in Kyoto
1467–77 Onin War razes much of the city
1580s Unification of Japan, Hideyoshi reorganizes Kyoto
1603 Tokugawa shoguns rule from Edo (Tokyo)
1868 Meiji Restoration and emperor moves to Tokyo
1945 Kyoto spared bombing in World War II
1964 Kyoto Tower initiates city modernization

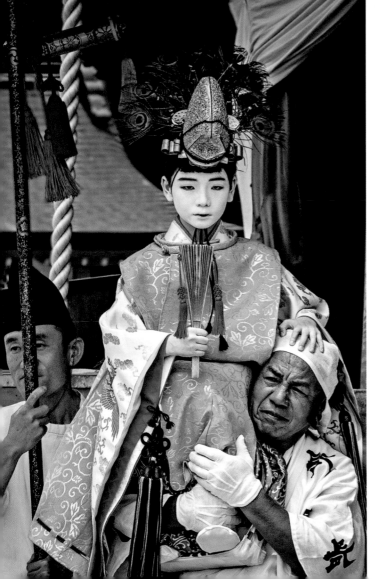

the city in terms of black holes and time warps that open up into different dimensions. There is a touch of magic about all this, and the enchantment goes back to the very origins of the city.

The founder, Emperor Kammu, had moved to Nagaoka in 784 to escape the straitjacket of Buddhism in Nara, but after a series of disasters he became convinced his new capital was cursed. Working closely with experts in geomancy, he sought a more amenable location. The requirements were that there should be mountains in the north, east and west, with open land to the south; there should be rivers to the east and west; and there should be a body of water to the south. He found what he was looking for in the Kyoto basin, and in 794 he named the new capital Heian-kyo, "Capital of Peace and Tranquility." In many ways, it was just that, as for nearly 350 years peace, poetry and prosperity prevailed, with not a single use of capital punishment. The worst fate imaginable was to be exiled from this glittering city.

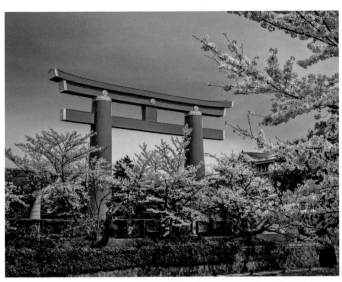

The city's festivals maintain ancient traditions, such as the *chigo* at the Gion Matsuri, who acts as a vessel for the *kami* (deity).

ABOVE The magnificent *torii* gateway of Heian Shrine is almost 82 ft (25 m) high and overshadows the museums in Okazaki Park.

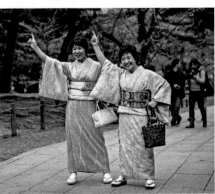

RIGHT Women in kimono enjoy posing for photos on a day out in Kyoto. Those who dress in traditional style get discounts at certain shops.

Heian-kyo was built following Chinese models, with a grid system that is still evident today. It means there is little worry about getting lost, for streets are mostly oriented north–south or east–west. With its auspicious beginnings, it is no surprise that the capital went on to remarkable achievements. Here, in Heian times, lived the aristocrat aesthetes who haunt our imagination, and the court ladies whose brilliant works still enchant. Here, also, the courtly lovers who visited after dark and left before dawn to write their "morning after poems." It was in Heian-kyo, too, that Abe no Seimei, the Grand Wizard of Yin-Yang, worked his magic among the spirits that lingered in the city's mists.

The Heian foundations were mixed with a large measure of Buddhism, and the city is studded with immense head temples. Central to this was the pragmatic Enryaku-ji Temple on Mount Hiei, which at a time when the samurai had overturned the established order, provided training for the founders of Japan's biggest sects:

the Pure Land sect, the True Pure Land sect, Rinzai Zen, Soto Zen and Nichiren. One of these played a formative role in shaping Kyoto culture—Zen, or to be precise, Rinzai Zen. It caught on with the city's ruling class and found favor from powerful sponsors. As a result, there are seven great Zen monasteries spread around the city, which between them have produced one of the world's great heritages, exemplified by Chinese ink paintings, architectural design and dry landscape gardens.

Two of Zen's notable spin-offs are Noh and the tea ceremony, both of which developed out of interaction with Kyoto's nobility. Slow-moving, elegant, profoundly spiritual, Noh is an acquired taste but one deeply appreciated by connoisseurs. Similarly, the tea ceremony, with its mannered movements, can be seen as an exercise in mindfulness and the subjugation of the ego. The ritual serves to raise awareness of the moment, and each gathering is treated as a unique occasion. The practice has won wider apprecia-

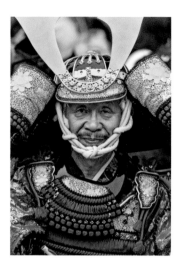

ABOVE The Jidai Matsuri (Festival of Ages), which highlights Kyoto's past, includes this samurai warrior from the Muromachi Period.

tion in recent years and spread around the world, but Kyoto remains its spiritual home.

For many, however, Kyoto's dominant image has nothing to do with Noh, or tea, or even Buddhism. It is the geisha. Her accomplishments are acquired by arduous training, backed by a whole industry of crafts which depend on her for business. They are part of the extraordinary

heritage of craftsmanship for which the city has a deserved reputation. In every field imaginable, from dolls to sword-making, the city has achieved excellence, and over 70 different handmade items are recognized as distinctively "Kyoto."

If Kyoto is a city of crafts, it is even more so a city of gardens. There are nearly 100 officially recognized gardens of special historical and artistic merit. Pond gardens, rock gardens, stroll gardens, paradise gardens, pleasure gardens, courtyard gardens, dry landscapes—there is no shortage of variety. Many have been maintained for centuries, with consideration given to replanting for future generations. Such is their fame that the city's name has been branded, and now there are overseas cities which proudly boast of their "Kyoto garden."

Yet, even gardens cannot compare with the number and variety of festivals. Pick a day and the chances are that somewhere in Kyoto there is an event of some kind. The "Big Three" are the Aoi Festival (May), the Gion Festival

(July) and the Festival of Ages (October). The parades are spectacular and attract huge crowds, but it is the smaller events that demonstrate the importance these religious festivities have for local communities.

In addition to these historical Kyotos, there is a rich layer of modernism. Following relocation of the emperor to Tokyo, Kyoto sought a new identity, and in its eagerness to escape the shackles of the past, it looked to innovation. Surprisingly, the ancient capital became an eager modernizer, running up an impressive list of firsts. The country's first state schools. The first public library. The first large-scale engineering works, which resulted in the Biwako Canal and the country's first water-power station. The first trams to run in Japan. The first town hall, the first film projection, the first Japanese city to sponsor a symphony orchestra. And, in recent years, the first manga museum. It comes as a surprise for some to learn that Kyoto is also a high-tech center, with such prestigious companies as

ABOVE A rare glimpse of a geisha entertaining guests at a private party in Shirakawa, said to be Kyoto's most beautiful street.

Nintendo, Omrom and Kyocera based here.

The industrial and technical side of the city is most apparent south of the railway station, away from the educational institutions in the north, for Kyoto is also a city of higher learning. It had already gained a reputation as a study center in Heian times, and in 1551, when Francis Xavier became the first Westerner to visit Kyoto, he headed straight for "the university" on Mount Hiei. Today, there are over 25 institutions of higher learning, including Kyoto University, ranked no. 2 in Japan and no. 26 in the world. The ratio of students to population is the highest in Japan. University cities have a special feel, and the youthful vigor adds to Kyoto's vibrancy.

Since 2013, one more layer has been added to the city's composition—tourist Kyoto. The city has long played host to visitors,

ABOVE The contemporary dance form of Butoh illustrates Kyoto's embrace of the avant-garde along with the traditional.

but by and large these were Japanese, of whom many were schoolchildren brought in by bus to learn about their national heritage. In 2013, the government launched a tourism drive, loosening visa restrictions and permitting the operation of LCCs (Low Cost Carriers). As a result, of the 15.5 million people who stayed one night or more in Kyoto in 2017, about a third were foreign, with the Chinese easily no. 1 in terms of numbers, followed by visitors from Taiwan, the United States and Korea. With government policy planning for an increase of foreign tourists to 40 million in 2020 and 60 million by 2030, Kyoto is looking to host more visitors with an interest in Japanese culture and to encourage them to stay longer.

Contemporary Kyoto is thus a deeply layered city, full of paradoxes. It is proud of its past yet forward-looking; conservative but with strong progressive credentials. Avant-garde student shows compete with traditional tea ceremonies, a special production of Noh with an exhibition of Impressionism. While juggernauts of steel go hurtling down four-lane highways, side streets not far away contain traditional housing with doors open and a sense of time stopped still. Photo-ops abound. Modern high-rises soaring over modest wooden houses, geisha chatting in Starbucks, priests heading for funerals on the back of scooters. Go to Kiyomizu Temple and you will be immersed in a sea of tourists; go to the Meiji Mausoleum and you will wonder if this is a tourist city at all.

The advice long-term residents like to give visitors is simple—to get lost. It is meant, of course, in the nicest possible way, for it is only by getting lost in the back streets that the true multilayered nature of Kyoto comes alive. You never know what will turn up next: a *tatami* maker next to a modern liquor shop; a round window with a cute doll display; a post-modern building squeezed into a space no bigger than a garage; a long alleyway leading invitingly to buildings hidden at its far end; a Buddhist temple with immaculate garden abutting a half-collapsed tofu shop. Improbable, dynamic, ancient and modern, Kyoto is a city that defies simple description. How fortunate, then, that we have the camera of Patrick Hochner to capture the images that make the city so remarkable. If a picture is worth a thousand words, then his surely speak volumes. So please take your time to enjoy these sights—these special Kyoto sights.

Glossary

The following terms are used in the text.

Nara Period (712–94)—Nara capital with Buddhist and Chinese influence

Heian Period (794–1186)—an aristocratic age with rule by the emperor

Kamakura Period (1186–1333)—Samurai take control under a shogun in Kamakura

Muromachi Period (1333–1573)—Shogunate rule from Kyoto, with strong Zen influence

Sengoku Period (1467–1568)—Time of Warring States and breakdown of authority

Azuchi-Momoyama Period (1573–1603) Unification by Nobunaga and Hideyoshi

Edo Period (1603–1867)—Tokugawa shoguns rule from the city of Edo (modern-day Tokyo)

Meiji Period (1868–1912)—Restoration of imperial rule and the emperor moves to Tokyo

Taisho Period (1912–26)—Industrial growth and "Taisho democracy"

Showa Period (1926–89)—Expansionism, World War II and postwar economic miracle

For the early part of its history, Kyoto was known as Heian-kyo (Capital of Peace and Tranquility). Only from the 12th century was it known as Kyoto. Similarly, Tokyo was known as Edo until the Restoration of the emperor in 1868, when a new government was established and the name was changed.

Onin War (1467–77) was a civil war that raged back and forth across Kyoto for almost 10 years and razed much of the city. Reconstruction began in the 1580s under Toyotomi Hideyoshi,

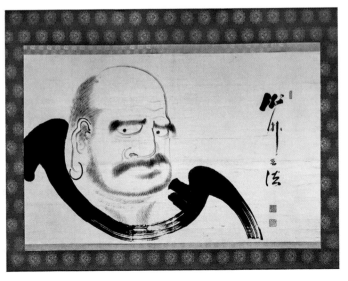

LEFT Like other Zen monasteries, Kennin-ji displays a Chinese ink portrait of Daruma (Bodhidharma), legendary founder of the sect.

who made major changes to the layout. Many of the massive temple buildings we see today were rebuilt then or later, in the 17th and 18th centuries.

People's names are given in the Japanese fashion, with family name first followed by the given name (e.g. Mishima Yukio). The word **"shrine"** is used for Shinto, which is a mix of animism and ancestor worship. Shinto shrines are typically called Jinja in Japanese (e.g. Kamigamo Jinja). The deified beings worshipped in shrines are known as *kami*.

"Temple" is used for Buddhism, and temple names in Japanese typically end in *-ji* or *-in* (e.g. Kinkaku-ji, Chion-in). In all, there are some 3,000 shrines and temples in Kyoto.

Kyoto's 17 Unesco World Heritage sites comprise the following (all but the last are included in this book): Byodo-in, Daigo-ji, Enryaku-ji, Ginkaku-ji (Silver Pavilion), Kamigamo Jinja, Kinkaku-ji (Golden Pavilion), Kiyomizu Temple, Kozan-ji, Nijo Castle, Ninna-ji, Nishi Hongan-ji,

Kyoto Average Temperatures

Month	Jan	Feb	Mar	Apr	May	Jun	Jul	Aug	Sep	Oct	Nov	Dec
Min (°C)	1	1	4	9	14	19	23	24	20	14	8	3
Max (°C)	9	10	13	20	25	28	32	33	29	23	17	12
Min (°F)	34	34	39	48	57	66	73	75	68	57	46	37
Max (°F)	48	50	55	68	77	82	90	91	84	73	63	54

Kyoto Average Precipitation

Month	Jan	Feb	Mar	Apr	May	Jun	Jul	Aug	Sep	Oct	Nov	Dec	Year
Prec.(mm)	50	70	115	115	160	215	220	130	175	120	70	50	1490
Prec.(in)	2	2.8	4.5	4.5	6.3	8.5	8.7	5.1	6.9	4.7	2.8	2	58.7
Days	8	9	12	11	11	13	13	9	11	9	8	8	121

Ryoan-ji, Saiho-ji (Kokedera), Shimogamo Jinja, Tenryu-ji, To-ji and Ujigami Jinja.

Opening times Please note that places generally refuse entry half an hour before the official closing time.

Best times to visit include the two seasonal highlights: cherry blossom (late March–early April) and maple colors (late November–early December). May and October are the most pleasant in terms of the weather. June–July is the rainy season, late July–early September is hot and humid, January–February can be cold but not freezing.

RIGHT Every February 2–4, the festival of Setsubun is held to dispel winter blues, and at Yasaka Shrine costumed geisha distribute bags of beans to protect against misfortune.

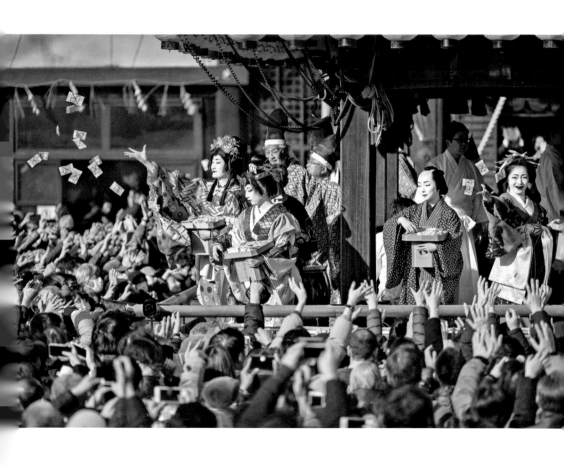

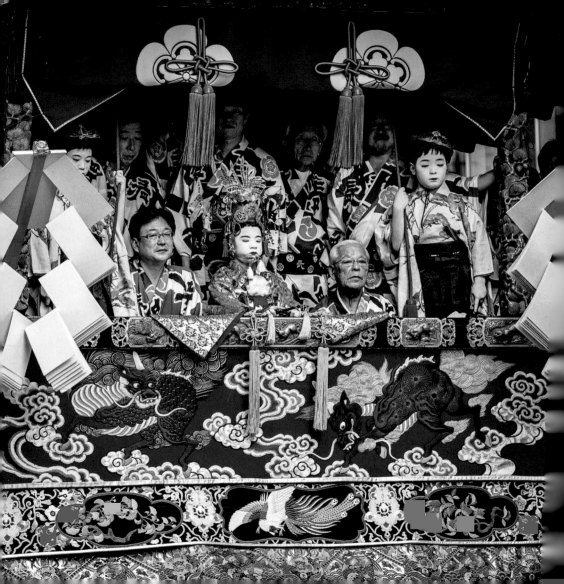

Experience Kyoto's Unique Culture Up Close

There was a time not long ago when Kyoto was known for being insular. Japanese from other parts of Japan found the city's populace to be cold and conservative. The traditional worlds of geisha, Noh and Buddhism were particularly closed, with little outreach to outsiders. "First timers are refused," ran the geisha slogan.

In recent years, Kyoto has undergone a complete change of attitude, fueled by the national tourist boom. Menus have appeared throughout the city in English. Welcome signs are common. There are explanations of cultural events, both on the Internet and in pamphlets. The whole corpus of Noh is available in English, geisha advertise their availability, and sitting meditation (*zazen*) sessions at temples welcome foreigners.

Along with such developments has come a change in the type of tourist. Visitors no longer want to just visit temples, shrines and gardens. They want to delve deeper into the culture. They don't want to hear about a tea ceremony, they prefer to participate in one. Rather than viewing swords, they want to know what it feels like to wield one. Instead of admiring kimono, they would like to learn how to wear one.

To meet these new demands, organizations have sprung up offering hands-on opportunities to foreigners. One website (**getyourguide.com**) lists no fewer than 250 activities covering everything you can think of, and more. Another company, WaK, offers over 20 experiences, ranging from tea ceremony to incense appreciation, while Kyogokoro specializes in appreciation of traditional activities such as cedar ball decoration, kimono weaving and making incense. For expert guidance, the Kyoto Visitors Guide (**kyotoguide.com**), Kyoto City Official Guide (**kyoto.travel**) and the Inside Kyoto (**insidekyoto.com**) websites provide information that even residents turn to for tips.

It can be said that Kyoto has truly been discovered now in a way not recognizable a mere decade ago. Travel magazines regularly rate the city among the best in the world, and Trip Advisor has it high in the international standings. As a result, the streets are alive with the sound of foreign tongues. There never used to be international chain hotels, but now there are the Four Seasons, Westin, Hyatt and Ritz Carlton. Nonetheless, such is the demand for accommodation that

LEFT The leading float of the Gion Matsuri features young *chigo* who represent divine presence at the festival.

at peak times visitors are forced to stay in Osaka and Otsu.

So welcome to the new Kyoto, the international Kyoto that invites participation. Rest assured that you will not be able to experience everything, for those of us living here for decades have not even managed that. Many who are drawn to Kyoto have difficulty in pinning down what attracts them exactly. It may be that with more than a millennium of refinement in the arts and crafts, there is something in the spirit of the place that touches the human soul and its need for beauty. Kyoto keeps calling us onward to better ourselves, and it is this constant striving for perfection that makes the city so special. It takes a remarkable cameraman to capture that, so please enjoy the photographic moments that follow. For those of us who live here, they are what make Kyoto so special.

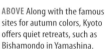

ABOVE Along with the famous sites for autumn colors, Kyoto offers quiet retreats, such as Bishamondo in Yamashina.

LEFT In mid-August, geisha from the Kamishichiken district take part in the community's Bon Odori dancing.

BELOW Participants in the Jidai Matsuri (Festival of Ages) pose in samurai costumes prior to the procession.

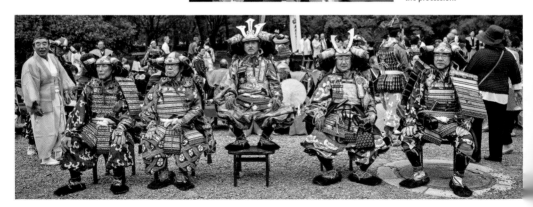

WELCOMING THE NEW YEAR January 1–3
A Time to Begin Everything Anew

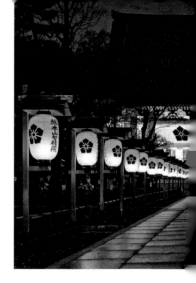

Beginnings are important in Japan. They signify freshness and reinvigoration, which is why they are celebrated with rituals. New Year in Japan is the biggest beginning of them all, and in the first three days of January the country's shrines enjoy their busiest period of the year.

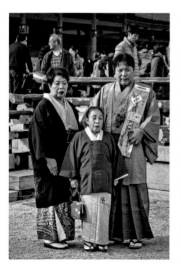

In late December, the custom is to settle up any outstanding matters. This also involves the "big clean-up," when residences are given a complete going over. In the past, everywhere shut down over the New Year, but these days convenience stores and a few shops remain open.

For foreign visitors, New Year's Eve is especially appealing. The custom is to eat *toshisoba* (year-end noodles), then to visit temples to ring out the old year with 108 strikes (one for each human attachment). The most popular place to see this is at Chion-in, where it takes a team of 17 monks to strike the enormous bell. After ringing out the old, it is time to welcome in the new by heading for a Shinto shrine, and at Chion-in the crowds are steered downhill to Yasaka Shrine, where worshippers purchase a lighted piece of rope with which to start a new year's fire in the family hearth.

New Year's Eve: Chion-in and Yasaka Shrine are popular spots. Alternatively, Kurodani Temple, then 20 mins to Shimogamo Shrine. See (writersinkyoto.com/2018/12/a-kyoto-new-year/).

Over the next three days throngs of people visit shrines, happily buying lucky charms and getting their fortunes for the year ahead. Some dress in kimono, and the bustling, joyful atmosphere is furthered by cups of sweet saké. It may be the coldest time of year, but it is one of the city's warmest occasions.

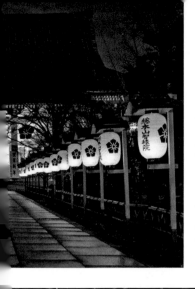

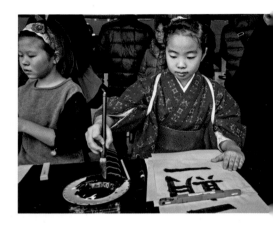

OPPOSITE BELOW Family portrait for Hatsumode (first shrine visit of the year), dressed up together with a lucky charm.

LEFT It is customary to visit a temple to see out the old year, and while the popular ones are crowded, others are peaceful.

RIGHT *Kakizome* (New Year calligraphy) has a special place at Kitano Tenmangu, whose deity is patron of the art.

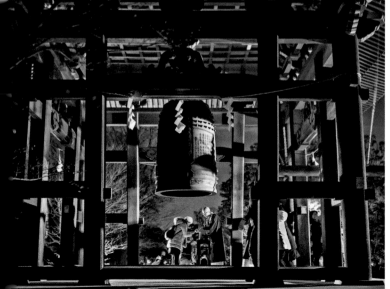

ABOVE On New Year's Day, food called *osechi ryori* is eaten. It comprises a colorful array of tasty items, each of which has a symbolic meaning.

LEFT On New Year's Eve, people queue at temples to ring out the old year, as here at Chishakuin. Traditionally, the bell is rung 108 times, once for every human attachment.

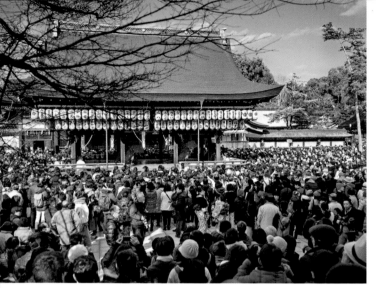

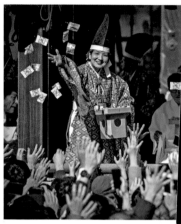

SETSUBUN FESTIVAL February 2–4
"In with happiness, out with the demons"

ABOVE LEFT AND RIGHT One of the most popular places for Setsubun is Yasaka Shrine. Celebrities and VIPs are invited to throw bags of beans to the crowd, who surge forward to catch them as protective talisman for the coming year.

Setsubun is a bean-throwing festival that originated in China to mark the division between winter and spring in the old lunar calendar. The highlight involves throwing roasted soybeans at devils while shouting "In with happiness, out with the demons." Why? Because demons represent the dark forces of winter (cold, illness, starvation), whereas the beans represent vitality and new growth.

For home celebrations, Japanese families typically buy small packets of beans and a demon's mask. As well as chasing the demon out of the house, it is customary to eat as many beans as one's age, plus one. There is also a tradition of eating specially thick *sushi* rolls while facing towards the "lucky direction" for the year.

In addition to these private festivities, there are public events featuring *mamemaki* (bean throwing). There is great jostling and scrambling to catch the beans because they are thought to ensure good luck in the coming year. Two popular venues are the Yasaka and Heian Shrines, where the beans are thrown by geisha. At Rozan-ji, grotesque

demons strut the stage, and at Shogo-in, *yamabushi* (mountain ascetics) set alight pine branches causing a thick pall of smoke.

The biggest of the city's festivities is at Yoshida Shrine, which takes place over three evenings. Stalls line the entrance to the shrine, offering an assortment of foodstuff and children's attractions. The main events are a huge fire of expended charms and demons which appear in the dark, so you will need to have your beans ready.

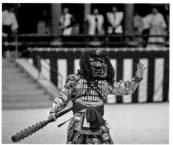

For a full listing of events in Kyoto, see (kyotoguide.com), search under Setsubun. The main day is Feb 3. Mibu Temple puts on a special Kyogen play (mibudera.com/eng/).

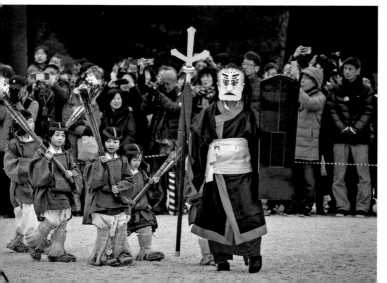

ABOVE LEFT At Heian Jingu, a demon struts before the audience like a pantomime villain. This traditional figure, who symbolizes the miseries of winter, is driven away by the vitality inherent in beans.

ABOVE RIGHT Setsubun, like other Japanese festivals, provides an opportunity to sample the fare at *yatai* stalls run by itinerant workers, set up along the approaches to shrines and temples.

LEFT Hososhi is a traditional character based on the government exorcist of former times, who wore a mask with four eyes to identify evil in all directions. Behind him, children play his attendants.

HANATORO NIGHT ILLUMINATIONS
Lantern-lit Romance in Spring and Autumn

Twice a year, for 10 days, thousands of lanterns line Kyoto's back streets in a display known as Hanatoro (Flower and Lantern Pathway). There are over 3 miles (5 km) of lanterns in all, and though it is a relatively recent addition to the Kyoto calendar, it has proven popular with locals and visitors alike.

The spring event takes place in the popular Higashiyama district, where some 2,500 lanterns illuminate a route from Shoren-in to Maruyama Park, and then along the lane leading to Kiyomizu Temple. The latter part, known as Sannenzaka (p. 98), is free of cars and filled with traditional features, which are highlighted to spectacular effect by the lantern light. If the timing is right, you may even be treated to a free musical performance.

The autumn illumination takes place in Arashiyama, one-time playground of Kyoto aristocracy. For 10 days, the riverside is lit up, as are the nearby streets. The Togetsukyo Bridge, framed by the dark mountains behind, takes on the appearance of the past, while the undoubted highlight is the ghostly profusion of bamboo stems in the famous grove behind Tenryu-ji.

The lanterns are made of plain wood and paper, on which painted images are brought to life by the candles inside. The play of light and shade has long been a staple of Japanese aesthetics, and here the lanterns create a flickering world that hovers between night and day. Some people dress up in light cotton *yukata* for the occasion, there are displays of artwork, and along the way temples and shrines have special openings. Thanks to the lanterns, the ancient buildings appear, quite literally, in a new light.

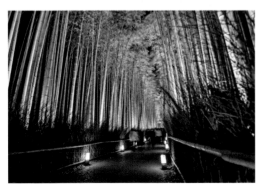

TOP In addition to lanterns lining the streets, Hanatoro features special performances, such as this one of illuminated paper monsters.

LEFT The autumn Hanatoro highlights the bamboo grove at Arashiyama, which is normally much more crowded than this.

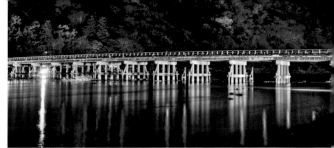

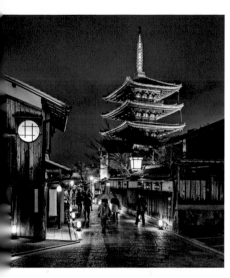

ABOVE The 377 ft (155 m) Togetsukyo Bridge in Arashiyama is seen to best effect during the illuminations.

LEFT In March, the traditional lanes of eastern Kyoto are dominated by the illuminated Yasaka-no-to pagoda.

BELOW The success of Hanatoro has led to other sights, such as Heian Jingu, making use of lanterns to attract evening visitors.

Higashiyama Hanatoro, March, 18.00–21.30. Arashiyama Hanatoro, early Dec. For exact dates, see (hanatouro.jp/e/).

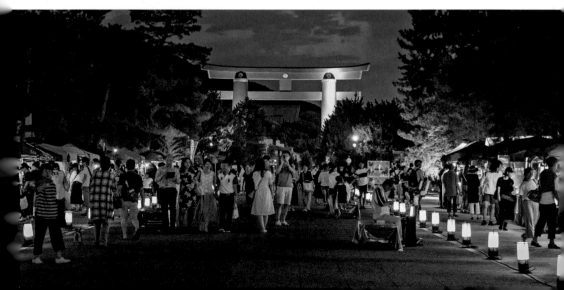

CHERRY BLOSSOM SEASON late March
A Time for Merrymaking

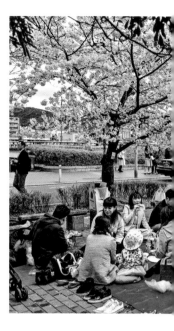

As the "soul of Japan," visitors are drawn to Kyoto for its heritage of traditional culture. That includes its cherry blossom. Poets have for centuries extolled the beauty, and the 12th-century poet-monk Saigyo was a particular devotee: "Let me die in spring under the flowering cherry and a full moon," he wrote.

One point of note is the intensity with which Japanese view the petals, for the attention to detail is characteristic of the culture as a whole. There are many famous spots for blossom viewing, but a warning—they will be crowded. On the other hand, crowds can be fun. The custom is to spread blue plastic sheets on the ground, and as spirits rise happy picnickers may invite passersby to join them.

The most revered tree is "the grand old man" of Maruyama Park, a wonderful weeping cherry which is illuminated at night. Stalls, selfie sticks and merry-

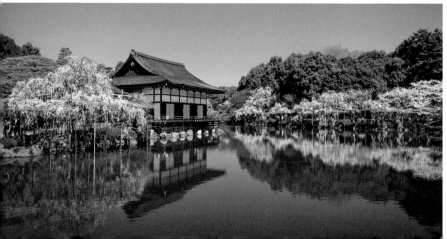

ABOVE In cherry blossom time, party-goers make use of every available patch of ground on which to spread vinyl sheets for picnicking.

LEFT The gardens of Heian Shrine are particularly popular in spring, as the beauty of the blossom is reflected in the landscaped pond.

LEFT The blossom attracts photographers of all types, concerned to capture every little detail of the opening buds.

BELOW Shirakawa Street, said to be Kyoto's prettiest, is lined by cherry blossoms, which even herons stop by to admire. It is popular, too, for wedding photos.

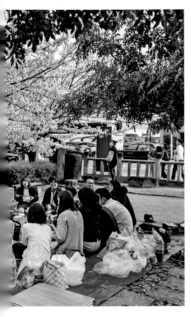

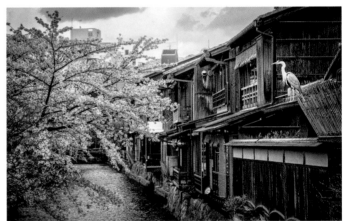

goers surround it. For those who prefer something quieter, a week-day walk along the Kamogawa provides a riverside promenade past a profusion of pink. For late-comers, the cherry trees at Omu-ro in Ninna-ji blossom a week or two later than elsewhere, enabling a final viewing before the city settles down to rhodo-dendron and azalea.

To see the festivity at its finest, head for Hirano Shrine at twilight.

Here, beneath a grove of illumi-nated cherry trees are squeezed salarymen, students, families, lovers, friends and strangers, all celebrating the joys of spring. Don't hold back: a glass or two of saké and you, too, may be intoxi-cated by the fragrance.

Cherry blossom begins in late March and lasts up to three weeks. For a listing, see (japan-guide.com/e/e3951.html) and (insidekyoto.com/kyoto-cherry-blossom-itinerary).

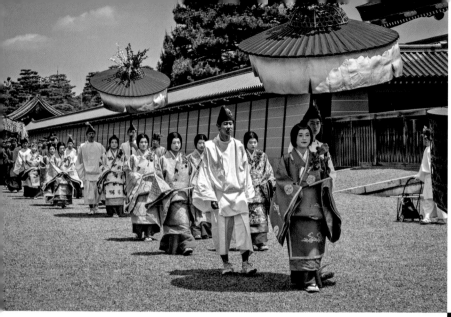

LEFT The festival's procession of figures in Heian-era clothing begins from the Former Imperial Palace at 10.30 and ends five hours later at Kamigamo Shrine.

BELOW Luxury travel for the Heian nobility was in decorated ox-carts, inside which passengers were seated on cushions.

AOI FESTIVAL May 15
The Oldest of Kyoto's Big Three Festivals

For Kyotoites, the month of May means the Aoi Matsuri. The main event takes place on May 15, when over 500 people in Heian-era clothing parade from Gosho (the Former Imperial Palace) to Shimogamo Shrine, then after a break on to Kamigamo Shrine. The two Kamo shrines act as joint hosts of the festival, which has imperial patronage through an envoy who brings offerings for the gods.

The festival dates back to the 6th century, before Kyoto was founded, when a series of disasters broke out, including crop failure and epidemics. Blame was

May 15 parade begins at Gosho 10.30 and finishes at Kamigamo Shrine around 15.30. For map, seat reservation, audio guide, see (japan-guide.com/e/e3948.html).

ascribed to the deities of the Kamo clan, so a festival was held to appease them. It took its name from the *aoi* plant, thought at the time to offer protection.

Though the festival has sometimes ceased to be held, it was always revived and is now a fixed part of the Kyoto calendar. There are several pre-events, notably horse racing (May 5 at Kamigamo), horse archery and a purification ritual (May 3 and 5 at Shimogamo). The latter features a young woman in the role of the Saio, an imperial princess who in former times presided over the shrines.

The grand parade features elegant horsemen and robed women, who display the full glory of the Heian nobility. Participants wear the distinctive *aoi* leaf and take an hour in all to pass by. The star of the show, however, is the

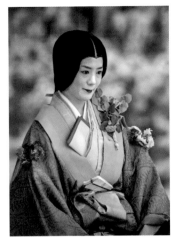

ABOVE As with other participants, the Saio (imperial princess) wears a sprig of *aoi* leaves, thought to ward off evil and disease.

LEFT Female children at the Heian court dressed in brightly colored kimono layers, uncomfortable on a hot day.

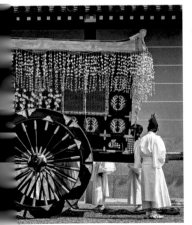

Saio, who wears the Heian court's formal style, a 12-layered kimono. It is stunningly beautiful, but spare a thought for the young lady as it can weigh up to 44 lb (20 kg).

SUMMER RIVERSIDE DINING May–September
Al Fresco Platforms Facing the Kamo River

Summer in Kyoto means heat and humidity. Over the centuries, citizens have devised many ways of combating the effect, one of which is sitting by the river to catch the gentle breeze that blows along the water. It brings into the heart of the city the coolness of the northern mountains.

In the early 17th century, the riverside was used for entertainment purposes, such as Kabuki (p. 118). Visitors to the capital would head for the riverside in the evenings, and *ukiyoe* paintings depict scenes of happy revellers. One of those enchanted by the custom was the poet Matsuo Basho, who wrote a prose-poem that ends with a haiku.

river breeze—
in a persimmon-dyed robe
the evening cool

Nowadays, there are some 100 restaurants with *kawayuka* (river platforms). Meals range from around ¥2,000 for something basic up to ¥15,000 for full courses. Traditional specialities, such as tofu and *kaiseki* delicacies, can be found alongside modern favorites like Kyoto beef. There is plenty of variety, with Chinese, European and Asian fusion, too.

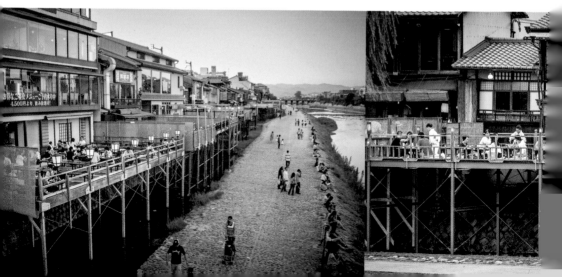

RIGHT A couple seated on flat cushions enjoy an outdoor meal in traditional style. Other platforms use Western-style tables and chairs.

BELOW LEFT An embankment along the western side of the Kamo River provides a promenade below the outdoor diners.

BELOW CENTER There are about 100 platforms in all, with food that varies from traditional Japanese to European.

BELOW RIGHT The view from Shijo Bridge at sunset highlights the mix of ancient and modern that typifies contemporary Kyoto.

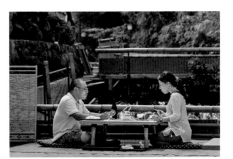

The season is May–September, between Nijo and Gojo Streets. Food is generally limited to evenings. Official webpage in Japanese (kyoto-yuka.com).

These days, the platforms span the narrow Misogi Stream, set slightly apart from the Kamo River. Walk along the embankment and you can get a feel of the atmosphere: office workers, wedding parties, student gatherings, foreign couples, even the occasional geisha entertaining clients. And for those in need of a break, Starbucks at Sanjo Bridge has a platform of its own where you can enjoy a green tea latté with a view of the Eastern Hills and a little touch of that riverside breeze.

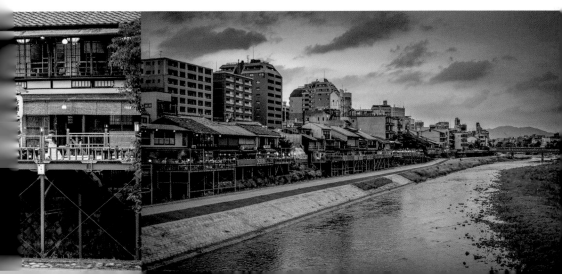

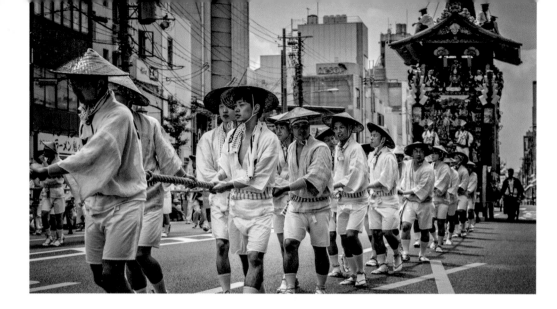

GION FESTIVAL July
Kyoto's Largest Communal Celebration

In July every year, downtown Kyoto plays host to the city's biggest festival. It lasts for a month and involves 23 different events, though the main attraction is the grand parade on July 17. It is one of the top events in Japan.

Like other Matsuri, the Gion Festival is religious in origin. It started in 869 when a major epidemic was ascribed to one of the deities of Yasaka Shrine. In response, the shrine organized a festival to placate the *kami*. Every time an epidemic broke out, this was repeated, until the festival was made annual in 970. Later, it attracted the backing of the city's merchants, who lavished their wealth on decorative tapestries, some of which were imported from the Middle East and Europe.

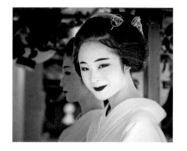

TOP The floats used in the parade can weigh up to 12 tons (12,200 kg) and require teams of 20 or more to pull them.

ABOVE The Hanagasa Junko (Flower Umbrella Procession), which takes place on July 24, includes *maiko* giving a dance performance.

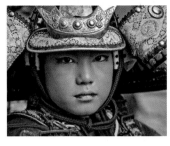

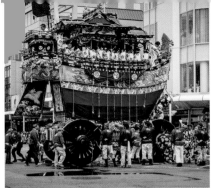

OBON & DAIMONJI August 13-16
Honoring the Spirits of the Dead

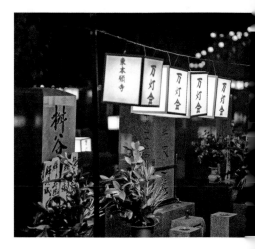

In the middle of August, at Obon, Japanese welcome back the spirits of deceased family members. It is one of the biggest events of the year, when families gather to clean graves and pay respects at the family altar. Then, in Kyoto on August 16, fires are lit on the surrounding hills in a "sending off festival" known as Daimonji.

The start of Obon is marked by 10,000 lanterns being lit in the Otani Cemetery on the Eastern

RIGHT For three nights at Obon, lanterns light the way to Otani Cemetery on the Eastern Hills to help guide the spirits of the dead.

CENTER RIGHT Monks take part in the Manto-e candlelight ceremony at Daigo-ji to welcome the spirits of the dead.

Hills. Known as Manto-e, the event marks the return of the ancestral spirits and highlights the bond between the living and the dead. Taking place from August 13 to 15, the hillside covered with flickering flames is one of Kyoto's most moving sights.

On August 16, fires are lit on five separate hills around the northern part of the city to guide the spirits back from where they came. The festival takes its name from the Daimonji Hill bearing the large Chinese character for "Dai" (Big). Though the reference is Buddhist, the significance is disputed. Another of the four hills

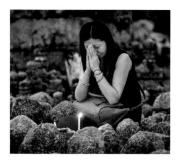

ABOVE Obon is a special time for Japanese, when the spirits of the dead seem particularly close at hand.

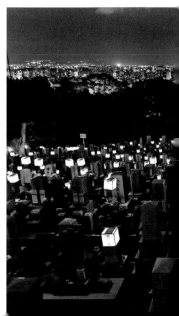

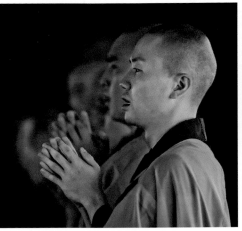

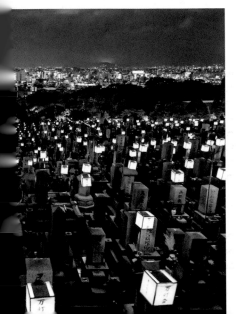

ABOVE RIGHT At Obon, people gather at the family altar, where the deceased are honored with offerings of food and Buddhist prayers.

LEFT From the top of Otani Cemetery, the view is of two illuminated worlds: that of the dead and that of the living.

Otani Cemetery is 10 mins walk from Yasaka Shrine. Daimonji takes place at 20.00 on August 16, best viewed from the Kamo River at Marutamachi or further north.

also bears the character for Dai, though much smaller, while the remainder feature a *torii* gateway, a boat for transporting souls and the Buddhist term "Myoho" (Wondrous Law).

Onlookers gather at viewing spots, and some dress in kimono for the occasion. As the fires light up from east to west, a thrill runs through the crowd. Though the event only lasts for 20 minutes, there is an awareness of something special as the veil between this world and the other dissolves into smoke, rising up into the darkness. It is a prime example of Japan's ancestor worship.

JIDAI FESTIVAL October 22
The Ancient Capital's Festival of Ages

The Jidai Matsuri is the most recent of Kyoto's Big Three Festivals, dating back to 1895. It was established to celebrate the 1,100th anniversary of the city's foundation. At the time, Kyoto was still feeling the loss of the imperial court to Tokyo in 1868, and was seeking ways to compensate for that loss.

To reassert civic pride, the authorities established the huge Heian Shrine and installed as *kami* Emperor Kammu, founder of Heian-kyo. (Later, Emperor Komei, last of the Kyoto emperors, was also installed.) To go with the new shrine, a historical pageant was set up and named Jidai Matsuri, meaning Festival of Ages. The

idea was to celebrate Kyoto's time as imperial capital, to celebrate Kyoto as it existed prior to 1868.

The festival takes place on October 22, the day when Kyoto was founded, and the procession from the Former Imperial Palace to Heian Shrine covers a distance of about 3 miles (5 km). Over 2,000 participants are involved,

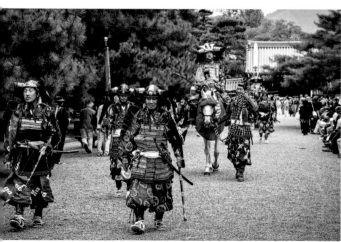

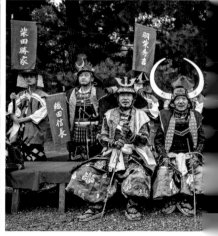

and it takes two hours for the whole procession to pass by. Much of its appeal lies in the lavish costumes, which have been woven and dyed in as authentic a manner as possible.

Like a traditional picture scroll, the magnificent procession unfurls to tell the history of imperial Kyoto in reverse order. Before one's eyes pass Restoration patriots, Edo-era women, "second founder" Toyotomi Hideyoshi, the saleswomen of Ohara, horseback archers, medieval aristocrats and court poets. Finally, signifying the religious nature of the festival, come two *mikoshi* (portable shrines) bearing the spirits of Kammu and Komei, the first and last of the imperial line to reign from "the ancient capital."

Seats can be reserved at convenience stores (in Jap) or at JTB travel offices. A color pamphlet explains the historical figures. See (japan.travel/en/spot/88/).

ABOVE One of the 2,000 participants relaxes prior to the procession. Ahead of him is a 3 mile (5 km) walk taking two hours.

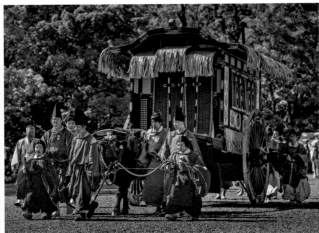

FAR LEFT Kusunoki Masashige, on horseback, was a 14th-century imperial loyalist who fought for the exiled Emperor Go-Daigo.

CENTER LEFT The 16th-century warlord Hashiba Hideyoshi rebuilt Kyoto after it had been destroyed in the Onin War.

LEFT Only the nobility could travel by ox-cart, the decoration of which reflected the rank of the person inside.

KURAMA FIRE FESTIVAL October 22
A Torchlight Procession in a Hillside Village

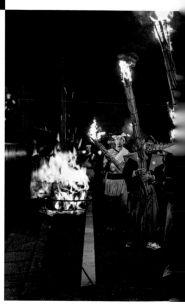

Huge pine torches, up to 16 ft (5 m) tall, are borne aloft on the shoulders of men in loincloths. Before them, children and teenagers carry smaller torches. Sparks fly here and there among the participants, and occasionally on spectators, too. Garments may get singed, but the wearers don't worry too much as it is said to bring good luck.

The small village of Kurama lies to the north of Kyoto, and to help protect the capital from evil it was decided to move Yuki Shrine there in 940. The relocation of the deity was accompanied by an imperial procession, which arrived in the dark and was guided by welcoming villagers with torches ablaze. This festival commemorates that event.

As dusk descends on October 22, small fires are lit in front of the village houses. Some open their doors to display family

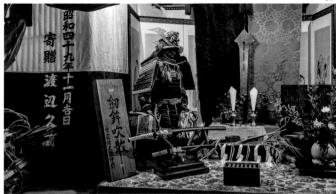

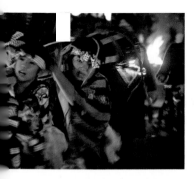

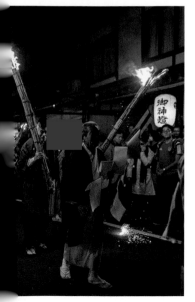

treasures, such as armor, pottery and folding screens. For the children, the festival is a rite of passage, and like their elders they dress in festive garb. The size of the torch is matched to the individual, with the heaviest weighing 176 lb (80 kg).

As the procession makes its way down the main street, cries of "saireya, sairyo" ring out. Those carrying the *mikoshi* face a test of strength in negotiating the steep steps at the entrance to the shrine, in front of which torches are piled high to make a huge bonfire. In celebration, there are cups of sacred saké, for the spirit of the past has been kept alive for yet another year.

ABOVE As in Kyoto's Gion Festival, some of the households along the route put their family treasures on display.

LEFT The procession is led by village dignitaries, who parade along the main street before turning up Kurama Hill to end at Yuki Shrine.

For Kurama, take the Eizan train from Demachiyanagi (30 mins, ¥840). Festival runs from 6.00 to midnight. Best to go early with warm clothes. (japanvisitor.com/japanese-festivals/kurama-fire-festival).

AUTUMN FOLIAGE SEASON November–December
Stunning Fall Maples Create a Riotous Display

Spring means cherry blossom, autumn means maple leaves. Japan's seasonal cycle, so important to its arts, is nowhere clearer than in the celebration of the changing appearance of trees. Crowds flock to places feted for their foliage, reinforcing the awareness of transience and beauty that underlies the Japanese sensibility and consciousness of nature.

In terms of autumn colors, cherry trees, with their somber hues, are the first to change in mid-October, then the sparkling yellows of the gingko trees add a brighter hue. The undoubted star, though, is the maple with its fiery reds, which peaks around the end of November. The northern hills are the first to turn, with the village of Kurama a favorite, not just for its hillside setting but for the train journey which runs through a tunnel of blazing red and gold.

There are numerous other maple spots, though popular ones can be very crowded. The city's eastern fringe is rich in sites, notably such temples as Kiyomizu, Kodai-ji and Eikando. Most famous of all is Tofuku-ji because of the 2,000 maples in the gorge that runs through it. Elsewhere, Arashiyama in the west, Takao in the northwest and the Philosopher's Path in the northeast all draw crowds of admirers.

In recent years, illuminations have added to the maple-viewing experience. Some are so stunningly spectacular that they

LEFT Autumn colors come in differing shades, but the star of the show is the Japanese maple with its fiery red and orange leaves.

remain lodged in the mind long afterwards. Each has its own character and people have different favorites. An interesting contrast can be had by visiting Byodo-in and the Shinto shrine of Kitano Tenmangu. In the gathering gloom of late autumn, these illuminated glories are guaranteed to light up your evenings.

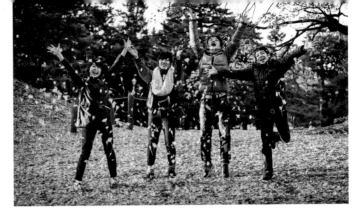

BELOW Kiyomizu Temple is spectacular at any time of year, but autumn illuminations add an extra magical touch.

Access—For Kurama, take the Eizan train from Demachiyanagi. A listing of maple sights is at (insidekyoto.com/autumn-colors-in-kyoto).

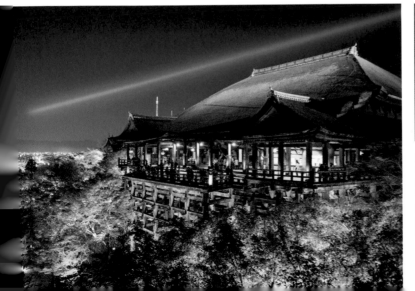

ABOVE The distinctive form of the maple leaf is a commonly used motif in Japanese culture, including artwork and kimono design.

TOP Seasonal change is a cause for celebration in Japan, whether in the form of food, flowers, or foliage.

THE MAIKO TRADITION
Trainee Geisha with Poise and Beauty

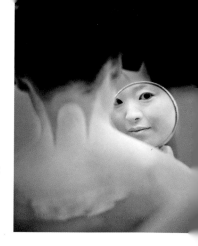

Maiko are the glittering stars of the Kyoto scene, who cause excitement just by walking down the street. They represent centuries of art and beauty and embody the essence of elegance. With their white faces, lacquered hair and gorgeous kimono, these apprentice geisha typify "exotic Japan."

To become a maiko, young women start training at 15 or 16, after junior high school. Before she enters her twenties, she will have graduated to be a *geiko* (the Kyoto term for geisha). The bright colors, hair ornaments and long sleeves are replaced with something less showy, for with age comes status and dignity. (In fact, these days many maiko leave after training to pursue other professions.)

The young women have busy schedules, for along with lessons in dance, music and deportment are work assignments. Until recently it was only possible to catch a glimpse of maiko as they hurried to work, and hiring them was only feasible for the rich and well-connected. Now, there are all kinds of opportunities to meet them, and some maiko publicize their activities in blog posts or YouTube videos.

Every item of the maiko's costume shows the refinement of Japanese craftsmanship: the elaborate hairstyle and ornaments; the dazzling kimono with seasonal reference; the embroidered *obi* sash; the high wooden sandals. A whole support system depends on her for employment,

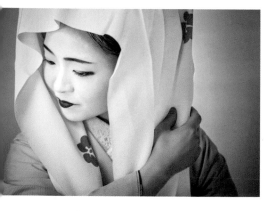

ABOVE CENTER The distinctive W shape on the nape of the neck is done by the *maiko* herself with the aid of double mirrors, and is considered a vital part of her charm.

LEFT Basic entertainment known as *ozashiki* is set for two and a half hours. Here, a dancer from the Maiko Theater performs with head covered by a *tenugui* cloth.

Gion Corner has a maiko dance (kyoto-gioncorner.com/global/en.html). For maiko dining (¥19,000) Yasakadori-Enraku (travel-kyoto-maiko.info) and Gion Hatanaka (gion-hatanaka.jp/maiko/index.html). Also information, including maiko beer garden, at (shinmonso.com/english/maiko).

including teachers, dressers and crafts people, yet beneath all the makeup and finery is just a young woman. In the transformation there is something magical.

BELOW LEFT The maiko's finery, seen here at a private entertainment, includes elaborate hair pieces, dangling sleeves and a broad *obi* sash.

BELOW The dangling obi at the back of the maiko is part of a sash that can be up to 20 ft (7 m) in length.

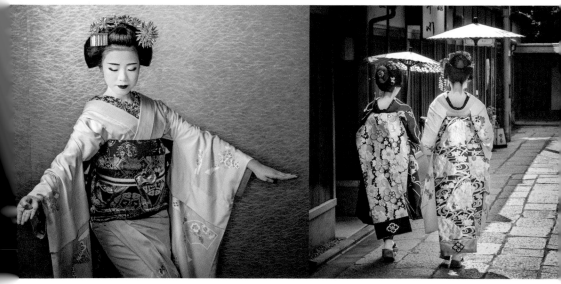

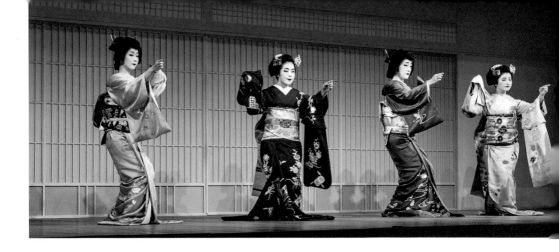

THE WORLD OF THE GEISHA
An Iconic Kyoto Tradition

For many people, Japan means geisha. Kyoto is their birthplace, for it was here that their elegance and artistry were first developed. They began as waitresses in the "tea houses" of the Edo Period, acquiring musical and dance skills to enhance their appeal. This went along with ornate hairstyles and eye-catching kimono.

These days, there are five functioning "flower districts" (geisha areas). Gion is the biggest and most famous, featured in Arthur Golden's *Memoirs of a Geisha*. The other areas have a more intimate feel: East Gion near Yasaka Jinja, Miyagawa-cho to the south, Pontocho near the city center and Kamishichiken in the north. The differences between them can be seen at the public dance performances they put on in spring and autumn every year.

The geisha lifestyle centers around two places: the *okiya* (boarding house) and the *ochaya* (tea house). The former is where

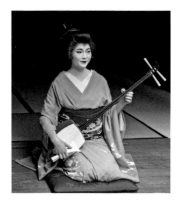

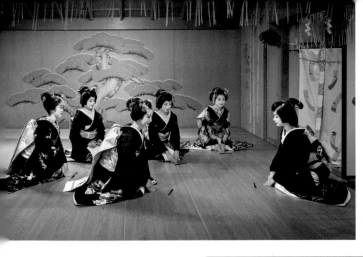

ABOVE Geisha and maiko in *kuromonsuki*, the formal black kimono, paying respects at the beginning of a new year. The kimono of maiko have brighter colors.

access to geisha was restricted to the wealthy and well-connected, but in recent years the once insular world has opened up. Remarkably, it now advertises itself to tourists, prices are much more affordable, and geisha evenings are even offered on the Internet.

BELOW Two geisha carrying *kago* bags for personal belongings, such as business cards and dancing fans.

Public performances are listed at (insidekyoto.com/kyoto-geisha). Gion Corner (¥3,150) includes a maiko dance (kyoto-gioncorner.com/global/en.html). For walking tour, etc. (kyotosightsandnights.com).

they live with their "family," run by an older geisha known as "mother." It is here that the apprentice geisha, known as *maiko*, are given guidance. The ochaya is where guests are entertained, typically with small talk, drinking games and performances of traditional dance or music.

The heyday of the geisha was the early 20th century, but with Westernization numbers declined, and today Kyoto has roughly 180 geisha and 78 maiko. In the past,

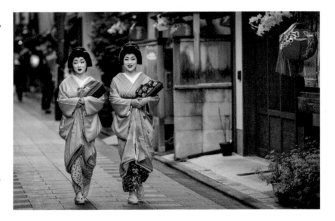

ZEN BUDDHISM
The Spiritual Source for Kyoto's Art and Culture

There are seven large Zen monasteries in Kyoto, inside the thick temple walls of which, guarded by sturdy gates, monks rise before daybreak to begin a daily round of chanting, meditation and menial chores. The monasteries contain numerous sub-temples. In addition, there are over 35 temples in the city headed by Zen priests. Together, the monasteries and other temples represent one of the world's great inheritances.

Zen arrived in Kyoto in the early 13th century. In contrast to previous Buddhist sects, it taught that the means of salvation was through sitting meditation, known as *zazen*. Ultimate truth lies within, so mastering oneself equates to mastering the universe. Two forms of Zen developed, notably Rinzai, which uses *koan* (mental puzzle) study and Soto, which encourages "just sitting." Later, a third type was added with the Obaku sect. Kyoto is almost exclusively Rinzai.

Thanks to patronage from the ruling class, Kyoto's monasteries were able to employ the top artists of the day. They not only produced Chinese ink paintings and decorated sliding screens, but also laid out innovative rock

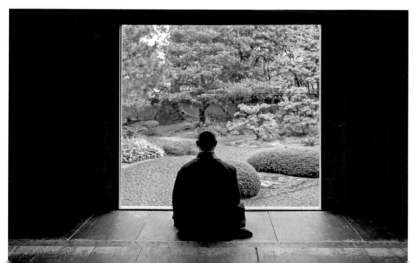

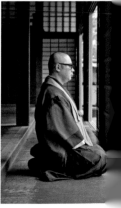

gardens. In this way, the temples became showcases of Zen arts, the guiding principle of which was based on a minimalism that cut to the essence of things.

Since the Meiji Restoration of 1868, temples have had to be self-financing, which means income from visitors can be vital. Some temples have welcomed the opportunity, though others are reluctant to compromise their religious purpose. Visitors who are in earnest will rise before dawn to join one of the zazen groups, for by sitting still they will move closer to the true essence of Kyoto.

RIGHT The perfectly raked dry garden at Kodai-ji features a cone of sand said to have a purifying effect.

BELOW Foreign visitors at Shunko-in receive instruction in how to sit correctly in the cross-legged position for Zen meditation.

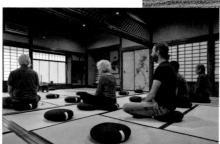

For talks, meditation and guided tours in English, visit shunkoin.com. See also Dougill and Einarsen's *Zen Gardens and Temples of Kyoto.*

LEFT TOP Bodhidharma, known in Japan as Daruma, is the legendary founder of Zen, whose stern features encourage followers to persist in their practice.

FAR LEFT AND LEFT Kawakami Takafumi, deputy abbot of Shunko-in, graduated from an American university and has been influential in the mindfulness movement of recent years. Here, he sits cross-legged in contemplation of the subtemple's dry landscape garden.

RIGHT A priest dressed for *takuhatsu* (asking for alms) blesses a passerby who has put a donation in his begging bowl.

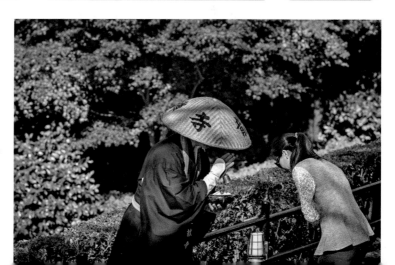

ZEN MONASTERY VEGAN CUISINE
The Art of Shojin Ryori

Shojin ryori originated from the need of Zen abbots to entertain high-ranking guests with appropriate meals. As with court food, it was meant to appeal to the eye as much as the stomach. The result was food that is healthy, locally sourced, seasonal and vegan. Zen principles were combined with a desire for deliciousness, and selection of the very best vegetables went along with the avoidance of waste.

Meals tend towards the plain, with seasoning designed to enhance the natural flavor and strong tastes like garlic avoided. Ingredients range from seeds and beans to roots and herbs. A typical meal may include boiled vegetables along with sesame tofu and a vinegar dish like winter melon. Whatever the ingredients, they will be accompanied by pickles, rice and *miso* soup.

The comparative luxury of shojin ryori contrasts with the everyday fare of Zen monks, whose simple meals are based on frugality. The idea is to ingest just enough to survive, without pandering to greed. In fact, much of Japan's basic foodstuff emerged from monastical kitchens: *miso*, tofu, *umeboshi* (pickled plum), *takuan* (pickled radish) and *natto* (fermented beans).

There are several places to sample shojin ryori in Kyoto, but for an authentic setting try the restaurants in Daitoku-ji and Tenryu-ji. They offer fine garden views, though it is advisable to avoid peak hours and book in advance. Preparation of the food is treated as a spiritual practice by which monks cultivate mindfulness, so consumption should also be done with respect. Gratitude is a promi-

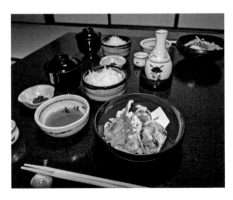

LEFT Traditional *shojin ryori* is local, seasonal and vegan. Here can be seen a *tempura* dish of deep-fried vegetables with a *shiso* leaf accompanied by sauce, pickles, rice and soup.

ABOVE LEFT A fried selection, including lotus root and bamboo shoot, with some stewed ingredients, such as aubergine and potato.

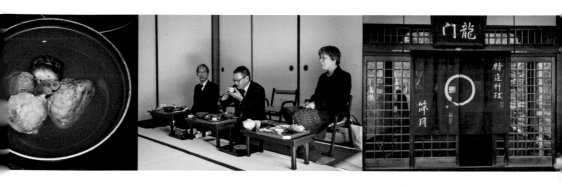

nent trait of Japanese culture, and seated before the meal there is much for which to be grateful.

Izusen in Daitoku-ji (075) 493-0889 (shojincuisine.com/tag/izusen/). Shigetsu in Tenryu-ji (075) 882-9725 (tenryuji.com/en/shigetsu/).

ABOVE CENTER It is customary to eat cross-legged at low tables, but for those who prefer, there are chairs.

ABOVE RIGHT The *noren* curtain for Tenryu-ji's Shigetsu restaurant has an *enso* circle signifying enlightenment.

RIGHT A shojin ryori set with sesame tofu, pickled radish, *shiitake* mushroom, skimmed tofu, *hijiki* seaweed, bamboo shoot, burdock, *konnyaku* devil's tongue, *nama-fu* gluten, rice and white *miso* soup.

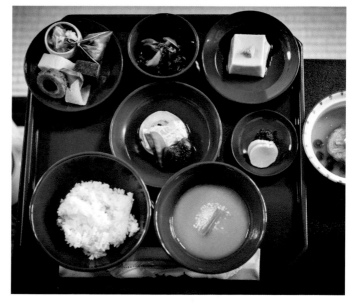

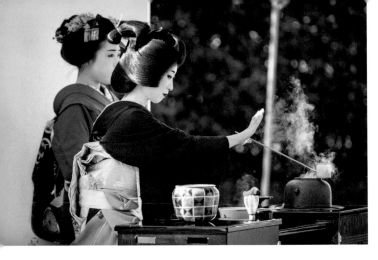

THE JAPANESE TEA CEREMONY
A Quintessential Kyoto Experience

Nothing speaks of Japan quite like the tea ceremony, for here in a simple ritual are assembled all its salient traits: the attention to detail; the refined etiquette; the seasonal references; the subjugation of ego; and the refined arts of calligraphy, pottery and flower arrangement. The birthplace of the tea ceremony was Kyoto, or more precisely, the city's Zen monasteries. "Zen and tea have the same taste," runs a traditional saying.

The origins of tea lie in China, but it was Sen no Rikyu (1522–91) who codified and shaped the modern tea ceremony. The son of a wealthy merchant, he became tea master to successive rulers of Japan. Despite his exalted position, he promoted equality, modesty and the values of *wabi-sabi* (the natural beauty of rustic simplicity).

Rikyu's aesthetic taste is exemplified in the tea houses he favored, based on peasants' huts made of rough wood, paper and mud. The "crawling entrance" he used not only enforced humility on visitors but prevented them from wearing swords. It thus served to promote a peaceful sense of companionship. In the tea ceremony, each occasion is treated as special. The tea motto of *ichigo ichie* can be translated as "just this one time meeting."

The appreciation and sharing of tea is carried out with a deep concern for aesthetics. "The way of Tea is a way of salvation through beauty," wrote the philosopher Yanagi Muneyoshi. Each item is chosen with care, and time is taken to admire the vessels and the decorations. There is a Zen-like concern to treasure the moment, and the ceremony is carried out in a spirit of meditative mindfulness. More than a simple bowl of tea, the participant is taking in a special Kyoto experience.

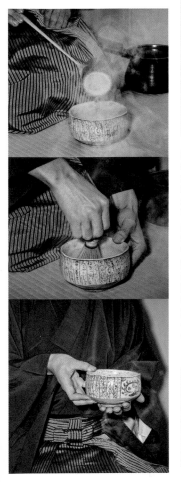

LEFT TOP, CENTER AND BOTTOM At the core of the ceremony is the mindful making of green tea. First, hot water is added to the tea powder, then whisked and finally the bowl placed before the guest.

ABOVE The tea house is modeled on the simple materials of a peasant's thatched hut.

RIGHT The main feature inside the tea room is the *tokonoma* alcove, here displaying a New Year's decoration.

BELOW RIGHT It is customary to turn the bowl around before offering it so that the front faces the guest.

To arrange a tea ceremony, Camellia (tea-kyoto.com). For an informed listing of opportunities, see (insidekyoto.com/kyoto-tea-ceremony).

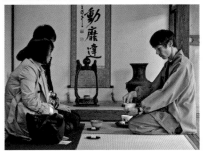

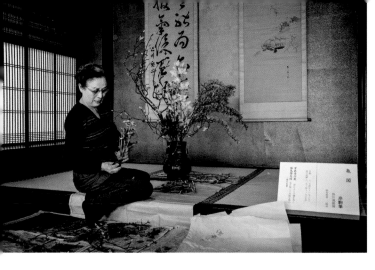

Along with scrolls, an alcove might house a prized piece of pottery. This could take the form of a vase containing a single flower, in keeping with the restrained *wabi-sabi* style of tea. Both scroll and flower relate to the season, connecting the onlooker with

IKEBANA & CALLIGRAPHY
The Treasured Arts of the Tokonoma Alcove

Go to an old Japanese house, or attend a tea ceremony, and you will see an alcove with a hanging scroll. It plays an important part in Japanese aesthetics, and learning to appreciate it is key to unlocking many of the country's cultural values.

The use of a raised alcove (*tokonoma*) originated during the 15th and 16th centuries, in the Age of Warring States. The proponents of tea, influenced by Zen, sought to imbue the ceremony with spiritual depth by using scrolls with Chinese ink paintings or calligraphic words of wisdom. Handwriting with an ink brush, which originated in China, was considered an art form in itself. Those who practiced it had to master different styles, and there were strict rules about what was considered pleasing.

nature and the passage of time. In this way, the tokonoma can teach important life lessons.

Grander floral displays, known as *ikebana*, can also be displayed in the tokonoma. These are thought to date back to medieval times, when flowers were offered at Buddhist altars. There are many schools, and the oldest among them, such as Saga Go-ryu and Ikenobo, originated in Kyoto. The latter displays eye-catching arrangements at its high-rise headquarters in Karasuma. Kyoto was once known as "the flowering capital," and here at Ikenobo the epithet is more than apt.

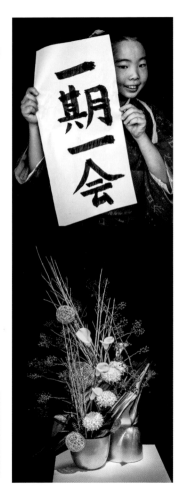

RIGHT Calligraphy of *ichigo ichie* ("just this one time meeting"), motto of the tea ceremony, which expresses how important it is to cherish the moment. Idioms with four characters are a favored form in Japanese and Chinese.

BELOW RIGHT Ikebana flower arrangements originated with the offering of flowers in Buddhism, and later the samurai practiced the art as a way of calming the mind. Now, there are over 1,000 schools.

LEFT The oldest ikebana school is Ikenobo, located next to Rokka-kudo, where priests living by the pond competed in offering beautiful arrangements. The Ikenobo headquarters stands next to the original pond and temple.

The earliest surviving tokonoma is in the Togudo at Ginkaku-ji (not normally open). For a calligraphy workshop, see (calligraphy.kyoto.jp/). For Ikenobo, (ikenobo.jp/english/).

NOH & KYOGEN THEATER
Profound Musicals with Comic Interludes

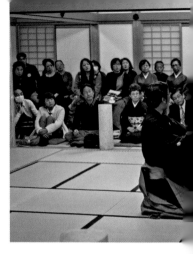

Painted at the back of the empty wooden stage is a lone pine tree. Flute, drums and deep-throated yelps evoke an eerie atmosphere. A robed figure glides imperceptibly towards mid-stage to deliver a monologue. Over the next 50 minutes nothing much happens, except that one of the characters confesses to being the unhappy spirit of a dead person. The whole event is unreal, mysterious and dream-like.

Noh theater originated in the 14th century from plays put on at religious events. It was perfected by a genius called Zeami, who won the patronage of the shogun. His plays have a spiritual quality deriving from his Shinto background and enhanced by the influence of Zen. The resulting performances are elegant and profound, in a way which appealed to the ruling class of Kyoto.

BELOW Masks play an important part in the other-worldly aesthetics of Noh, lending characters an enigmatic quality. In all, there are said to be over 200 different kinds of masks.

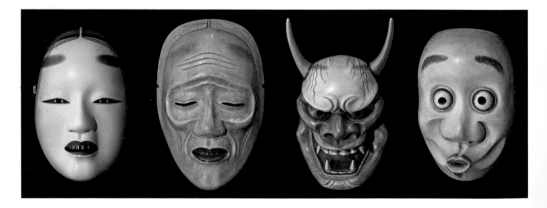

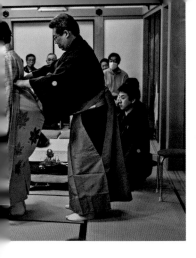

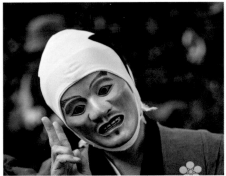

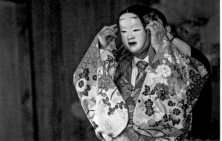

CENTER LEFT Noh costumes are often precious heirlooms handed down over generations, and such is the complexity of the embroidered finery that it requires attendants to arrange.

LEFT Kyogen characters, such as this performer at Arashiyama's Maple Festival, use simple commoner's clothing for their comic skits.

BELOW LEFT An attendant stands behind an actor to help put on his mask. The full effect with embroidered kimono can be stunning, evoking the Japanese aesthetic of *yugen* (elegant profundity).

Today, plays are put on at two main venues: Kyoto Kanze Kaikan and Kongo Noh Theater. The two groups have different traditions, and their masks and costumes, handed down over generations, are prized items. With its slow pace, archaic language and traditional themes, Noh may seem outmoded, yet it is not unusual to see people practicing by the riverside, and in recent years it has even made inroads abroad.

Performances typically feature several short plays interspersed with a humorous sketch called Kyogen. A favorite theme is that of servants outwitting their master. There are also non-verbal comedies, known as Nembutsu Kyogen, performed at temples. Originally aimed at illiterates, the mimes combine humor with Buddhist teachings. At Mibu Temple, the same plays have been performed for 700 years, proving that in Kyoto, at least, the show really does go on.

For a listing of Noh performances, see (the-noh.com/en/schedule/). Mibu Kyogen (¥800) takes place at Setsubun, also early Apr and Oct (mibudera.com/eng/).

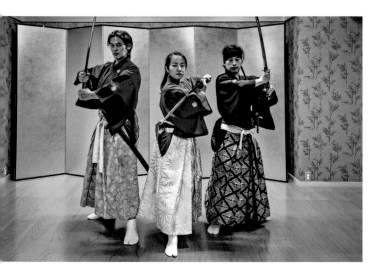

THE SAMURAI SWORD
A Blade Forged and Wielded with Lethal Beauty

It is often said that whereas Edo was a city of samurai and masculinity, Kyoto was a city of refinement and feminine arts. Yet, it was the emperor's court in Kyoto that gave birth to the samurai, and it was here, too, that the highest quality swords were forged to take into battle.

The derivation of samurai comes from a word meaning "to serve," and early samurai were in the service of the nobility. Their leaders were the illegitimate offspring of emperors, and by the 12th century two powerful factions had emerged: the Genji and the Heike. The classic compilation, *Tale of the Heike*, tells of the war between them.

With its animist traditions, swords were seen in Japan as the very soul of a samurai. Sword-making was thus a vital matter, which was treated as a spiritual undertaking. Kyoto swords, in particular, were noted for their beauty and durability. Forged with painstaking care and polished to perfection, they were given as gifts to powerful warlords as a way of cementing alliances.

In the 1870s, following the Meiji Restoration, swords were forbidden and samurai consigned to the feudal past. Now, there is only one practicing swordsmith in Kyoto, though there are still courses in *iaido* (Way of the Sword) and shops that specialize in high-quality swords (upwards from ¥500,000). There are also introductory lessons for tourists, where dressed in samurai garb participants are taught how to slice through bamboo. For the connoisseur, though, the Kyoto sword is more than just a weapon, it is a true work of art.

OPPOSITE A demonstration of the different ways of holding a sword by the Samurai Kembu Theater.

RIGHT A double slice performed by sword master Kawata Akihiko of Samurai Juku. The first slice is diagonal. The second cuts through the severed piece in mid-air.

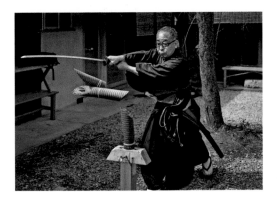

BELOW LEFT Samurai armor not only offered effective protection but was aesthetically pleasing. A full outfit weighed 44–66 lb (20–30 kg).

BELOW RIGHT The Japanese sword (*katana*), considered the soul of its samurai owner, is a curved, single-edged blade with a long handle that is grasped with both hands.

Samurai Juku (samuraijuku.com) and Kyoto Samurai Experience offer introductory sword practice. Lessons in iaido at Kyoto Budo Center. Nearby shop Tozando sells armor and swords. The Samurai Kembu Theater (samurai-kembu.jp) has a stage show, as does Toei Film Studio (p. 200).

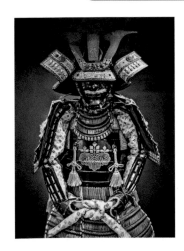

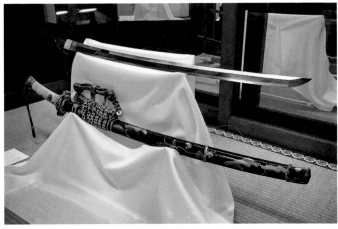

THE KIMONO
A Stylish Garment for Every Occasion

The natural elegance of the Japanese kimono belies the amount of industry that goes into its creation. To begin with, there are at least eight different styles and motifs, depending on such factors as class, wealth, age, marital status, season and taste. Then there is the artistry and craftsmanship involved. In mastering such subtleties, Kyoto kimono merchants helped further the city's reputation for excellence.

The making of a kimono begins with the design, which usually has a seasonal reference. This is plotted on graph paper and colored to make a pattern sheet. The weaving process involves the cutting of warp threads (up to 8,000, in some cases), and the result may feature plants, animals, auspicious symbols and decorative objects.

The long wrap-around sash, called *obi*, is made of dyed yarns woven into a brocade. The Nishijin area, famous for embroidery and kimono-making, has been active since early Heian times, and the sound of looms can still be heard in the streets. Such is the finery, that obi can be more expensive than even the most exorbitantly priced kimono.

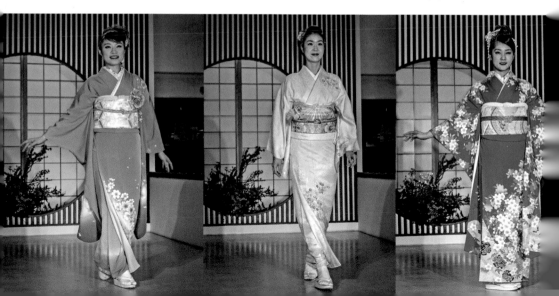

Casual summer wear, known as *yukata*, is unlined and made of cotton, whereas kimono are made of silk. Originally worn as bath robes, yukata remain standard at hot spring resorts. In recent years, they have become popular with visitors to Kyoto, particularly gaudy versions in contrast to the muted colors of the past. Traditionally, they were paired with *geta* sandals, fan and carry bag. These days, though, they might well be seen with sports shoes and selfie sticks!

OPPOSITE BELOW The daily Nishijin Textile Center fashion show highlights the elegance of kimono.

BELOW Flowers are often used in kimono patterns because of the seasonal reference. Characteristic of spring is the five-petal cherry blossom.

LEFT *Kyo-yuzen* is a complicated method of dyeing, which involves the use of glutinous rice to prevent the colors mixing.

BELOW A demonstration of traditional *obi*-making at the Nishijin Textile Center.

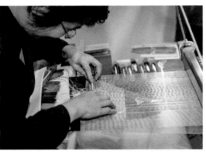

Nishijin Textile Center's free kimono show (nishijin.or.jp/eng/watch). Yumeyakata has a huge range for rent (en-kyoto.yumeyakata.com). For shopping, Mimuro with 50,000 items, 10.00–18.30 (mimuro.net/english/). Also Kyoto Handicraft Center (kyotohandicraft-center.com/concept/?lang=en).

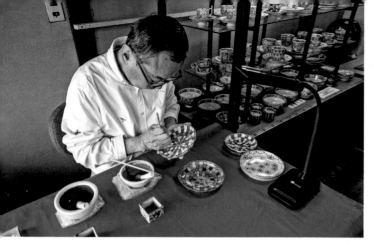

workshop with a potter's wheel. The kilns tend to be large and communal, meaning that Kiyomizu-yaki comes in a wide range of quality. It makes browsing the pottery shops on *chawan-zaka* (tea cup slope) all the more intriguing.

Another Kyoto speciality is Raku, famous for its tea bowls. It originated in the late 16th century with the collaboration of

KYOTO CERAMICS
Kyo-yaki, Kiyomizu-yaki and Raku Style

Japan is not only famous for the quality of its pottery but for the variety, fueled by the central role of ceramics in the tea ceremony and cuisine. It results also from the diversity in local clays, an example being Shigaraki, not far from Kyoto, which uses clay from the ancient bed of Lake Biwa. Coarse and sandy, it leaves tiny cracks as it dries.

A very different style developed with Kyo-yaki (Kyoto pottery) during the 17th century. It was initiated by a group of gifted artists working with provincial potters, one of whom was Nonomura Ninsei. Known for the delicate designs and the intense colors of his tea items, he is celebrated now as "the father of the Kyo-yaki pottery movement."

During the Edo Period, the area around Kiyomizu Temple housed a nucleus of house-potters, some of whose descendants have survived until today. Typically, the houses have a long corridor to the back garden and a small

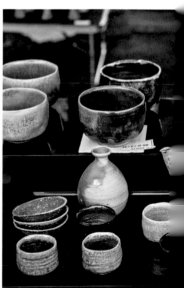

the potter Sasaki Chojiro and tea master Sen no Rikyu. In keeping with the latter's preference for *wabi-sabi*, the bowls are modest, irregular and muted, with black predominating. They fit snugly in the hand, transmitting the warmth inside. Remarkably, 400 years after their first creation, contemporary pieces are still being produced by the same family. That is Kyoto for you!

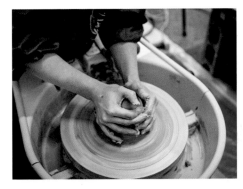

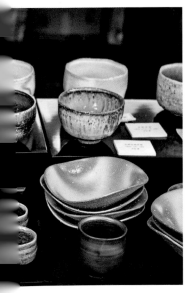

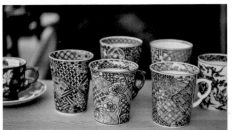

Robert Yellin Yakimono Gallery for expert guidance (japanesepottery.com). Rokurokudo offers English lang (rokurokudo.jp/en/). See also house-museum of Kawai Kanjiro (search on e-yakimono.net) and Raku Museum (raku-yaki.or.jp/e/museum).

OPPOSITE ABOVE Hand-painted plates at the Pottery Festival on Gojo Street, which takes place in early August and features over 400 vendors.

OPPOSITE BELOW A display of pottery in the Kiyomizu Danchi pottery area, featuring saké cups, flasks, bowls and plates.

ABOVE LEFT Lessons in using a potter's wheel can be had at Unraku-gama or Kiyamizu no Sato in the Kiyomizu Danchi area in Yamashina.

LEFT Hand-painted Kiyomizu motifs applied to Western-style tea mugs.

BELOW A cute modern version of the good luck *tanuki* (racoon), saying "I'll do my best with studying."

KYOTO'S FABLED CRAFTS
The Endless Search for Perfection

Few cities can begin to compete with the wealth of Kyoto's crafts, for as a former imperial capital, the city nourished excellence in all manner of goods. Even after the Tokugawa established Edo as the shogunate capital in 1603, the German physician Englebert Kaempfer visited Kyoto from Dejima and noted that the craftsmen produced everything imaginable "in utmost perfection."

Remarkably, even in these days of mass production, many of the handicrafts have survived, and the Fureiaikan (Kyoto Museum of Traditional Crafts) displays no fewer than 74 different types. Products include dolls, incense, fans, metalwork, bamboo items, brushes, umbrellas, cards, chopsticks, *washi* paperwork and woodblock prints. Many exhibits have to do with the tea ceremony, *maiko* accessories or Buddhist paraphernalia, such as altars, statues and rosaries.

RIGHT A demonstration of engraving at the Fureaikan (Kyoto Museum of Traditional Crafts), housed in the Miyako Messe building. Different crafts are demonstrated on different days.

BELOW Damascene work, the inlaying of metals into one another, came to Kyoto along the Silk Route over 1,000 years ago, and typically features gold or silver hammered into steel.

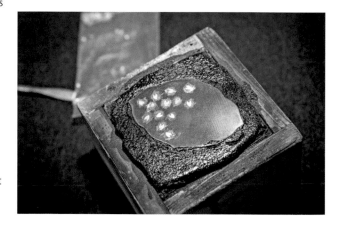

The striving for perfection that characterizes Kyoto crafts is typified by lacquerware. Up to 15 coats are applied to a single item, each coat, in turn, being rubbed down to a smooth finish. In the case of Kodai-ji lacquer, silver and gold are sprinkled onto the wet surface to give a lustrous finish to the sumptuous sheen.

Traditional craft shops are still dotted around Kyoto, and discovering them is one of the joys of wandering the back streets. For those with limited time, the Handicraft Center provides a one-stop opportunity for picking up

The Kyoto Handicraft Center and the Fureaikan (Kyoto Museum of Traditional Crafts) are 10 mins walk apart in the Okazaki Park area. Souvenirs in the former, explanations in the latter. Visit (kyotohandicraftcenter.com; https://kmtc.jp/en/).

souvenirs. It is said that the quest for perfection evident in the crafts set standards that were transmitted to the modern labor force and facilitated the success of the city's high-tech industries, such as Nintendo, Kyocera and Omron.

BELOW, LEFT TO RIGHT *Uchiwa* fans used by *maiko* and *geiko* are given away as keepsakes. Here, a demonstration of making mini-uchiwa starts with a pattern paper for the *mon* (crest), which is filled in with red ink on white paper. A bamboo handle is affixed, then the person's name is written vertically in calligraphic form alongside the crest. The finished fan can be kept as a souvenir.

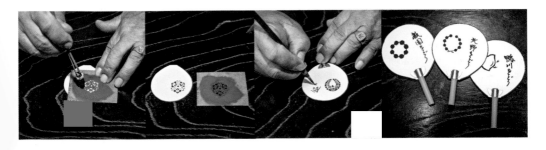

MODERN BUTOH THEATER
Avant-garde Performance Art

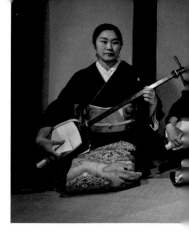

Butoh has been described as "grotesque," "otherworldly," and "weird." Some love it at first sight, others find it off-putting. Like Reiki, it has won more attention abroad than in its home country. Though not a Kyoto art, as such, the city is host to the world's first dedicated theater space (audience restricted to eight).

The beginning of this performance art form is credited to the collaboration, in 1959, of Hijikata Tatsumi and Ohno Kazuo. The former saw the performance in terms of "distress," and in a sense it was an attack on the Kyoto tradition of refinement. Hijikata looked to the coarseness of common folk, and the performers are typically naked in white makeup, writhing or moving with distorted posture.

In 2016, the Kyoto Butoh-kan opened in a traditional storehouse called a *kura*. Made of earth and plaster, kura were built by merchants to protect their treasures from fire and weather extremity. Accordingly, the walls are thick and the windows small and well-protected. Inside, the space is restricted, with seating on a Japanese cushion (*zabuton*) placed on a *tatami* mat. The intimacy of the occasion creates a greater sense of involvement.

There are currently three plays being offered, each a solo performance of around 45 minutes. The theme of water runs through one of the plays, while the second features flowers and vitality. The third is the most abstract, exploring the interaction within the body of anti-matter and matter, resulting in a beam of light. As always with Butoh, you can be sure to expect the unexpected.

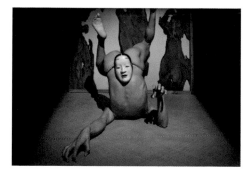

LEFT On Saturdays, there are performances by Yasuo Fukurozaka of a piece entitled "Antigravitation, Lovely Face." It is centered around the meeting of matter with anti-matter, and in the challenge to the limits of comprehension the world gets turned upside down.

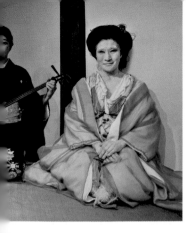

LEFT The founder of the Butoh theater, Ima Tenko, poses with *shamisen* musicians in an illustration of the way the experimental art form builds on tradition.

BELOW On Thursdays, a 45-minute performance is presented by Ima Tenko, inspired by various images of water.

ABOVE In his performance of "Underworld Flower," Yurabe Masami links the beauty of flowers to the mysterious afterworld of *yomi* in Japanese myth.

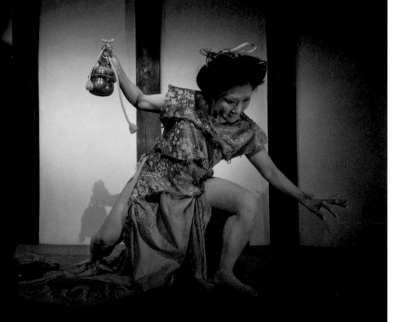

Butoh-kan is 5 mins walk from Karasuma Oike subway stn. Performances twice nightly at 18.00/ 20.00. Entry ¥3,800 (by reservation only). (075) 257-2125. Map and reservations (butohkan. jp).

KYOTO'S FLEA MARKETS
Displays of Antiques, Clothing and Food

In the precincts of an ancient temple, a swarm of people busily move from stall to stall. There is an old kimono; some prized porcelain; a wooden carving; Japanese *washi* paper; scrolls; second-hand *yukata*; handmade jewelry; pickled Kyoto vegetables; fried noodles, and much more. Temple flea markets have something for everyone.

In recent years, new markets have sprung up, but two traditional venues remain the best value for visitors. The Kobo-san market is held at To-ji Temple on the 21st of every month; Tenjin-san takes place at the Shinto shrine of Kitano Tenmangu on the 25th of every month. To-ji flea market is more crowded but the latter is larger.

To-ji Temple has a beautiful precinct boasting the city's oldest pagoda, next to which is an open space which fills on market days with 800 stalls. These offer virtually everything, from used goods and old clothing to precious items and bric-a-brac. Food of all kinds is available. Tools, toys and memorabilia are displayed next to sword items and tea ceremony goods.

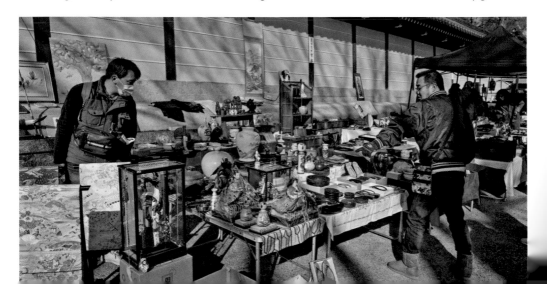

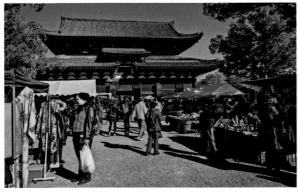

Kitano Tenmangu is similar but more spread out, with 1,000 or so stalls set along the approach to the shrine and around the back. There is a festive atmosphere, and the displays are beautifully set out. Since second-hand items are not regarded favorably in Japan, foreigners are often delighted with the reasonable prices for such goods as used kimono and *obi* sashes.

One other market worth mentioning is the popular Handmade Market held at Chion-ji on the 15th of each month. The 350 stalls are set up in the cramped temple forecourt, where crowds circulate between jewelry, plant pots, edibles and household objects. It is best to go early!

15th—Chion-ji, 8.00–16.00
21st—To-ji; 7.00–17.00
25th—Kitano Tenmangu, 7.00–16.30. For a full listing, see (handsonkyoto.com/kyoto-flea-market/).

ABOVE LEFT To-ji also plays host to an antiques market called Garakuta-ichi on the first Sunday of the month.

ABOVE Ichimatsu dolls with their glass eyes and flesh-colored skin are a popular item, representing the youth of Edo times.

OPPOSITE ABOVE Japanese curios on sale at Kobo-san, the open-air flea market held on the 21st of every month at To-ji temple.

OPPOSITE BELOW Items on display at Tenjin-san, the open-air flea market held every month on the 25th at Kitano Tenmangu shrine.

RIGHT Prices at the flea markets can be surprisingly reasonable. Here, at Kitano Tenmangu, second-hand kimono and *obi* sashes are on sale for just ¥1,000.

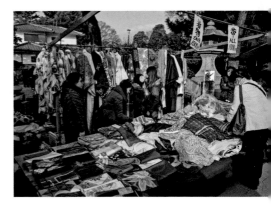

KYOTO'S KAISEKI CUISINE
Exquisite Feasts for the Eyes and the Palate

In 2013, Japan became the second country after France to have its national cuisine recognized as a world heritage. *Washoku* (Japanese food) is characterized by its freshness, balance and beauty of presentation. In order to bring out the natural taste, a minimum of seasoning is used.

Pride of place in Japan's food culture goes to Kyoto's *kaiseki*, the country's equivalent of haute cuisine. It emerged out of the elaborate sophistication of aristocratic kitchens, tempered by the healthy vegetarian dishes of Zen. The food is served on specially shaped crockery, decorated with seasonal leaves or flowers. Careful consideration is given to color, harmony, shape and design, so that the dishes are a feast for the eyes as much as for the palate.

A full dinner of some 13 dishes may come with an eye-popping price, but these days there are also mini-kaiseki of five courses, which at lunchtime present good value for money. Courses typically include something boiled, something grilled, something deep-fried, something steamed and/or a vinegared dish. Meals end with rice, pickles and *miso* soup, followed by a simple dessert such as a sorbet or a slice of fruit.

Years of training and sophistication go into the preparation of the dishes. A strand of burdock offset by a small piece of eel. Bamboo in white miso sauce. Small sushi balls topped by a thin

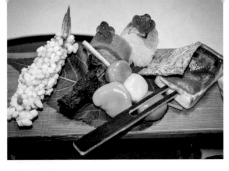

salmon strip. Such dishes are a reminder that food at its finest can be more than mere nourishment. In the hands of Japan's master chefs, it is elevated to an art form. Of all of Kyoto's many attractions, this is certainly the most appealing.

RIGHT Fried prawn, sushi with cod roe, gluten, broad bean and spinach on a shiso leaf.

BELOW A chef's assistant prepares to dish out rice to finish the meal, served with mushroom, red pepper and green vegetable.

BELOW FAR LEFT Contemporary *kaiseki* with caviar, squid and *shiso* leaf served at the Gion Sasaki restaurant.

BELOW LEFT Clam soup with vegetables served at the Mitsuyasu Restaurant.

BELOW A plate with bamboo root, firefly squid, *natane* leaf and broad bean at Kennin-ji Gion Maruyama.

BELOW RIGHT Fish grilled between thin slices of wood, decorated with pine as a symbol of good fortune.

For a listing, try (savorjapan.com/list/?kw=kyoto+kaiseki). For mini-kaiseki, try Hanasaki Manjiro (kyoto-manjiro.com/english.html). See also Minokichi chain (japanese-kyoto-cuisine.com).

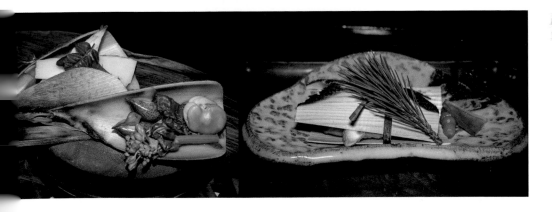

OTHER POPULAR KYOTO SPECIALITIES
Tofu, Obanzai and Kyo-yasai Cooking

Although *kaiseki* is Kyoto's gourmet cuisine (p. 66), the city boasts several other specialities. One is the Zen-inspired *shojin ryori* (p. 46). Others have developed from the abundance of pure water, particularly in the district of Fushimi where saké and tofu are produced.

Tofu comes in many different forms, some of them creamy, almost like yogurt. It was introduced from China in the Nara Period (712–84) and became a favorite of the Kyoto aristocracy before spreading to the wider population. Nowadays, it is prepared in many ways, whether fried, boiled, or baked. One more unusual form is *yuba*, which is skimmed from the surface during the boiling process. It is tasty, healthy and low in calories.

Obanzai is a style of home cooking developed by the Kyoto citizenry, which uses cheap seasonal and local materials. Meals

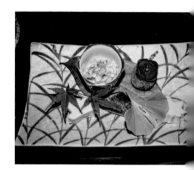

ABOVE Autumn appetizers at the Tosuiro restaurant include tofu with chrysanthemum, dried persimmon and boiled herring.

LEFT A counter with *obanzai* dishes laid out for selection. The food is simple, seasonal and cooked to bring out the natural flavor. Typical ingredients are vegetables, tofu and seafood.

OPPOSITE BELOW *Aburimochi* (grilled rice cake with sweet *miso* sauce) is sold at two shops outside Imamiya Shrine, one dating back 1,000 years and the other since 1656.

consist of small dishes, so it is possible to sample many different ones. The food is mainly vegetable based and served with rice and *miso* soup. There is no waste, yet it is healthy, fresh and tasty. Take *okara*, for instance, which is the pulp left over in the making of soy milk.

In recent years, there has been a boom in *kyo-yasai*, which are vegetables grown in Kyoto Prefecture with distinctive characteristics. There are around 40 such vegetables altogether, which owe their origin to medieval times

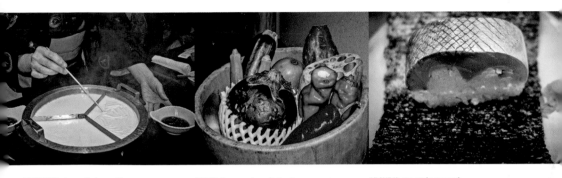

ABOVE *Yuba* is curdled soymilk, in other words, the skin skimmed off the top of boiled soymilk.

ABOVE *Kyo-yasai* are distinctive vegetables grown in the Kyoto area, deriving from the need to provide vegetarian food for the city's monks.

ABOVE Kyoto-style pressed sushi, with mackerel marinated to preserve it on the long journey inland.

when Buddhist temples cultivated special foodstuff for their vegetarian needs. High in nutrients, the vegetables have a rich flavor, which means they need little seasoning. This makes Kyoto the perfect place to "veg out."

For a list of tofu shops (theculturetrip.com/asia/japan/articles/kyotos-best-spots-for-delicioustofu/). For obanzai (traditionalkyoto.com/eat/obanzai/). For a listing of kyo-yasai (kyoyasai.kyoto/eng/details).

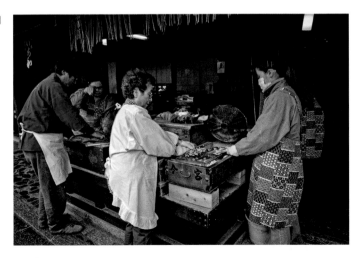

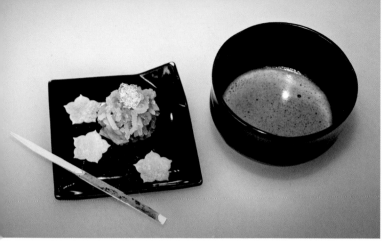

MATCHA GREEN TEA SETS
Whisked Green Tea with Japanese Sweets

You are sitting on a wooden veranda overlooking a temple garden. A woman approaches and places before you a bowl of whisked green tea and a piece of *wagashi* cake. You slice off a piece with the sliver of wood that serves as a knife and savor the taste. There is a flavor of chestnut, in keeping with the autumnal season.

You pick up the bowl with two hands, cupping it with the right and supporting it with the left. Warmth pervades your body as the lingering sweetness of the confectionery offsets the bitterness of the tea. You sit back in appreciation. The tea set has relaxed your body and opened your soul. It is one of Japan's gifts to the world.

Tea was imported from China in Heian times, but did not catch on until the arrival of Zen. The confectionery was also an import from China, which was refined for the nobility and branded as

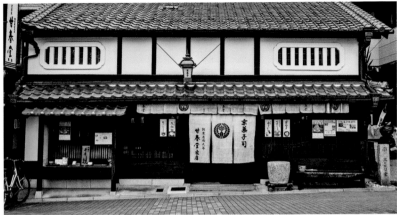

kyo-gashi (Kyoto sweets). The most common type uses red beans, boiled to form a paste to which sugar and flavorings are added. The paste is wrapped with rice flour and shaped with reference to folklore, or the season.

Wagashi are considered healthier than their Western counterparts because of the absence of animal products. They also have greater cultural significance. Once restricted to the elite, the practice of eating something sweet with whisked tea spread among commoners in the Edo Era and can now be enjoyed by all. A bowl of tea and a piece of confectionery make a perfect Kyoto pick-me-up.

ABOVE Homemade set of higashi, a drier confectionery, the sweetness of which offsets the bitterness of the *matcha* tea.

Matcha sets are available throughout the city. Ippodo green tea specialist is in Teramachi (ippodo-tea.co.jp/en/). Wagashi specialist Toraya is next to Gosho (global.toraya-group. co.jp/pages/toraya).

MACHIYA MERCHANT HOUSES
Traditional Wooden Townhouses with Elegance

In amongst the high-rise apartment and commercial blocks of Kyoto, dwarfed by its neighbors, stands an unusual wooden building with earthen walls and clay tiles. It is over 100 years old, and the narrowness belies the spaciousness inside. Though it is just 26 ft (8 m) wide, it extends back almost 164 ft (50 m).

The style of building is called *machiya*, and it owes its chief characteristic (narrow and long) to a government system that taxed households by the width of the frontage. There are slatted windows for privacy, bamboo blinds to keep out the fierce sunlight and scorched wood to reduce fire risk and to guard against insects. Since urban dwellers in the Edo Period were classed as merchants or artisans, the buildings often served for business as well as for living.

Internally, the machiya was split into two, with front rooms given over to commerce. Deeper within were the private living quarters. At the rear, was the main family room, overlooking a small courtyard garden. (Prosperous houses also boasted an inner and front garden.) These open spaces provided light, and their ferns, rocks and stone lanterns connected to the outside world.

Although Kyoto has the largest number of pre-war buildings in Japan (it escaped the bombing of World War II), modernization has meant that thousands of machiya have been replaced by apartment blocks. Recently, there has been a reappraisal, and many have been preserved by being turned into restaurants, shops and guest houses. The combination of comfort and traditional setting has proved a winning formula. Eat, drink or stay in a machiya. It is a Kyoto experience not to be missed.

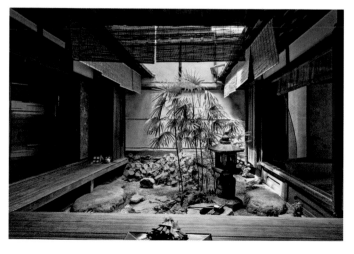

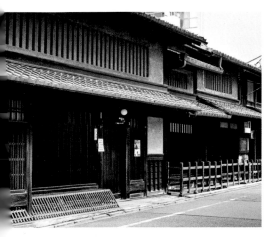

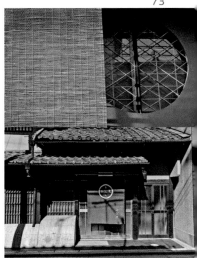

LEFT Complete rows of *machiya* houses are relatively rare now, though once they were ubiquitous. Since it was forbidden to look down on samurai, second-floor windows were closely latticed.

RIGHT Round windows are rare and expensive to make. To provide protection from the sun, a bamboo curtain is hung in front.

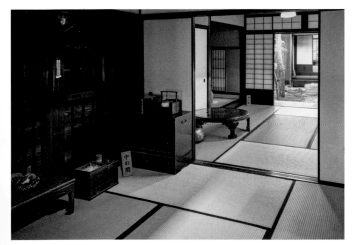

LEFT The interior of a renovated machiya, with a middle room for guests and a back room for family life. Business was done at the front.

OPPOSITE Depending on the wealth of the owner, machiya would contain small gardens decorated with rocks, plants, a water basin and stone lantern.

Machiya experience (tondaya. co.jp/english/). Culture classes in a machiya (wakajapan. jp/). See also Clancy's *Kyoto Machiya Restaurant Guide*. For guest houses, see (mykyo-tomachiya.com) and (inside-kyoto.com/kyoto-machiya).

KYOTO RYOKAN
Traditional Inns with True Hospitality

Elegance and relaxation. Sophistication and informality. Hot water soaking and exquisite food. Where can you find all those in one package? In the Japanese *ryokan*, the Kyoto ryokan in particular. The city has a high reputation for *omotenashi* (Japanese-style hospitality) and this is nowhere more apparent than during a stay at one of the city's ryokan.

There are notable differences between a ryokan and a Western hotel. Take your shoes off at the entrance and you can wander around in slippers and *yukata*, especially when going to the baths. There is little furniture save for a low table with cushions, and in the evening a *futon* is laid out on the *tatami* for sleeping. Most appealing of all are the sumptuous meals interspersed with hot water soaks taken in the communal bath.

Dinner is usually served privately in the room, with an extensive spread of appetising dishes. There will be something from the sea, something from the mountains and something from the vegetable fields, together with white rice, pickles and *miso* soup. Breakfast the next morning will typically have fish, rice, seaweed, miso soup and a surprise or two, such as a raw egg.

In terms of etiquette, it is not done to wear slippers on tatami, and—a vital matter—take off the toilet slippers before exiting the WC. As for the public bath, wash thoroughly beforehand and make sure to rinse off all the soap. It is customary to use a hand towel for washing, which also serves as a modesty towel when walking around naked. When in Rome, bathe as the Romans do!

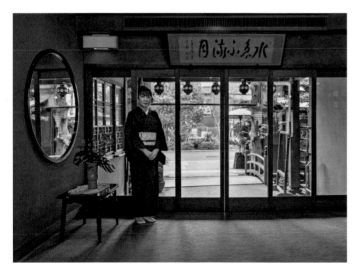

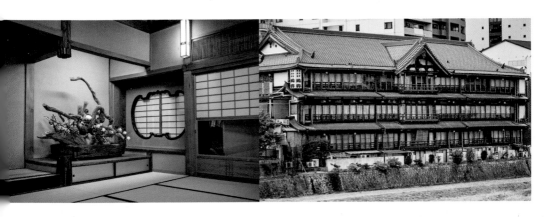

ABOVE LEFT One of the pleasures of staying at a *ryokan* are the special touches, such as this seasonal *ikebana* display.

ABOVE RIGHT Tsuruse on the Kamogawa preserves the classic exterior of a ryokan, but inside is a banquet hall used for weddings and tour groups.

LEFT Staircases in traditional ryokan are often steep and slippery, requiring care when using them.

RIGHT Hiraiwa in the traditional area of Gojo Rakuen calls itself a backpacker ryokan, with minimal furnishings and service.

OPPOSITE BELOW Seeing guests off in traditional style involves bowing and waving until they pass out of sight.

For an informed guide to Kyoto ryokan (insidekyoto.com/kyoto-ryokan). For more about omotenashi, Japan National Tourist Organization (jnto.org.au/experience/culture/omotenashi/).

NATURE WALKS AROUND KYOTO
On Foot and off the Beaten Track

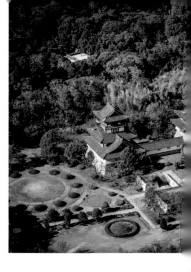

Many of Kyoto's top sights incorporate attractive walks. The Philosopher's Path, Arashiyama, Daigo-ji and the hill of Fushimi Inari serve as examples. For some people, the whole city is one big walking arena, but for those with limited stamina here are four easy walks that mix nature with culture.

Walk 1 The top recommendation is the Daimonji Hill behind Ginkaku-ji. It is a gentle woodland walk with moderately steep sections. It leads to the large Chinese character inscribed on the hill, from where views open up over the city. Sunsets can be spectacular, and on a clear day you can see as far as Osaka.

Walk 2 Closer to the heart of the city, the walk from Kurodani Temple through Shinnyodo Temple to Yoshida Hill leads through an ancient cemetery and unspoilt area that is often used as a location for historical drama. On the wooded slopes of Yoshida Hill is an attractive shrine and the wonderful Cafe Mo-an.

Walk 3 To the north is Takaragaike Lake, which takes about 40 minutes to walk around. Viewed

LEFT Kyoto still holds some special secrets, such as Cafe Mo-an in the woods of Yoshida Hill (Walk 2).

across the pond, the large conference hall resembles a giant ship floating on the water. For the adventurous, there are footpaths into the woods, some with views over the city.

Walk 4 In the southeast of Kyoto are two imperial mounds which offer peace and greenery. One is that of Kyoto's founder, Emperor Kammu, and 15 minutes away is the much grander mound of Emperor Meiji. From foundation in 794 to relocation in 1868, the two men measure out Kyoto's time as the imperial capital. This is a wooded walk, and over 1,000 years of history!

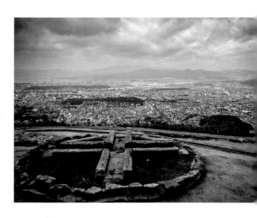

LEFT The walk between Emperor Meiji's burial mound and Emperor Kanmu's, visible at top left of the picture, leads through woods that pass by the rebuilt Fushimi Castle, which is not open to the public (Walk 4).

RIGHT Surrounded by mountains on three sides, Kyoto offers many vantage points from which to look down on the city, but none are quite as splendid as the view from Daimonji Hill looking west (Walk 1).

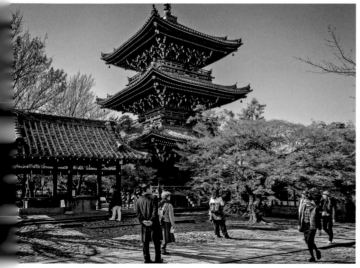

LEFT The three-story pagoda at Shinnyodo Temple is set in spacious grounds, which are often used for film locations because of their historic feel. The cemetery next to it leads into the adjacent Kurodani Temple (Walk 2).

Starting points:
Walk 1: Ginkaku-ji
Walk 2: Kurodani, just
 north of Heian Jingu
Walk 3: Takaragaike stn on
 the Eiden line
Walk 4: Any Tambabashi stn,
 walk 10 mins uphill

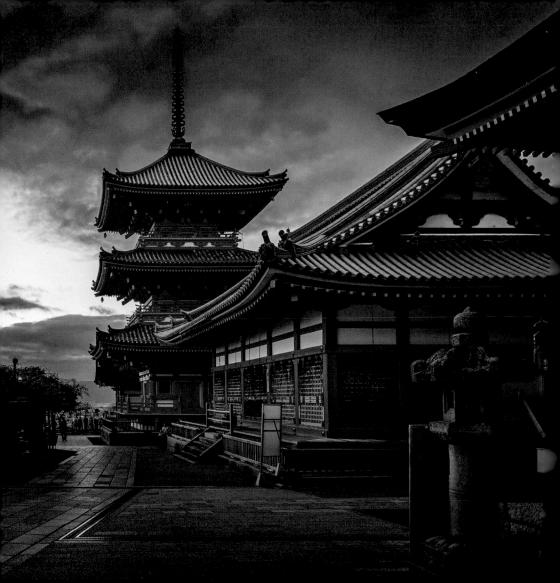

Exploring the City Center & the Eastern Hills

The city center is a bustle of jostling crowds, department stores and shopping arcades, but step away from the main routes and you will find an appealing mix of ancient and modern. Old wooden *machiya* alongside trendy designer restaurants; a *tatami* maker squeezed between brand-name stores; temple grounds next to a capsule hotel. It is what makes Kyoto so fascinating.

Wander the back streets and there are discoveries around every street corner. That is why the best advice that foreign residents can give visitors is to "get lost"—in the nicest possible way! Leave the digital maps behind and roam carefree wherever your whims suggest. You will find cherry blossom overhanging an old canal; an architect-designed small building; a love hotel glittering like Las Vegas.

The downtown district is relatively compact and it is possible to walk across the whole area in 30 minutes. Within this restricted space are distinctive areas. Shijo Street boasts expensive shops, travel agents, banks and top department stores, such as Daimaru and Takashimaya. Younger shoppers head for the clothes and souvenir shops in nearby arcades, such as Shinkyo-goku and Teramachi. There are cafes and cheap eating places, as well as the city's main movie complex. The market street of Nishiki starts here, and look out for the quirky shrine called Nishiki Tenmangu.

On either side of the Kamo-gawa River are contrasting entertainment areas. To the east are the hostess bars where salarymen go to relax after work. The narrow streets have glamorous dress shops, sci-fi architecture and neon noticeboards. The area is just north of the geisha district, making it an intriguing place to walk around in the evenings as you are sure to see something out of the ordinary.

On the west side of the river is Kiyamachi, directed more towards students and the general public. Walk down the little side streets and you will find a dizzy world of "live houses," darts bars, kebabs and karaoke. The variety is striking, from the sleazy to the sophisticated and back again. Large disco halls stand next to little three-customer pop-up bars covered with polythene to keep out the cold.

Then there is Pontocho, a single alleyway with a multiplicity of choice. At peak times, the crowds

LEFT Kiyomizu is usually packed, but to beat the crowds try opening time (6.00) or near closing time (18.00 pm/18.30 in summer).

move slowly, which gives an opportunity to take in the food items on offer. There is something for everyone: Japanese, fusion, Western and Asian. Geisha live here, too, and at the northern end is the theater hall where performances are held in spring and autumn. Charlie Chaplin visited in 1932 and was delighted with the show he saw, particularly the stylized method of acting. Here is a fine example of "the water trade" in the heart of Kyoto, so take a walk on the wild side and go with the flow of people down old Pontocho lane, for you are sure to find something to your taste.

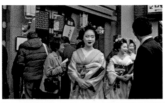

LEFT Geisha and *maiko* arriving at the Minami-za Theater in Gion to attend the special year-end Kaomise Kabuki performances.

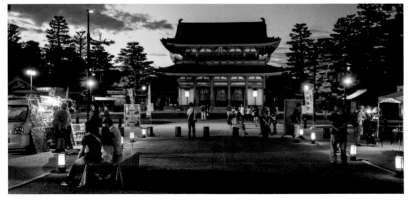

ABOVE The garden of Shisendo taken right after the villa opens at 9.00 in the morning, before the crowds arrive.

LEFT The two-story front entrance of Heian Shrine, with its approach lit by lamplight as part of a special evening event.

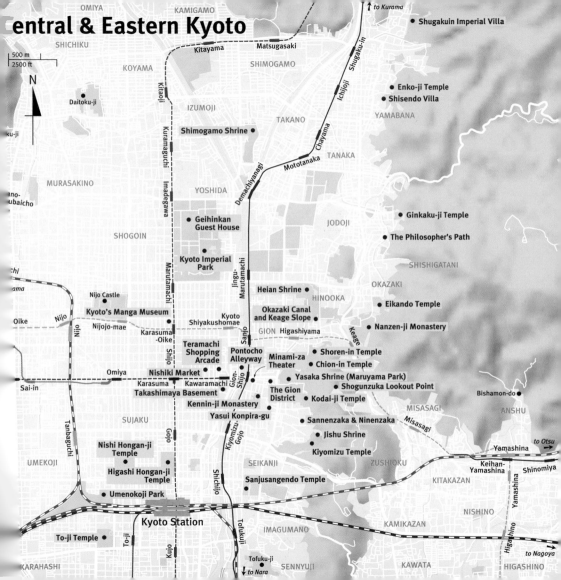

town people to spend all day in the complex. As well as an observation desk, there is a long flight of stairs extending up to the 15th floor and a Skyway tunnel suspended 148 ft (45 m) above the main hall. The architect, Hara Hiroshi, supposedly drew on Kyoto tradition in the design, though the vast interior resembles a UFO.

Step outside the southern exit and there is another monument

KYOTO STATION
A Futuristic Gateway to the Ancient Capital

It is huge. It is overwhelming. It is futuristic. It is everything romantic images of Kyoto are not. Some visitors are baffled on arrival. Is this the city of temples, of geisha, of tradition? The answer is yes, but it is also the city of Nintendo, Kyocera and big business. This is a city where modernization jostles with tradition, a city of change within continuity. Welcome to Kyoto.

The station was put up in 1997, belatedly commemorating the city's 1,200th anniversary. A century earlier, the Heian Shrine had been erected to honor the past. What a contrast! The massive modern edifice has 15 stories and is nearly a third of a mile (500 m) long. Far from being a mere station, it houses a department store, theater, luxury hotel, tourist information center, government offices, underground malls and restaurants galore.

The dimensions are staggering, and it is not unusual for out-of-

LEFT As well as bullet trains, the massive building of Kyoto's main station houses walkways, escalators, underground malls and 15 floors of shops.

BELOW The post-modern architecture by Hara Hiroshi makes coded reference to the ancient capital, such as the grid-like layout of the streets.

to modernization: Kyoto Tower. It was purpose-built in 1964 for the Tokyo Olympics, and was the city's tallest building at the time. Designed to resemble a Japanese candle, it contains shops and a viewing restaurant. Kyoto Station and Kyoto Tower were both causes of controversy in their time, but are now symbols of a modernizing city that looks to the future as well as the past.

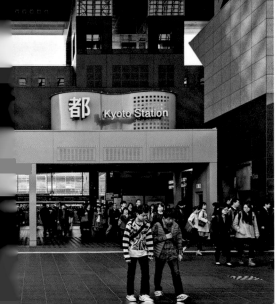

TOP Tradition and modernity mix in easy congress at ticket machines that are speedy, efficient and bilingual.

ABOVE The station is well equipped to deal with an average of 200,000 people who pass through on a daily basis.

Further details (en.wikipedia.org/wiki/Kyoto_Station). For map and orientation (kyotostation.com/kyoto-station-map-finding-your-way/).

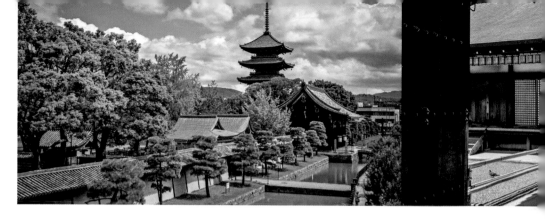

TO-JI TEMPLE
Kyoto's Iconic Shingon Pagoda

Japan's largest pagoda has long served as the iconic image of Kyoto. For centuries it stood supreme on the urban landscape, lending the city a spiritual air. Now dwarfed by modern development, it nonetheless retains its majesty when seen up close.

Founded in 796, To-ji was one of only two temples originally allowed in Heian-kyo. To-ji means East Temple (the West Temple was destroyed). It belongs to the Shingon sect, Japan's equivalent of Tantric Buddhism, with its metaphysics, mudra and mandala. The temple grounds are open to visitors, though to enter the inner section with its halls and pond garden requires payment.

In the Main Hall, rebuilt in 1606, sits a nearly 10 ft (3 m) statue of Yakushi Nyorai, the healing buddha. Next door in the Lecture Hall is Kyoto's most stunning collection of statuary, with 21 larger-than-life figures. They comprise a contrasting mix of compassionate buddhas and fearsome protectors, at the center of which sits the prime mover of the universe, Dainichi Nyorai.

Inside the temple's southern entrance is the statue of sect founder and culture hero, Kukai (known posthumously as Kobo Daishi). Every month on the 21st, a huge flea market called Kobo-san is held in his honor. Hundreds of people make their way to the

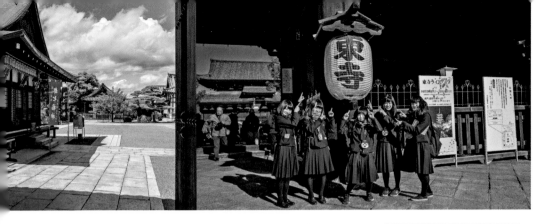

ABOVE One of the attractive old buildings in the outer compound, five of which are designated as National Treasures.

temple from Kyoto Station, a walk that takes them from a futuristic edifice to a medieval complex of Buddhist monks. It is one small example of "time-slip Kyoto."

ABOVE The traditional signage of the lantern, saying To-ji, contrasts with the intrusive modern boards alongside.

BELOW LEFT The charming inner garden known as Shoshibo is only open on special occasions.

BELOW CENTER The temple founder was Kukai (774–835), known by his posthumous name of Kobo Daishi.

BELOW RIGHT The monthly flea market on the 25th is named Kobo-san after the temple's founder.

Access—5 mins walk from Toji stn on Kintetsu line. Open 9.00–17.30 (16.30 in winter). Inner compound ¥500 or ¥800 when pagoda opens. Museum ¥500. First Sunday—antique market; 21st—flea market. (075) 691 3325 (toji.or.jp/en/).

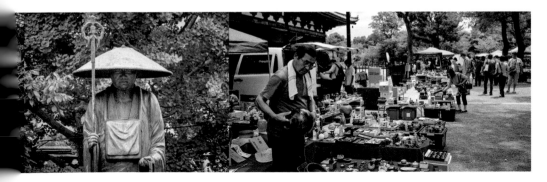

HIGASHI HONGAN-JI TEMPLE
A Massive Pure Land Temple and Paradise Garden

Two walled and moated "fortresses" lie just north of Kyoto's JR station. These are the joint head temples of the True Pure Land sect (Jodo Shinshu). The sect's founder, Shinran Shonin (1173–1263), taught salvation through a Buddha named Amida, who promised to receive all who call on his name in his Pure Land paradise.

So popular was the sect that when a family feud erupted in 1602, the ruler Tokugawa Ieyasu saw an opportunity to divide it. Hongan-ji, meaning the Primal Vow of Amida, was thus split into Nishi (West) and Higashi (East). Today, the two temples continue to be run by descendants of the same Otani family, who cooperate while administering separate branch temples.

The main hall of Higashi Hongan-ji, one of the largest wooden buildings in the world, is 2,800 ft (76 m) in length, 125 ft (38 m) in height and is supported by 90 massive pillars. Next to it stands the Amida Hall, almost as large. One notable feature is a glass case displaying women's hair from the Meiji Period, donated by volunteers. The strands were woven into ropes to pull the enormous tree trunks needed for reconstruction.

The temple owns the garden of Shoseien, a couple of blocks away. Granted to the temple in 1641, it was designed by Ishikawa Jozan of Shisendo, who created an attractive pond garden. The highlights include a Chinese Corridor Bridge with a cypress bark roof and the gracefully arched Snow-capped Bridge, suggestive of Monet. Beautiful in every season, the strolling garden can truly lay claim to being the proverbial hidden gem.

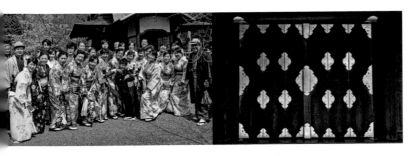

FAR LEFT A group outing pictured at Higashi Hongan-ji's Shoseien garden, a couple of blocks from the temple.

LEFT The gold-leaf entrance gate reflects Momoyama opulence in the early 17th century.

BELOW Detail of a chrysanthemum from the ornate decoration on the temple's woodwork.

OPPOSITE The main compound of the temple and the imposing two-story entrance gate.

BELOW LEFT The Chinese-style Corridor Bridge of Shoseien, a garden retreat owned by the temple.

BELOW RIGHT The gracefully arched bridge of Shoseien perfectly harmonizes with its surrounds.

Access—5 mins from Kyoto JR stn. 5.50–17.30 (16.30 in winter). Free. (075) 371-9181 (higashihonganji.or.jp/english). Shoseien 9.00–17.00/16.00 winter, ¥500 (higashihonganji.or.jp/english/tour/shosei-en/).

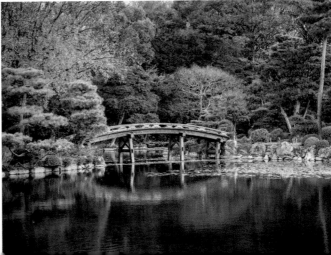

NISHI HONGAN-JI TEMPLE
A World Heritage Site with Cultural Treasures

Nishi Hongan-ji is the counterpart of Higashi Hongan-ji, though it can claim seniority in having been founded first (in 1591) and to having more branch temples. It also has World Heritage status, thanks to the wealth of cultural assets it acquired from the dismantling of Toyotomi Hideyoshi's palace.

The dimensions of the buildings are staggering. The Amida

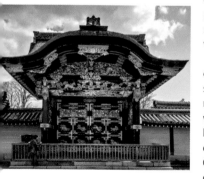

ABOVE This magnificent Chinese-style gate is decorated in the flamboyant manner that characterized the Momoyama period of art (1573–1615).

Hall has 132 huge pillars and a capacity of 1,500 people. Along with a statue of sect founder Shinran are paintings of Pure Land prophets, stretching back into antiquity, with both Chinese and Indian figures. An elegant connecting corridor runs to the Memorial Hall (Goeido), which is even larger, with an amazing 227 pillars supporting a building that can accommodate over 2,000 people. It houses a statue of Shinran coated with lacquer mixed with his cremated ashes.

The temple houses Japan's largest outdoor Noh stage, as well as some fine artwork in reception rooms which were made for the warlord Hideyoshi to demonstrate his power. On the southern side of the compound is the ornate Chinese-style Karamon Gate, covered with auspicious motifs and figures from moral tales. The bright colors typify the flamboyance of the Momoyama Age.

ABOVE The administrative building's approach is lined with pine trees, symbol of the eternal, and the doorway has purple curtains to match the temple's wisteria logo.

There is a guided tour each afternoon (in Japanese), which finishes in the temple's prized possession: a pond garden enclosing a pleasure pavilion which bears paintings of the 36 Immortal Poets. Moon-viewing parties and tea ceremonies are held here on special occasions. Relocated from Hideyoshi's palace, it ranks alongside the Silver and the Golden as one of the three great pavilions of Kyoto.

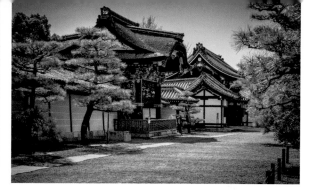

BELOW This 400-year-old ginkgo tree is a treasured item because it has survived devastating fires that destroyed the rest of the temple.

ABOVE The thatched Amidado Gate is used only for the imperial family, while the tiled main gate is for the public.

ABOVE Detail of a Chinese-style lion, a protective good luck symbol, on the Higurashimon Gate in the south of the compound.

Access—15 mins walk from Kyoto JR station. 5.30–17.00, 18.00 in summer. Grounds free, open all year. Guided tour in Japanese 14.30–15.30 (donation welcome). (075) 371-5181 (hong-wanji.or.jp/english/).

UMENOKOJI PARK
Kyoto's Railway Museum & Aquarium

There is grass on which to play sports, a walking course, a wooded area and an attractive restaurant with garden attached. It is a small oasis of greenery, which in addition hosts two special attractions: a train museum and a large aquarium.

The Steam Locomotive Museum is the largest in Japan. It was recently reopened with an impressive range of interactive exhibits. Centered around a 20-track roundhouse dating from 1914, it has 50 different trains on display, covering everything from steam to *shinkansen* (bullet train).

The oldest of the trains is an 1880 imported model that ran in Hokkaido. Another to attract attention was specially fitted out for the imperial family. But there is more to the museum than trains, for also featured are historical costumes, tickets, model stations, an explanation of signal

systems, a viewing platform and even a simulator. There is a special carriage, too, in which "station *bento*" (lunch boxes) can be eaten.

Kyoto and trains may be unexpected, but how about Kyoto and the sea? The Aquarium justifies itself by aiming to provide "edutainment." As well as copious explanations, there are experiential events and presentations by

LEFT The Railway Museum has been renewed to make it more interactive and interesting for children. Push a button and doors will open.

BELOW LEFT The aerodynamics of recent *shinkansen* make a startling contrast with the solid frontage of the early Kodama.

RIGHT The use of dolphins in the restricted space of the aquarium pool has proved controversial with animal rightists.

Access—20 mins walk from JR Kyoto stn or 15 mins from To-ji Temple. Bus to Umenokoji koen mae. Locomotive Museum 10.00–17.30, ¥1200. 075 314-2996 (kyotorailwaymuseum.jp/en/guide/). Kyoto Aquarium 10.00–18.00 (last admission 17.00), ¥2,050. 075 354-3310 (kyoto-aquarium.com/en/).

RIGHT The aquarium is popular with families, particularly on rainy days, as children are fascinated by the range of fish and sea creatures on display.

FAR LEFT *Shinkansen* trains first ran between Tokyo and Osaka in 1964, since when there has not been a single fatality. Maximum speed is 200 mph (320 kph).

LEFT The steam locomotive bearing the imperial chrysanthemum on its front was decked out in 1928 for Emperor Hirohito to make a trip to Kyoto for his enthronement ceremony.

specialists. The facility is divided into zones, and amongst the exhibits are Japanese giant salamanders, 10,000 sardines, Cape penguins and a coral reef. The inclusion of a dolphin show has caused considerable controversy, in response to which the aquarium pushes its green credentials. Harmony with nature? That is up to the visitor to judge.

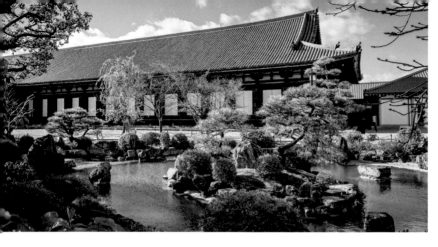

LEFT A view across the temple pond towards the extraordinary wooden building in which are contained 1,001 lacquered statues of Kannon, the Buddhist deity of compassion.

BELOW Every year on the second Sunday of January, a national *kyudo* (archery) contest takes place alongside the 390 ft (120 m) long building.

SANJUSANGENDO TEMPLE
The World's Longest Wooden Building

Sanjusangendo is extraordinary in so many ways. The building extends 387 ft (118 m), making it the longest wooden building in the world. Inside are 1,000 Buddha figures lined up on either side of an enormous sitting statue. Built in the 1160s, the hall constituted the private chapel of a vast estate owned by Go-Shirakawa, a former emperor.

The ex-emperor was motivated by belief in Amida, who made a vow to welcome into his Pure Land paradise all those who

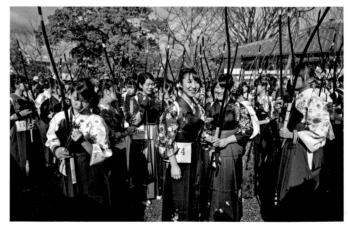

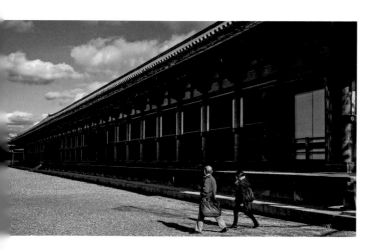

LEFT The wooden structure was first put up in 1164 but burnt down in 1249. Only 124 statues survived, the rest having to be replaced.

BELOW The kyudo competition in January, which originated 400 years ago, is held on the Coming of Age weekend, meaning 20 year olds have something to celebrate.

Access—20 mins walk from JR Kyoto stn. 5 mins from Keihan Shichijo stn. 9.00–18.00 (Nov 16–Mar); 8.00–17.00 (Apr–Nov 15), ¥600. (075) 561-0467 (japan-guide.com/e/ e3900.html).

called on his name. The statues represent a messenger of Amida called Kannon, who as a bodhisattva mediates between this world and the other. Kannon manifests in different forms, and here it is the so-called Thousand Armed Kannon.

Walking in front of the rows of statues can be unnerving, much like facing a heavenly choir. Despite first impressions, the statues differ in body shape, eye width and robes. Look long enough and it is said that you will come to recognize a friend or relative.

The original building, painted in bright colors to represent the Pure Land, tragically burnt down in 1249. This necessitated the replacement of no fewer than 875 of the statues. Amida's Pure Land lies in the west, towards which the worshipper would have faced. The full effect of the glittering statues would have been realized when the central doors were thrown open and the first rays of the morning sun alighted on the gold-leaf array. In a city of many special moments, this must have been the most magical.

KIYOMIZU TEMPLE
Kyoto's Former Number One Tourist Sight

Throngs of people move slowly up a crowded slope lined by shops offering souvenirs and bites to eat. Like medieval pilgrims, they are on their way to Kyoto's most famous temple, mixing the secular with the religious. With its commanding location and astonishing architecture, Kiyomizu has long been one of Kyoto's outstanding jewels.

The origins of the temple have to do with the Otowa Spring (Kiyomizu means pure water). In 778, a monk named Enchin Shonin was led to it by a vision he had, following which an aristocratic patron donated a large hall in the style of the nobility. The main building still has a shingled roof like those of palaces, rather than a tiled roof like temples. Inside is a 1,000-armed Kannon (deity of compassion), exhibited to the public only once every 33 years.

A viewing platform, originally intended for sacred dance, stands above a steep slope. The massive supporting pillars use no nails and at the furthest point extend down a drop of 43 ft (13 m). In the past, it was a favored suicide spot. Nowadays, it is noted for the spectacular views over southern Kyoto.

Apart from Jishu Shrine (p. 96), the spacious and wooded grounds contain a pagoda where pregnant women pray for an easy birth, and the Otowa Spring where people line up to drink the

ABOVE CENTER The temple stands on the slopes of the Eastern Hills (Higashiyama) and offers spectacular views of the setting sun.

LEFT Worship at the three-story Koyasu Pagoda in the temple grounds supposedly brings about easy childbirth.

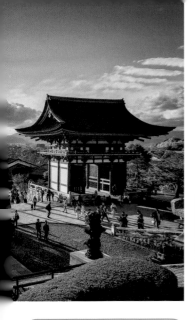

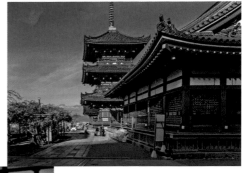

RIGHT The vermilion red pagoda near the entrance, reconstructed in 1633, is a repository for sutras and stands 102 ft (31 m) high.

LEFT The temple offers picturesque backdrops for photo memories, and sightseers often become sights in themselves.

BELOW The temple's platform stands 43 ft (13 m) above the hillside below, and the whole complex is held together without the use of nails.

Access—10 mins walk from Kiyomizu bus stop or 20 mins from Kiyomizu-Gojo, Keihan line. 6.00–18.00, ¥400. (075) 551-1234 (kiyomizudera.or.jp/en/).

water. There are three streams said to favor, in turn, health, longevity and success, and visitors have to choose between them. In this way, the pure water of Kiyomizu has been nourishing the souls of tourist-pilgrims for well over 1,200 years.

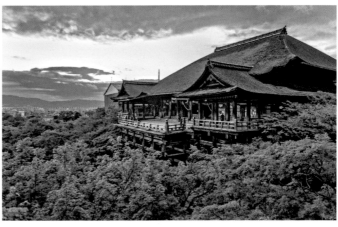

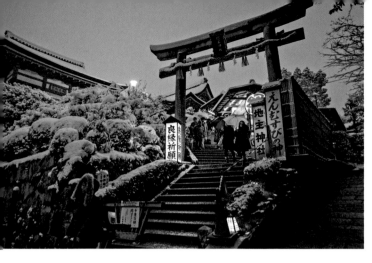

JISHU SHRINE
Kyoto's Popular "Love Stones"

Rebuilt in 1633 with bright Momoyama colors, the small shrine looks to some more like a theme park than a religious space. There are fortune slips, lucky love charms and colorful subshrines where people rub statues of deities or pour water over them. There are also a lot of excited young people.

Judging by its location, the shrine appears to be an integral part of Kiyomizu Temple, and indeed it used to be. For over 1,000 years, Shinto and Buddhism were fused together, but after the Meiji government came to power in 1868 they were separated. As a result, Jishu Shrine is an independent institution, at the same time being part of the Unesco Kiyomizu World Heritage site.

The main *kami* is Okuninushi no mikoto, a deity from the Izumo area famed for fostering *enmusubi* (meaning good connections, though for young Japanese there is only one kind of connection that matters). There are statues of Okuninushi with a hare, in reference to a legend that he saved the animal from being abused by his brothers.

The shrine's most famous feature is a pair of stones set 59 ft (18 m) apart. Those seeking a partner have to walk between them with their eyes closed (love being blind). Many ask a friend to assist them verbally, which means in love they will need the help of a third party to succeed. There

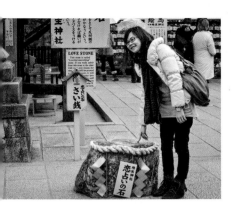

LEFT Sacred rocks in Japan are often noted for their special powers and are marked by a *shimenawa* rice rope to show their divine nature.

RIGHT A noticeboard announces that the famous love stones are a means of divination for making a good new relationship.

BELOW There are many subshrines in the crowded space, such as this one for Haraedo no Okami, who presides over purification.

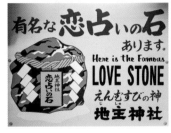

ABOVE Jishu Shrine's most famous feature is a pair of "love stones" between which people walk with eyes closed.

are boards bearing the names of those who have written in with thanks for finding love, several of whom are foreign. It is testimony to how love does indeed transcend borders: cultural, religious and linguistic.

Access is through Kiyomizu Temple (¥400). Open 9.00–17.00. Every first Sun at 14.00 ritual with dispersal of free love amulets.

SANNENZAKA & NINENZAKA
Passageways to a Traditional Past

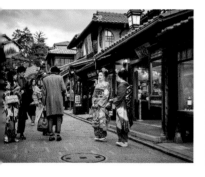

LEFT Some shops in Sannenzaka provide costumes for foreign tourists, such as this pair who are dressed as *maiko*.

RIGHT Ninenzaka is lined with traditional buildings selling typical Japanese goods, such as food and handmade crafts.

Two traditional lanes paved with flagstones and lined with wooden shop fronts run along the east of Kyoto. Sannenzaka is the longer of the two, nearly a third of a mile (0.5 km) in length. Ninenzaka is a branch consisting of 330 ft (100 m) on either side of some stone steps. They lie in the Higashiyama district, connecting ancient temples, gardens and traditional *ryokan* inns.

The pedestrian lanes are free of the intrusive overhead wires that mar many of Japan's cityscapes. Rickshaw rides are available from eager young men in traditional garb, and with young women dressed in colorful *yukata* there is something of a festival atmosphere. It all makes for a sense of the past, and the bustling crowds attest to the popularity.

Many of the shops and restaurants lining the lanes have been upgraded without losing their historical appearance. This is shopping heaven for those who enjoy browsing. Japanese confectionery, pickles, souvenirs, incense and fans are just some of the items. There are places to partake in a tea ceremony, rent kimono, learn how to make dolls or scoop your own tofu. There is even an old wooden house with a Starbucks and several stylish European restaurants.

During peak times in spring and autumn, it is a good idea to avoid the daytime crush by visiting early in the morning or for an evening stroll. The shops may be

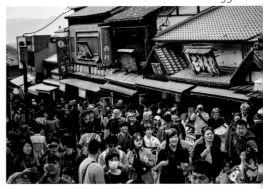

RIGHT At peak times, the lanes get very crowded, particularly the approach to Kiyomizu Temple. Go as early or as late as possible.

BELOW The flagstone walkway linking Maruyama Park and Ninenzaka is known as Nene no Michi, and is recommended for an evening stroll.

Shops are generally open 9.00–17.00, extended during spring and the autumn foliage season (p. 38). Yasaka Shrine to Kiyomizu can be walked in about 30 mins, but with browsing it might well take half a day.

shut, but with the subdued lighting the ancient surrounds are even more atmospheric. Free of the crowds, the stone lanes, pagodas, and Buddhist statuary take on a magical life of their own. This is particularly true of Nene no Michi, which extends the route up to Yasaka Shrine. In this relatively quiet area lies a small alley called Ishibe-koji, which is free of traffic and modern buildings. Here you get a real feel for the charms of pre-war Kyoto.

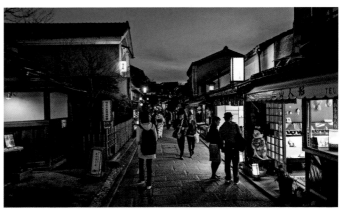

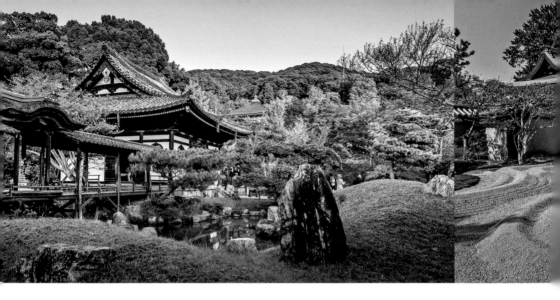

KODAI-JI TEMPLE
A "Luxurious" Zen Hillside Retreat

More than a temple, Kodai-ji is a collection of cultural properties assembled by the widow of Japan's ruler, Toyotomi Hideyoshi. Known as Nene, she became a nun following his death in 1598 and won the patronage of the new shogun, Tokugawa Ieyasu. The result is a Zen temple with luxurious touches.

Before entering the gardens, visitors are directed indoors to view painted *fusuma* (sliding screens) and a dry landscape which is raked into different designs over the course of the year. Like a Zen *koan* (mental puzzle), it challenges the onlooker to give it meaning.

The large stroll garden has an upper and lower pond. It has won attention in recent years for its seasonal illuminations, when the shallow water acts as a breathtaking mirror for cherry blossoms or maple leaves. The path through the garden leads up an incline past a memorial hall for Hideyoshi and his wife. At the top of the hill stand two historical tea houses (Hideyoshi was a keen practitioner). The return path leads through a bamboo grove, affording a close-up view of an enormous Ryozen Kannon statue, built in 1955 as a war memorial.

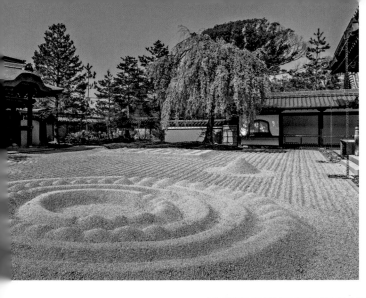

LEFT The dry landscape garden south of the main building takes different forms during the year, leaving the visitor to ponder the meaning.

Access—5 mins walk from Higashiyama Yasui bus stop or 15 mins taxi from Kyoto stn. Kodai-ji, 9.00–17.00, ¥600. (075) 561-9966 (kodai-ji.com/e_index.html). Entoku-in subtemple, 10.00–5.00, ¥500. (075) 525-0101.

RIGHT In the upper area of the temple grounds is a bamboo grove past which visitors are taken by the path leading to the exit.

Nearby stands the subtemple of Entoku-in, where Nene spent her last years. The refinement of her taste is evident here also, though on a smaller scale. The narrow passages and fusuma paintings make this an attractive alternative to its larger neighbor, ending with the option of a green tea set in front of one of the most dynamic rock gardens in the whole of Japan.

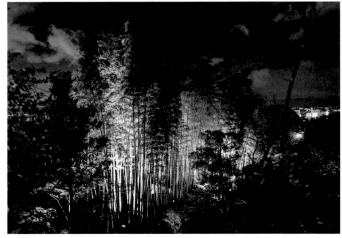

YASAKA SHRINE (MARUYAMA PARK)
Sacred Guardian of the Gion District

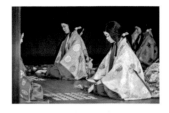

At the eastern end of the Gion's main street stands a strikingly beautiful vermilion gate. The steps to it are a popular place to pose for photos, and the pathway leads past food stalls to Yasaka Shrine. In the middle is a stage decorated with a triple row of lanterns. At night time, when the lanterns are lit, there is a fairy tale atmosphere.

Yasaka's claim to fame is as sponsor of the celebrated Gion Festival in July. Large warehouses store the floats. Founded in ancient times, the shrine was for most of its history part of a larger temple complex. Only in 1868 did it opt to be an independent shrine, which acts as the guardian for the nearby Gion district.

The Main Building, with its magnificent cypress bark roof, was last rebuilt in 1654. Because the precincts are filled with sub-shrines housing important *kami* from around the country, it is said that paying respects here is equivalent to touring the nation. One subshrine, Utsukushi Gozen-sha, is dedicated to beauty, and

ABOVE On January 3, the Hyakunin Isshu New Year card game takes place, with participants dressed in the formal attire of the Heian nobility.

LEFT The vermilion colored two-story entrance gate presents a fine spectacle along Shijo Street, onto which it faces.

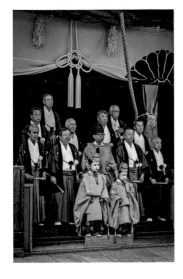

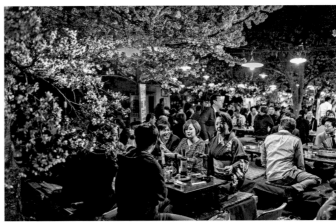

geisha, unsurprisingly, can often be seen worshipping there.

Yasaka Shrine stands next to Maruyama Park, laid out by Meiji-era gardener Ogawa Jihei, who utilized water piped from Lake Biwa. The small arched bridges and carp ponds give the grounds a distinctly Japanese feel. Apart from cherry blossom time in early April, the park is a quiet retreat from the crowds of Gion, and in the evenings it serves as a dark extension to the lantern-lit shrine that extends towards the Eastern Hills.

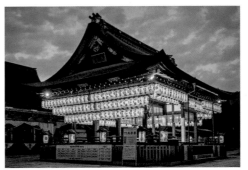

Access—close to Gion bus stop or 5 mins from Gion-Shijo stn on Keihan line. Always open, free entry. 075-561-6155 (yasaka-jinja.or.jp/en/).

ABOVE LEFT The shrine sponsors the annual Gion Festival in July, when young boys, known as *chigo*, play an important role as vessels of the *kami*.

ABOVE Maruyama Park is adjacent to the shrine, normally a quiet retreat in the evenings but packed with picnickers at cherry blossom time.

LEFT In the evening, the shrine is at its most lovely, illuminated by lanterns which bear the name of their donor.

CHION-IN TEMPLE
Headquarters of the Pure Land Sect

With its stunning woodwork and immense dimensions, Chion-in is designed to impress. The massive entrance gate was featured in *The Last Samurai*, the spacious grounds contain two gardens of note, and the huge bell, for long the largest in the world, requires a team of 17 monks to ring.

The temple is the headquarters of the Pure Land sect, known in Japanese as Jodo-shu. It is dedicated to Honen (1133–1212), who taught belief in a Buddha named Amida. According to ancient sutras, the deity promised salvation to all who called on his name. It opened up Buddhism to ordinary folk, whereas earlier sects had focused on the ruling classes.

The temple was rebuilt by the powerful Tokugawa family in the 17th century. The large-scale Mieido (Memorial Hall) houses a statue of sect founder Honen, next to which is an Amida Hall. On the hillside stands a mausoleum containing the ashes of Honen. The two main gardens provide a contrast, with the traditional Hojo Garden dating to the mid-1600s, while the Yuzen Garden, with rocks and pond, was designed in modern times.

The temple has prepared a pamphlet on the Seven Wonders of Chion-in, to enhance the visiting experience. They include a cat that sees in three directions; sparrows that have flown away from a painting; an umbrella and large rice paddle left behind in the rafters; floorboards which squeak when trodden on; and—the biggest Wonder of all—a "cucumber rock" from which auspicious gourds sprouted.

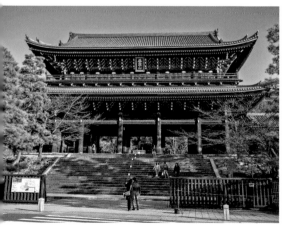

ABOVE A 12th-century monk, Honen, founded the Pure Land sect (Jodo-shu), for which Chion-in is the head temple.

LEFT The colossal Sanmon Gate, built in 1619, is the largest of its kind in Japan, 79 ft (24 m) tall and 164 ft (50 m) wide.

BELOW At New Year, the temple bell is rung 108 times by a team of monks in a popular event which is often televised.

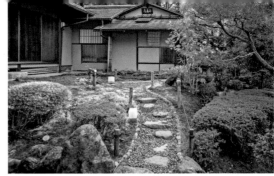

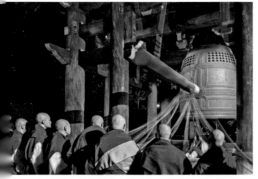

Access—10 mins walk from Gion or from Higashiyama stn on Tozai line. Open 9.00–16.30 (later during illuminations). Grounds free, Abbot's Quarters and gardens, ¥500. (075) 531-2111 (chion-in.or.jp/en/).

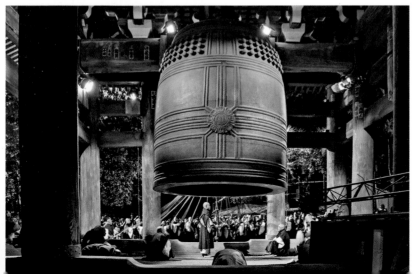

ABOVE Yuzen-en, with its tea house garden, was redesigned in 1954 to commemorate the 300th anniversary of the founder of the *yuzen* style of dyeing cloth.

LEFT The temple bell dates back to 1633 when it was the largest in the whole world, weighing a massive 70 tons (71,000 kg).

SHOREN-IN TEMPLE
An Elegant Garden and Imperial Residence

Shoren-in is a peaceful alternative to the crowds found elsewhere. It has a prestigious past, and head priests were formerly drawn from the imperial family. Like some of Kyoto's other temples, it started life as an imperial residence before being converted. As a result, it retains something of the elegance of palace architecture.

The entrance is marked by awe-inspiring camphor trees, over 700 years old. In the Kacho-den are paintings of lotus flowers and the 36 Immortal Poets, while in the large *tatami* room visitors sit and take in the pond garden designed by master-artist Soami (d.1525). In fact, the temple is a garden-lover's dream, for it also boasts a moss garden, a dry landscape garden and an azalea garden designed by another master, Kobori Enshu (1579–1647).

Covered corridors run between buildings in the style of Heian palaces. The main hall has an

RIGHT The stroll garden, with its meandering pathway, was designed by famed landscaper Kobori Enshu (1579–1647). It winds its way around the buildings, past a tea house and up a slope to a shrine from where there is a view over the temple grounds.

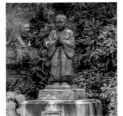

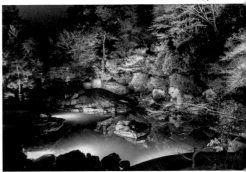

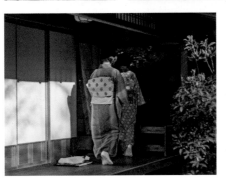

LEFT The main hall was transferred here from the imperial palace, and the temple retains the feel of an elegant villa. Until the 1860s, head priests were appointed from the imperial lineage.

ABOVE LEFT Shinran Shonin, one of Japan's most influential religious figures, was ordained here as a monk at the age of nine.

ABOVE There are light-ups three times a year, in March for the Hanatoro, in early May for Golden Week holidays and in November for autumn colors.

LEFT The temple's cherished tea house, restored following an arson attack in 1993, is host to prestigious tea ceremonies.

unusual object of worship: a mandala. Also of note is a tea house called Kobun-tei, which burnt down in 1993 but was reconstructed with painstaking care using the same type of wood and craftsmanship. Inside are paintings by Uemura Atsushi, a Kyoto artist specializing in birds and flowers.

In spring and autumn, Shoren-in attracts a stream of visitors for its superb illuminations. The deity worshipped here, Shijoko Nyorai, is characterized by light, so the temple feels that the event has a divine connection. "It appears as if the pure and sacred land comes to life," runs the publicity. It is a claim well worth checking out.

Access—5 mins from Higashiyama stn on Tozai line or from Jingu Michi bus stop. 9.00–17.00, ¥500. Illumination 18.00–22.00, ¥800. (075) 561-2345 (shorenin.com/english/).

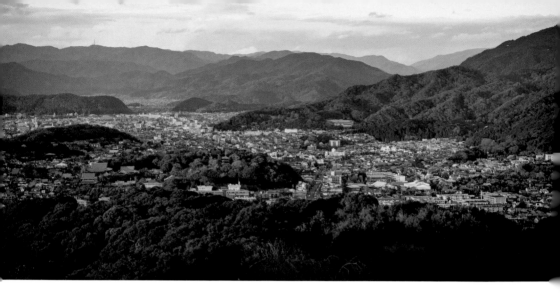

SHOGUNZUKA LOOKOUT POINT
A Historic Spot from Which to View the City

ABOVE The north of the Kyoto basin seen from Shogunzuka shows how the ancient capital has expanded to fill every piece of flat ground.

According to tradition, this is where it all began. In the year 794, on the 2nd day of the 10th month, Emperor Kammu stood on this hillside and surveyed the land below. "The mountains and rivers are the collar and belt of this area and make it a natural citadel," he declared. It was to be the location of his new capital, Heian-kyo.

Ten years earlier, Kammu had abandoned the Nara capital because of the power of Buddhists. However, he soon became convinced that the new capital at Nagaoka was cursed. Under the pretext of hunting expeditions, he sought land which would meet the requirements of geomancy: mountains to the east, north and west; open land to the

south; rivers flowing along the east; and protection against the vulnerable northeast.

To guard his new capital, Kammu had the statue of a shogun buried on the hill (Shogunzuka means Shogun's Mound). Today, the site still offers commanding views. From the observation desk one can even see Osaka to the south. Best of all are the stunning

sunsets over the Western Hills.

Shogunzuka now belongs to the temple of Shoren-in, down in the river basin below. There is a rather plain Worship Hall, which houses a replica of a famous "Blue Fudo" painting, as well as gardens with 200 cherry trees and an even greater number of maples. In spring and autumn, there are evening illuminations which give the hillside an enchanting quality. Shogunzuka is no longer just a historic site, it is a Kyoto sight.

ABOVE RIGHT In mid-August, when the Daimonji Sending-off Festival takes place, the Chinese character for (Buddhist) Law is lit on a northern hill.

RIGHT The temple at Shogunzuka is known as Seiryuden and belongs to Shoren-in, 720 ft (220 m) below in the Kyoto basin.

BELOW The temple stands next to a grass mound supposedly containing the statue of a shogun for the city's protection.

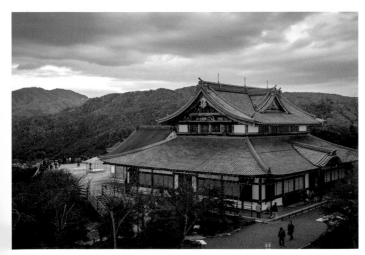

Open 9.00–17.00, ¥500. Spring/autumn illuminations 17.00–19.30. Shuttle bus 70 operates at weekends (see website below). Taxi from Sanjo or Keage approx ¥1,000. (075) 771-0390 (shorenin.com/english/shogunzuka/).

YASUI KONPIRA-GU SHRINE
A Unique and Quirky Love Shrine

Of the many love shrines in Japan, Yasui Konpira-gu may be unique in having a rock to climb through. It is not just a way of praying for a new relationship, but of severing an old one. This makes it particularly popular with the young.

The procedure is first to write one's name and wish on a piece of paper, then crawl through a hole in the oddly shaped rock to free oneself of a former relationship. By climbing back through again, the wish is made for a new relationship. It is a symbolic rebirth of a new self. Finally, the paper is glued to the rock, joining hundreds of others.

According to folklore, the origins of the shrine go back to

ABOVE Until 1868 Yasui Konpiragu was a Buddhist temple, since when it has reinvented itself as a love shrine in keeping with its surroundings.

LEFT The main approach from the east leads past cherry trees and *ema* plaques on which are written hopes for love encounters.

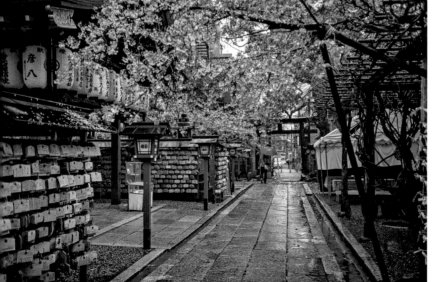

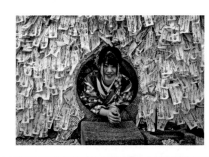

RIGHT Climb through one way to break a bad relationship, the other way to find a new love.

BELOW The rock is covered in paper strips glued to it in the hope that love will favor the person named.

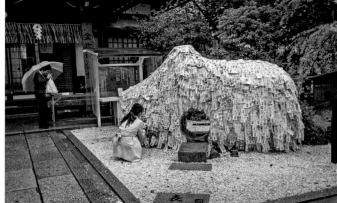

the 7th century. For most of its history, it was primarily Buddhist but opted to be Shinto in 1868 when the Meiji government forced separation of the two religions. Now it occupies the southeastern fringe of Gion, ironically sandwiched between love hotels. As at other shrines, people write their wishes on wooden plaques called *ema*, and there are hundreds of requests hung up for the *kami* to read.

The shrine is noted for its Kushi Matsuri, when thanks are given to hair ornaments for their years of service. In attendance are geisha, mindful of the proverb "hair is a woman's life." The highlight is a procession featuring the elaborate hairstyles of women down a millennium of change. It constitutes part of the "flower district" of Gion, but it also exemplifies the strands that bind Japanese to their ancestral traditions.

Access from Gion, 5 mins walk. Open 24 hours a day, free entry. Shrine office, 9.00–17.30. Museum, ¥500. Kushi Matsuri on 4th Sunday of Sep. (075) 561-5127 (yasui-konpiragu.or.jp/en/about/).

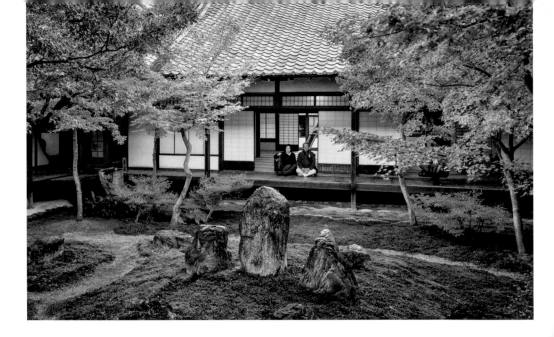

KENNIN-JI MONASTERY
Kyoto's Oldest Zen Buddhist Temple

Kennin-ji may not be the most attractive of Kyoto's seven Zen monasteries, but it is a superb repository of Japanese art and aesthetics. Its location in Gion makes it easily accessible, though visitors entering from the north miss the clarity of the layout. In Chinese fashion, the central axis starts from the Messengers Gate in the south, and runs through the Sanmon Gate and Lecture Hall to the Abbot's Quarters.

The temple was founded in 1202 by a monk named Myoan Eisai, who brought back from China the new teaching of Rinzai Zen. The grounds are lined with

LEFT The focal point of the Hojo's northern garden features three upright stones representing the Buddhist triad.

RIGHT The Reishodo building located behind the Abbot's Quarters contains relics, such as bones.

BELOW The sliding screen paintings by Kaiho Yusho (1533–1615) are among the temple's most prized possessions.

BELOW RIGHT The ceremonial entrance gate to the Founder's Hall containing Eisai's grave opens onto an "empty" dry landscape.

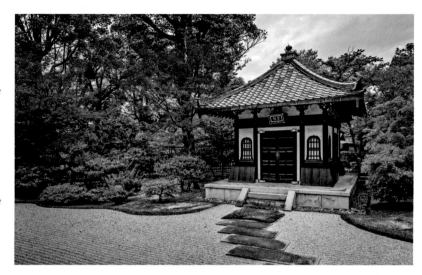

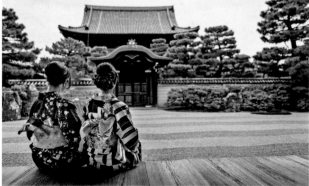

LEFT The ceiling dragon and its twin, commissioned in 2002, were painted in Hokkaido on a huge piece of Japanese paper by Koizumi Junsaku.

neatly trimmed tea bushes, in reference to Eisai having intro-duced (or reintroduced) tea from China. He promoted it both for medicinal purposes as well as a means of staying awake during meditation.

Once the temple occupied a vast area, with 53 subtemples in all. Now there are just 14. Never-theless, its former prestige is

Access—7 mins from
Gion Shijo stn on
Keihan line or 15 mins
from Shijo Kawara-
machi on Hankyu line.
Open 10.00–16.30,
¥500. (075) 561-6363
(www.kenninji.jp/
english/).

RIGHT Kennin-ji is a working
monastery, with a handful
of monks in training and
senior figures running the
subtemples.

evident in the wealth of precious
assets: rock gardens, tea houses
and paintings ("The Wind and
Thunder Gods" by Tawaraya Sotat-
su, the temple's prized possession,
is only represented by a replica).

It is conventional in Zen Lecture
Halls to have a huge dragon paint-
ed on the ceiling for its protective
qualities. (The creature also medi-
ates between worlds.) In this case,
there is a pair of dragons, inter-
locked in yin-yang fashion as if
to show the underlying unity of
things. It was painted on a huge
piece of paper which was fixed to
fill the ceiling area, and to view it
properly people sometimes lie
down on the floor. Try it. It makes
for one of those magical Kyoto
moments.

ABOVE AND RIGHT The
inner garden of the Hojo
features a mossy circle
and rock, along with a
square well. They are set
in raked gravel repre-
senting a sea of infinity.
Next to the garden is
a famous painting by
Sengai Gibon showing
the three shapes in
an artwork dubbed
"The Universe." Taken
together, garden and
painting point to Zen
notions concerning form
and emptiness.

THE GION DISTRICT
Kyoto's World-renowned Geisha Area

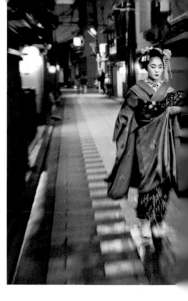

For many people, Gion is synonymous with just one thing: geisha. But there is more to the area than that. Walk down the Gion section of Shijo Street and the place is alive with crowds browsing craft, confectionery and souvenir shops. Some have not changed in a hundred years. Others are sophisticated and brand new.

The geisha area, with its well-preserved wooden houses, has the feel of another age. The main street is Hanami-koji, and at the junction with Shijo Street is the famous entertainment house called Ichiriki, featured in *Memoirs of a Geisha*. It was here that in 1702 the leader of the 47 Ronin pretended to lead a dissolute life

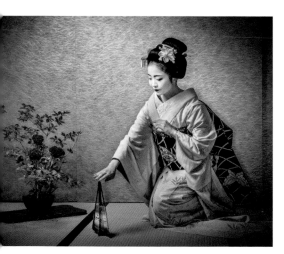

ABOVE A *maiko* called Fumiyoshi in the traditional atmosphere of the Miyagawa-cho "flower district."

LEFT An evening's entertainment, called *ozashiki*, may feature a traditional dance performance by a maiko, such as here with Fukutama of Miyagawa-cho.

while plotting revenge for the death of his feudal lord.

To the north, in Shimonzen and Furumonzen Streets, is an antique and craft area. There is a sense of "Lost Japan" in the old houses, with their treasured wall hangings, textiles and second-hand goods. Close by is what some consider to be Kyoto's loveliest street, Shimbashi. Lined by cherry trees, it runs alongside the Shirakawa Stream, and in the restaurants that overlook it geisha can sometimes be spotted entertaining guests.

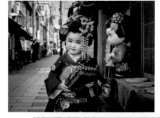

Access—25 mins walk from Kyoto JR stn or bus to Gion bus stop or Gion Shijo stn, Keihan line. Performances at Gion Corner twice nightly at 18.00 and 19.00, ¥3,150. (075) 561-1119 (kyoto-gioncorner.com).

ABOVE RIGHT A young girl emerges from a rental costume shop dressed as a maiko.

RIGHT Two off-duty maiko dressed informally in *yukata* making their way along Gion's Hanami-koji Street.

BELOW One of the many restaurants in Gion, in this case offering beef stew and *shabu shabu* at reasonable prices.

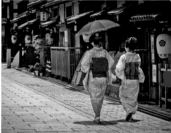

Around 5.30 in the evening, geisha set out for their assignments, drawing crowds in their wake. With the onset of darkness, thoughts turn to dining, and these days there is no shortage of places with English menus. For those with limited time, Gion Corner offers a one-hour package of seven traditional arts, which includes a dance by *geiko* and *maiko*. This is one way to see them without paying exorbitant rates. Recent years have also seen more events advertised on the web.

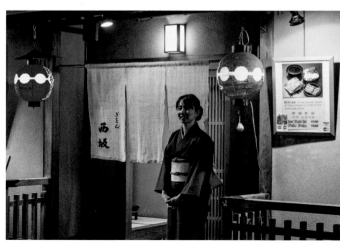

MINAMI-ZA THEATER
Traditional Kabuki with Spectacular Special Effects

It is colorful, it is stylized and it is spectacular. Kabuki can leave one gasping with amazement. There are poses, elaborate makeup, special effects, sword fights, gorgeous costumes and a large cast. It is theater for the common folk, and it all began in Kyoto.

On the east end of Shijo Bridge is the statue of a cross-dressing female with a samurai sword. This is Okuni, a dancer who came to Kyoto around 1600 and staged a new *kabuki* (crazy) style of performance. It quickly caught on, but prostitutes used the opportunity to advertise themselves, as a result of which women were banned. Today, Kabuki is still male only, with *onnagata* (men who play women) highly appreciated for their special skills.

There were once seven Kyoto theaters, but today just one remains: Minami-za on Shijo corner. The present building was completely restructured in 2018 to make it earthquake proof. In fact, Kabuki is only occasionally performed because it is expensive to stage, though every December there is a special season known as Kaomise ("show your face"), when the top per-

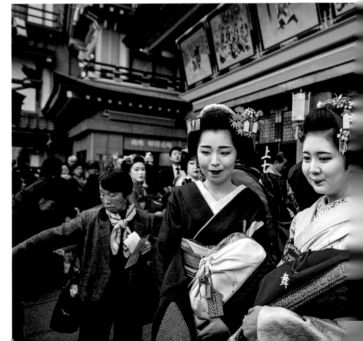

RIGHT Kaomise, the year-end festival of Kabuki, is an important item in Kyoto's social calendar and is attended by geisha and *maiko*.

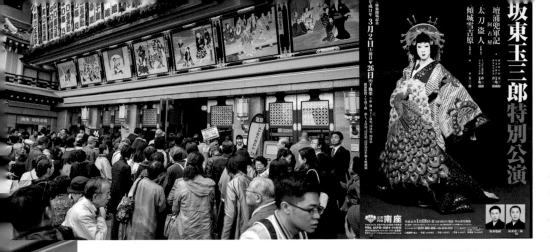

ABOVE Performances for the year-end kaomise extravaganza are sold out well in advance, and there is a crush to get into Kyoto's last remaining theater.

ABOVE RIGHT A poster advertising performances by Bando Tamasaburo, Japan's leading *onnagata* actor (female impersonator).

RIGHT Detail of one of the paintings of scenes from Kabuki plays that are placed along the front of the theater.

formers in Japan take part. For those who can afford it, this is an absolute must-see.

Kabuki plays date from the 17th and 18th centuries, so the archaic language can be difficult to follow, even for Japanese people. These days there are useful English guides, which help to explain the action. The plays feature folklore and historical events, with a focus on the melodramatic. Nothing typifies the art form more than the theatrical poses struck by actors on the walkway that leads from the stage through the audience. It is a tour de force, Japanese style, and one that owes its origins to Kyoto.

Access—1 min from Gion Shijo stn, Keihan line. Tickets range from ¥4,000 to over ¥20,000. English Audio Guides. (075) 561-1155 (kabukiweb.net/theaters/minamiza/information/index.html).

OKAZAKI CANAL & KEAGE SLOPE
A Cherry Blossom-lined Canal and Scenic Rail Line

When the emperor left Kyoto in 1868 to live in Tokyo, it tore the heart out of the city. Along with him went not only the imperial court but a whole support system. To compensate, the city embraced modernization. The biggest undertaking was a canal bringing the water of Lake Biwa to Kyoto, which took five years to complete and involved boring through the mountains.

The canal served several purposes. It carried boats bringing foodstuff from Shiga. It provided water for "the flowering capital," and it fueled a power station, which provided energy for Kyoto's trams. This made the city the most progressive in Japan, but

ABOVE The *torii* of Heian Shrine rises imperiously above the cherry blossom.

BELOW LEFT The 19th-century canal was built for transport and electricity but now serves for leisure trips.

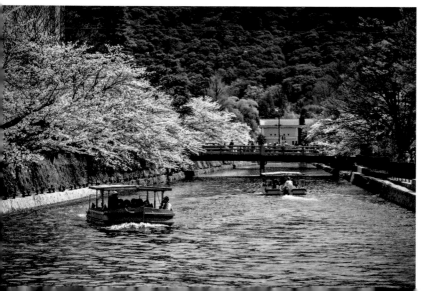

it came at a price for the project cost more than the whole national budget.

At Keage, boats were offloaded and put onto rail tracks to descend the incline. The former engineering works are used now for tourism, with walks along the rail tracks and cruises along the canal as its waters head towards the Kamo River. Cherry trees line the surrounds, making the destination popular in spring. With the trees illuminated at night, the watery reflection doubles the effect of the blossom.

The Okazaki area around Heian Shrine is packed with possibilities. To the south of the shrine are the National Museum of Modern Art and the Fureaikan Museum of Traditional Crafts. On the west is Kyoto's martial arts center, to the north of which is the Handicraft Center, full of souvenirs. To the east is the Kyoto Zoo and Murin-an, a Meiji-era promenade garden. Here in Okazaki, whichever way you turn, there is sure to be something of interest.

BELOW The incline at Keage still has rail tracks but these days is only used by pedestrians.

BELOW RIGHT Selfies with a cherry blossom background are a must for those having a special day out.

Access—5 mins from Keage stn, Tozai line. Canal boat boarding point in front of Kyoto Zoo, 8.00–20.30, ¥1,200, 25 mins. Reservations (kyoto-tabi.or.jp/events/jkkfn/_en/).

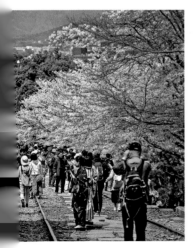

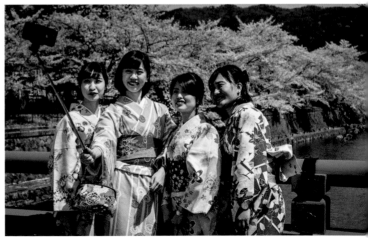

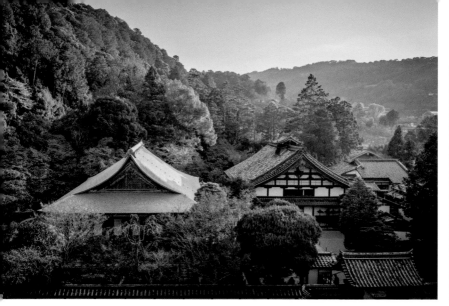

NANZEN-JI MONASTERY
A Vast and Magnificent Zen Temple

In the past, Nanzen-ji was ranked top of Kyoto's Zen hierarchy. Founded by a former emperor, it had some outstanding abbots and powerful patrons, so that at its peak it consisted of 62 sub-temples and housed 1,000 monks. Now, there are just 13 subtemples and a handful of monks. The magnificence of its art and architecture, though, is a reminder of its former glory.

The temple has a different feel to other monasteries. For a start, the precincts are open rather than enclosed. For another, the alignment is to the west rather than the south. Then there is the brick aqueduct added in Meiji times, which runs through the grounds carrying water from Lake Biwa.

The enormous Sanmon Gate, with its steep wooden staircase, offers extensive views from the second floor, and at the Lecture Hall is an opening through which a ceiling dragon can just be discerned in the darkness within. For some visitors that suffices, and

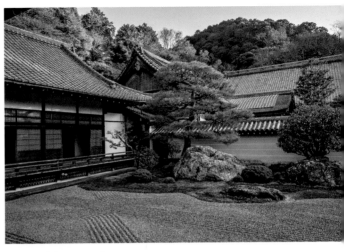

ABOVE CENTER The massive Sanmon Gate, 72 ft (22 m) tall, has a steep staircase to the upper floor with views and statuary.

LEFT Zen aesthetics are apparent in the clean lines and stylized minimalism.

ABOVE The refined rock garden of the Abbot's Quarters combines different elements into a unified whole.

BELOW An attractive brick aqueduct runs through the grounds, carrying water from Lake Biwa.

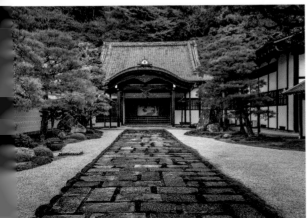

they are content to follow the water flow along the aqueduct down the nearby slope. Others head for the lovely subtemple of Konchi-in, with its "borrowed scenery" garden.

Most visitors, though, go to see the celebrated artwork in the Abbot's Quarters, where two re-located halls house replicas

of some 100 paintings. There are several gardens, amongst which is a rock garden by Kobori Enshu from around 1600, representing a tiger and cubs. The theme is echoed by master-artist Kano Tanyu in a painting of bamboo and tiger. Yin and yang here combine in a forceful representation of the vitality of nature.

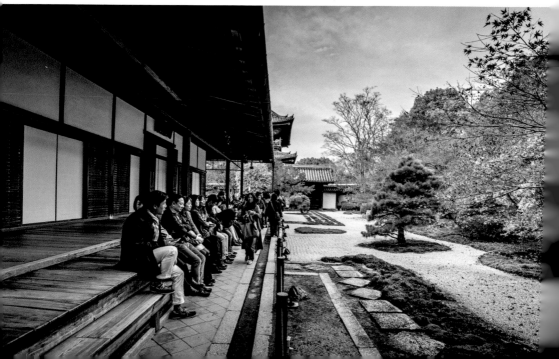

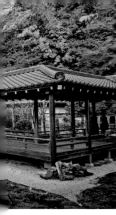

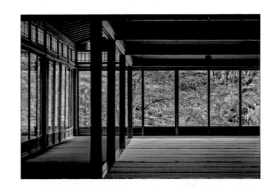

RIGHT The autumn illumination at Tenjuan is a favorite, thanks to the dazzling colors of its pond garden.

BELOW Sliding screen paintings typically depict auspicious items on a gold-leaf background, which glows in darkened temple rooms.

ABOVE The covered walkway in the grounds of the Abbot's Quarters offers views of the various gardens and tea houses.

LEFT The Tenjuan subtemple has a formal garden, which leads the eye to a gate that is only ever opened for imperial members or messengers.

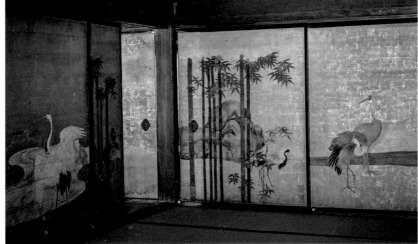

Access—5 mins from Keage stn, Tozai line. Sanmon Gate, 8.40–17.00, ¥500. Abbot's Quarters, 8.40–17.00, ¥500. Nearby tofu restaurants: Jun-sei, Taian-en and Okutan. (075) 771-0365 (nanzen.net/english/index).

EIKANDO TEMPLE
A Glimpse of Amida's Pure Land Paradise

Famed for its stunning maple colors, Eikando is the pick of the autumn illuminations. It is also popular in cherry blossom time, when the pond garden takes on an enchanted air. But there is more to the temple than that, and it merits a visit when crowds are headed for celebrated sights elsewhere.

Founded in 863 as a Shingon temple, Eikando later converted to the Pure Land sect. Its chief object of worship—and prized treasure—is an unusual statue called Mikaeri Amida. Not only is it unusually small, just 30 in (77 cm) tall, but Amida's head is turned looking backwards over his shoulder. According to legend, he was leading a group of monks reciting sutras when he turned round and encouraged the person behind to keep up with him.

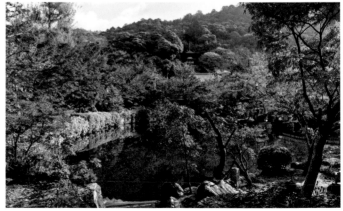

LEFT In autumn, the temple grounds are a riot of color, as seen in this aerial photo.

LEFT BELOW The breathtaking autumn colors of the pond garden can be admired while enjoying a *matcha* tea set.

RIGHT Eikando is a Pure Land temple whose main buildings run along the base of the Eastern Hills.

BELOW The autumn light-up, with its fairy tale atmosphere, has proved wildly popular in recent years.

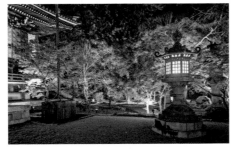

Access—near Nanzen-ji, 15 mins from Keage stn, Tozai line or 5 mins from Nanzenji-Eikando-michi bus stop. 9.00–17.00, extended during illuminations, ¥600. (075) 761-0007 (eikando.or.jp/English/index_eng.html).

ABOVE The bodhisattva Jizo, who guides the spirits of dead children, is close to Japanese hearts and is often depicted as cute.

There are three main buildings, connected by wooden corridors in the aristocratic style of architecture. As well as the Amida Hall, built in the 17th century, there is the Shakado (Hall of the Historical Buddha), with rock garden and painted *fusuma* (sliding screens). In addition, there is the Mieido (Memorial Hall), which houses a statue of Honen, 12th-century founder of the Pure Land sect.

Set along the base of the Higashiyama Range, the extensive grounds not only accommodate an attractive pond garden but a Tahoto pagoda that has a round second story on top of a square base. The result is a quintessential Japanese scene. During seasonal illuminations, sitting by the pond with a green tea set, you may feel you too have had a glimpse of Amida's Pure Land.

THE PHILOSOPHER'S PATH
A Pleasant Walk for Any Season

This is one of the city's most popular walks. It extends for about 1.5 miles (2.4 km) alongside a canal lined by trees, notably maple and cherry. On the way are cafes, boutiques and craft shops, even a bamboo grove and views over the city.

The path came into being with the building of the Biwako Canal at the beginning of the Meiji era. The canal was 12 miles (20 km) in length, fueling the city's first power station and helping to distribute water to "the flowering capital." It was one of the earliest large-scale works in Japan.

The eponymous philosopher was a Kyoto University professor called Nishida Kitaro, who liked to walk the path when lost in thought. He was part of the Kyoto School of philosophy, which attempted to bridge Western and Eastern thinking. These days, he might not find the crowded path conducive to contemplation, particularly in spring and autumn. It is busy also on June evenings when fireflies attract onlookers.

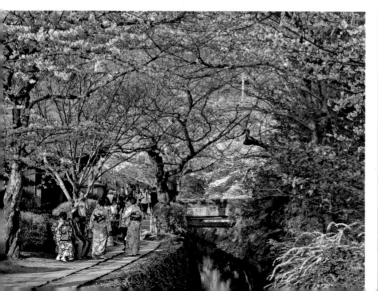

The walk takes about 30 minutes, but it is best to browse. The hillside roads hold pleasant surprises. Honen-in near the northern end is a quiet oasis with raked gravel beds and the grave of author Tanizaki Junichiro. At the southern end is the quirky Otoyo Shrine, notable for statues of animal guardians. Look around the grounds and you will find a hawk, a snake, foxes and monkeys. As you might expect, here on the Philosopher's Path there is much that gives pause for thought.

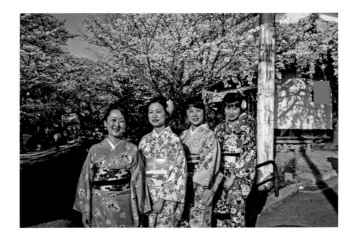

ABOVE Kyoto in spring is enhanced by the many young women who dress up and pose for photos.

FAR LEFT The 1.5 mile (2.4 km) long walk is lined with hundreds of cherry trees which burst into color in late March.

LEFT Autumn also sees the pathway festooned with color as nature puts on its second show of the year.

RIGHT The path is popular with artists, and many of the little shops along the way sell arty goods and crafts.

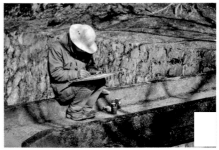

The path is open all year and runs from Ginkaku-ji in the north down to Eikando and Nanzen-ji in the south. For a drink or meal, get off the main pathway for a more leisurely atmosphere.

GINKAKU-JI TEMPLE
The Sublime "Silver Pavilion"

BELOW A raised bed of raked gravel, along with a perfectly shaped gravel cone, dominates the first part of the garden tour.

More than a temple, Ginkaku-ji is a prime example of Japanese garden arts and architecture. It was built in 1490 by a shogun more concerned with aesthetics than the civil war raging in his capital. Ashikaga Yoshimasa was a grandson of the man who built the Golden Pavilion, and like his grandfather he built a huge estate, which after his death was turned into a Zen temple.

The entrance path runs behind a tall hedge, as if separating the spiritual world from the secular. Inside is a large conical pile of

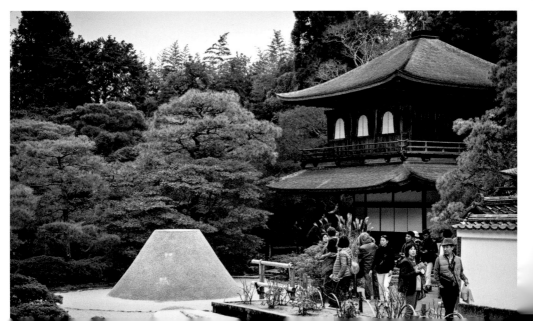

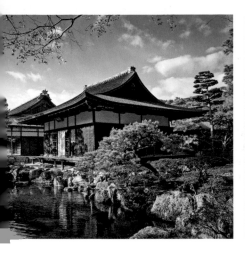

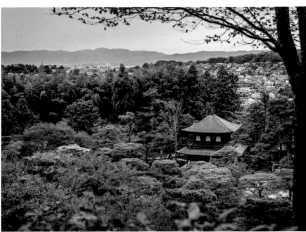

sand that may represent Mount Fuji or mythical Mount Sumeru, alongside which is a raised bed of raked gravel resembling rippling water. Interestingly, the dry landscape is complemented by an adjacent pond garden, which contains carefully positioned rocks to reference famous sights.

The two-story Silver Pavilion and the Togudo Hall are the sole survivors from the original estate. The hall was Yoshimasa's private quarters and contains the earliest example of what is now considered standard Japanese design: paper window, *tatami* and alcove. It also holds the first dedicated space for the tea ceremony. In fact, here on this estate several other of Japan's traditional arts were refined and perfected.

On the adjacent hillside, a path takes the visitor up to vantage points, before leading back past moss and bamboo to end with the pavilion itself. Though the Golden Pavilion is gold, surprisingly the Silver Pavilion is not silver. The usual explanation is that Yoshimasa ran out of money, but the intention may have been for its lacquered wood to reflect the moonlight bouncing off the water and silvery sand—a Kyoto aesthetic, for sure.

Access—bus to Ginkakuji-mae or walk 30–40 mins from Nanzen-ji, open 8.30–17.00 (9.00–16.30 in winter), ¥500. (075) 771-5725 (kyoto.travel/en/shrine_temple/130).

ABOVE LEFT A pond garden lies adjacent to the dry landscape, demonstrating the great variety in the Japanese tradition.

ABOVE View of the temple pavilion from the adjacent incline that forms an integral part of the temple layout.

OPPOSITE BELOW A mysterious, perfectly shaped cone of sand stands close to the pavilion from which the temple takes its name.

SHUGAKUIN IMPERIAL VILLA
Hillside Gardens with Spectacular Views

ABOVE LEFT The landscaped grounds were laid out by retired emperor, Go-Mizunoo, in the mid-17th century.

During the Edo Period, emperors were powerless and Japan was ruled by the shogun in what is now Tokyo. The imperial family was encouraged to dissipate their energy in harmless cultural pursuits. The shogunate was delighted, therefore, when the strong-willed Emperor Go-Mizunoo, who had tried to resist their control, resigned and turned instead to garden design.

During the making of the Sento Gosho garden (p. 142), Go-Mizunoo collaborated with the top designer of the age, Kobori Enshu. He later applied the skills he had acquired to create a new estate at Shugakuin, funded by the shogun. The site is set on an incline, making it different from other estates. As the path winds upwards, the level of formality falls away. A Lower Pavilion for outsiders gives way to the Middle Pavilion for trusted allies, and finally the private quarters of the emperor himself, the Upper Pavilion.

For an imperial villa, the materials are strikingly simple: earthen walls, paper panels, cypress bark roofs. The pathway around the expansive garden employs a "conceal and reveal" technique. The Lower Pavilion has views of the Hiei foothills, then as the path zig-zags uphill the views are blocked by hedges until all of a sudden a vast panorama opens before you. In autumn, when maple colors dapple the landscape, the view is breathtaking.

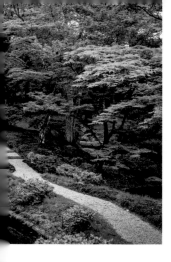

LEFT The guided tour leads up slopes from the Lower Villa past the Middle to the Upper Villa, each with its own garden area.

BELOW The grounds are kept in immaculate condition, with fallen leaves removed as quickly as possible.

BOTTOM The northern hills serve as background to the autumn colors, whose beauty is doubled by the landscaped pond.

BELOW It is not possible to enter the villas, though there are openings for visitors to see the elegant interiors.

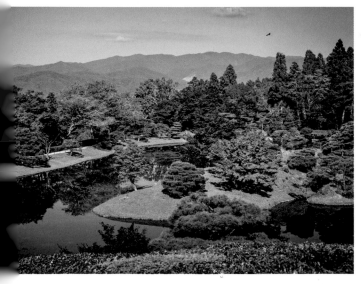

In the privacy of the Upper Pavilion, Go-Mizunoo liked to watch sunsets. The retired emperor made special outings here from his Kyoto palace two or three times a year, accompanied by a large entourage. From power politics he turned to poetry and moon-viewing parties. Sitting at the top, you will understand why.

Access—Shugakuin stn on Eizan line, walk 12 mins. Guided tours, free, limited numbers, audio guide available. For applications, see (sankan.kunaicho.go.jp/english/guide/shugakuin.html).

SHISENDO VILLA
An Idyllic Retreat with a Peaceful Garden

Who has not dreamed of leading a quiet life devoted to the arts? At the age of 59, a Zen acolyte by the name of Ishikawa Jozan decided to do just that. In 1641, he built himself a retreat near the foothills of Mount Hiei and asked master artist Kano Tanyu to paint the Thirty-six Chinese Poets.

Jozan had been a leading samurai under Tokugawa Ieyasu during the siege of Osaka (1614–15), but the pair fell out over tactics. After taking Buddhist vows at Myoshin-ji, he turned in later life to the Chinese model of the literati, who led independent lives in keeping with the Confu-

cian ethos of studying the past to cultivate virtue. Jozan was one of the first practitioners in Japan.

Jozan's retreat is a model of refined simplicity. At its entrance is a rustic gate, which is more decorative than functional. The pathway to the house obscures sight of the residence until you reach the inner gate, where the main building with its second-floor moon-viewing room can be seen. Inside is a Zen altar, a study room and a living space with veranda.

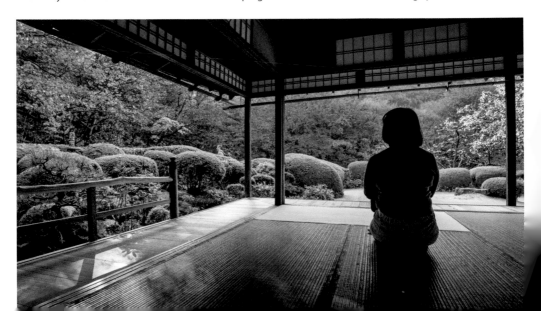

OPPOSITE BELOW The removal of sliding door partitions erases the division of garden and interior, allowing immersion in nature.

RIGHT Small touches add to the overall aesthetics, furthering awareness of seasonal change and life's transience.

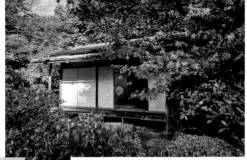

ABOVE The photos here were taken shortly after entry time, when the estate still exudes the air of a peaceful retreat.

LEFT Rounded azalea bushes provide middle ground between a dry landscape of white sand and the backdrop of trees.

BELOW LEFT This moss-covered lantern, beautified by nature, exemplifies the Japanese aesthetic of *wabi-sabi*.

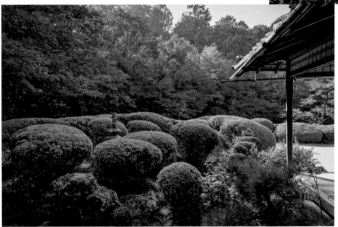

Access—Bus 5 to Ichijoji Sagarimatsucho, 5 mins walk, or Ichijoji stn, Eiden line, 20 mins walk, 9.00–17.00, ¥500. (075) 781 2954 (kyoto-shisen-do.com/En/top.html).

With its sliding doors removed, the living space merges with the outdoors. This garden scene is rated among the best in Kyoto. Brushed white sand is bordered by neatly trimmed azalea bushes and trees that draw the eye upwards to the "borrowed scenery" of the hills beyond. The composition is accompanied by the soothing sound of a tiny waterfall, interspersed with the repetitive clack of a deer scarer, as if marking nature's heartbeat. Sit, look and listen, for here is the very essence of Kyoto.

ENKO-JI TEMPLE
A Zen Sanctuary with Spacious Grounds and Gorgeous Gardens

"Hidden gem" is much overused in Kyoto, but Enko-ji may rightly claim to be one—except in autumn when its maple display draws coach tours. It does not rank among Kyoto's top temples, is difficult to access from downtown, and the head priest is concerned to maintain a solemn atmosphere. To conserve nature, he even stopped the lucrative maple illuminations.

Relocated from Fushimi in 1677 (wooden buildings are easily transported), Enko-ji was an educational center, active in publishing Buddhist texts. Its former prestige is reflected in work by top-ranking artists: a folding screen by Maruyama Okyo of the temple's bamboo grove, and Chinese ink paintings by Tomioka Tessai showing humans dwarfed by nature. There is also a modern dry landscape representing a dragon about to take flight.

The main attraction is a pond garden laid out in front of the Main Hall, with moss, azalea, rocks and maple trees combining to create a pleasing composition. In one corner is a *suikinkutsu*, a device by which dripping water is

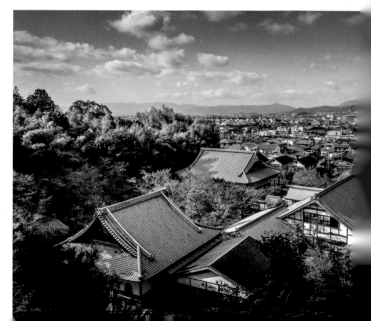

LEFT Autumn leaves start to turn in mid-November, falling to the ground around the end of the month. The temple is on the edge of Kyoto, but worth making the trip to see its maple trees.

BELOW The Zendo meditation hall has perfectly spaced cushions on which practitioners sit cross-legged in just half a *tatami* mat of space. The temple welcomes participation by outsiders but asks for prior notification.

ABOVE LEFT A touch of Zen humor, with a young boy resting on a *mokugyo* drum while mice watch him. Known as Warabe Jizo, such statues depict the bodhisattva as a child.

LEFT A view over the temple buildings to the city beyond, taken from the top of the slope at the back which contains graves, including one for the tooth of the founder, Tokugawa Ieyasu.

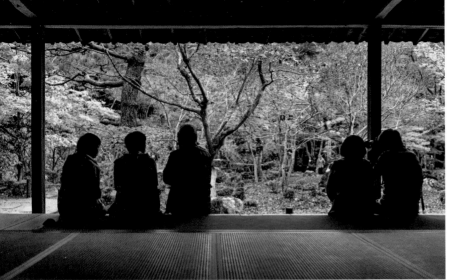

TOP The Jugyo no Niwa garden in front of the main hall is noted for the brilliance of its maple trees.

ABOVE Another cute Warabe Jizo, said to soothe the mind of those who see them.

RIGHT The moss-covered Jugyu no Niwa is highly regarded, not just for its maples but for its layout and sculpted shapes.

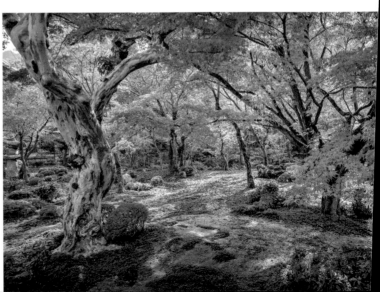

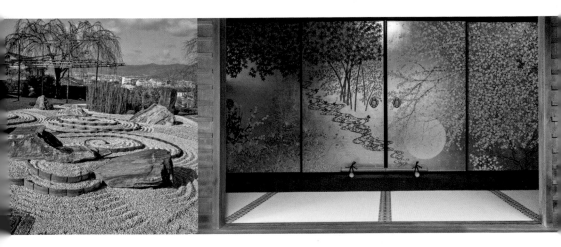

amplified by a pot buried underground. The sound acts as acoustic counterpart to the washing of hands prior to the tea ceremony, in that it serves to purify the mind.

At the back of the temple, beyond the meditation room, is a hillside with graves. One is for temple founder, Tokugawa Ieyasu (though it only contains a single tooth). Follow the path and views open up over Enko-ji and neighboring houses. On certain days, with no one around, you may well feel that, yes, indeed, this is a hidden gem.

ABOVE LEFT The dry landscape, known as Honryu-tei (Running Dragon), depicts the creature about to take flight in a sea of clouds.

ABOVE RIGHT In the entrance to the Main Hall is a brash modern painting by a contemporary member of the Rimpa School.

RIGHT Japanese have long believed that the beauty of architecture starts from the roof, in this case the tiled structure of the belfry.

Access—Eizan railway to Shugakuin or Ichijoji, walk 15 mins, or bus 5 to Sagarimatsucho, walk 7 mins. Open 9.00–17.00, ¥500. Zazen by prior reservation Sun 6.00–8.00, with short talk and rice meal, ¥1,000. (075) 781-8025 (enkouji.jp/zazen.html).

HEIAN SHRINE
A Replica of Heian-kyo's State Hall

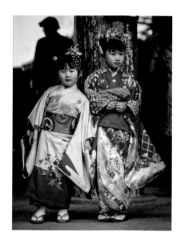

To celebrate the 1,100th anniversary of Kyoto's foundation, the city authorities planned a new Shinto shrine. It was to be a replica of the original state hall of Heian-kyo, built on a 5/8 scale. The architecture reflects the Chinese orientation of the ancient capital, and the vermilion color was thought to be a protection against evil.

The shrine opened in 1895, one of several measures taken to compensate for the loss of the imperial court. The intention was to instill pride for having been the capital for over 1,000 years, and the shrine was dedicated to Kyoto's founder, Emperor Kammu (737–806). Later, Emperor Komei (1831–67) was added, so the

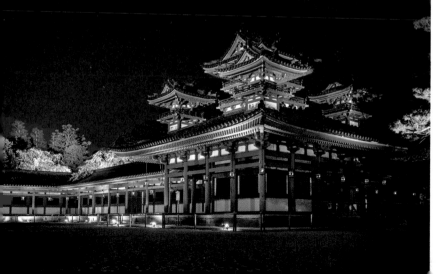

ABOVE In mid-November, when the festival of Shichi-Go-San (7-5-3) takes place, children of those ages dress up to visit Shinto shrines in a rite of passage that originated in China.

LEFT The beauty of the shrine is highlighted by illumination, while the distinctive vermilion speaks to the ancient Chinese belief in the color's life-enhancing nature.

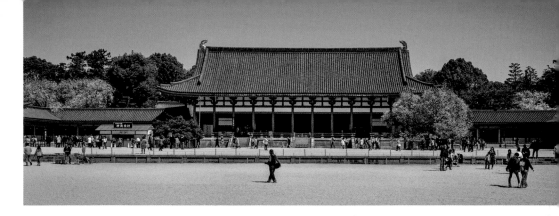

shrine deifies the first and last emperors to reign from Kyoto.

At 79 ft (24 m) the welcoming *torii* is one of the largest in Japan. A pond garden surrounds the compound on three sides and was laid out by famed designer Ogawa Jihei. It is in the traditional style, but with modern touches such as the use of European shrubs. The landscaped surrounds, with picturesque stepping stones and covered bridge, make this a popular place for wedding photos.

The shrine's large compound means that it can play host to major events, such as the Setsubun Bean Throwing Festival on February 2–4 (p. 20) when geisha disperse beans, or early June

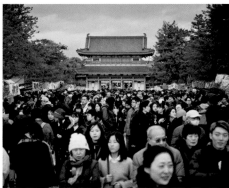

ABOVE The imposing main building is a replica of the original State Hall of Heian times, reduced in scale, in front of which was planted on either side a *tachibana* orange and a cherry tree.

RIGHT Because of its spacious size, the shrine is able to accommodate vast numbers of visitors for grand occasions, such as Hatsumode, when people make their first shrine visit of the year.

when spirits from the past glide through the gloom in Takigi Noh. For visitors to the city, the shrine makes an auspicious starting point, for by paying respects here the worshipper is honoring the spirit of Kyoto in a very real sense.

Access—Higashiyama on Tozai line, walk 10 mins, or city bus 5 or 100 from JR stn, 6.00–17.30, free to enter, gardens, ¥600. (075) 761-0221 (heianjingu.or.jp).

KYOTO IMPERIAL PARK
Palaces, Picnics and Ponds

ABOVE The Former Imperial Palace (Gosho) not only includes the emperor's one-time residence but also a grand state building.

Not far from Kyoto's crowded downtown is a large area of open land with 50,000 trees. Rectangular in shape, it is nearly 1 mile (1,300 m) in length. Once this was the preserve of the emperor and his entourage, containing 200 noblemen's houses. When the capital moved to Tokyo in 1868, the enclosure fell into disuse. Now it is preserved for the good of the people.

The emperor's former palace, known as Gosho, has been opened to the public in recent years, allowing visitors to walk round the wooden buildings. The unfortified structures speak of symbolic rather than military authority, in harmony with their surroundings. Appreciation of nature is typified by the sliding panels which open onto veran-

das, extending the interior into the pond garden outside.

Another estate, the Sento Gosho, contains a stroll garden that once belonged to a 17th-century palace destroyed by fire. The much admired garden features a meandering path that winds past tea houses, the highlight being a shoreline formed by individually placed pebbles along the margin

of a pond. At the nearby Geihin-kan Guest House (p. 144) is a modern take on the pond garden.

There is more to Gosho than aristocratic estates, however, for in amongst the pine and cedars are pleasant groves of plum and cherry. There are shrines, too, and sports activities such as tennis and baseball. Dog walking and bird watching go on throughout the year, for here in the heart of the city is a much-loved oasis of green space, as if in consolation for the missing emperor.

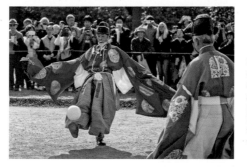

LEFT One of the pastimes of the Heian nobility was a type of kick-ball called *kemari*, in which a circle of participants cooperate in keeping the ball in the air for as long as possible without losing poise.

RIGHT As well as imperial estates, the park contains leisure areas which range from a plum grove to tennis courts.

BELOW Sento Gosho, once home to retired emperors, is notable now for its stroll garden, with carefully landscaped ponds.

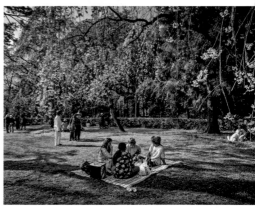

Access to park free. Former Imperial Palace, 9.00–17.00/16.00 winter. Audio guide, free. Tours at 10.00 and 14.00, 50 mins, register inside entrance. Sento Gosho online booking (sankan.kunaicho.go.jp/english/guide/kyoto.html).

GEIHINKAN GUEST HOUSE
Contemporary Japanese Design at Its Finest

There are few chances to see a contemporary version of Japan's architectural arts, but the Geihinkan offers a supreme example. Built in 2005, it mixes push button technology with ancient aesthetics, so that *fusuma* sliding screens open at the click of a switch.

Located in the Former Imperial Park, the guest house has low-level roofing which mimics that of the old imperial palace, though instead of shingles there is nickel and stainless steel. At the center of the complex is a pond, around which the guest house is arranged on three sides, offering different perspectives. At night, subdued lighting illuminates the rippling water, and a boat stands ready to ferry guests in the moonlight. Feeding the carp is said to be popular with foreign VIPs.

The craftsmanship at the guest house is of the highest possible quality. The main door is made from a 700-year-old zelkova (Japanese elm), with bronze handles displaying a cloisonne motif of silk cord to signify enduring ties. Inside, guests are welcomed by a large *ikebana* display, while the 250 tatami mats are made

LEFT The main building appears to be in the Heian style but uses concrete and has one story underground.

OPPOSITE BELOW LEFT Traditional aesthetics are displayed in the use of natural materials, restraint in decor and simple, clean lines.

OPPOSITE BELOW RIGHT Lighting is subdued, with paper screens to soften the natural light and lanterns adding a warm glow.

BELOW The state guest house was planned in 1994, completed in 2005, and opened all year for public viewing in 2016.

Access—10 mins walk from Maru-tamachi or Imade-gawa stn on subway line. Self-guided tour with audio, free, or sign up for guided tour, ¥2,000. Advance reservation at (gei-hinkan.go.jp/en/kyoto/).

from the choicest parts of specially cultivated rushes.

Each room displays the clean lines of Japanese aesthetics, showcasing the decor to best effect. The magnificence of a Nishijin kimono is spread in all its glory across a simple white wall, and braided tapestries display 39 different types of Japanese flowers. When cypress doors with gold-leaf patterning are slid open to reveal an unexpected stage with geisha ready to perform, one imagines even the most world-weary head of state would be impressed by this characteristic Kyoto moment.

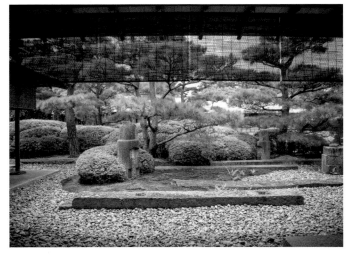

SHIMOGAMO SHRINE
A World Heritage Site in Ancient Woodland

Shimogamo is part of a Unesco World Heritage site pairing with Kamigamo Shrine, further to the north. Both were established by the Kamo clan long before the foundation of Heian-kyo. They share the same foundation myth, which concerns a princess who finds a red arrow floating in the river, takes it home and becomes pregnant with the *kami* of thunder and lightning.

Because it stands at the confluence of two rivers, Shimogamo Shrine is said to be a "power spot." It is also guardian of ancient woodland known as Tadasu no mori, a relic of the primeval forest that once covered the whole river basin. The wood is often mentioned in ancient poetry for its atmospheric setting of splashing streams and filtered moonlight.

The shrine layout, dating back to the 11th century, consists of outer and inner compounds

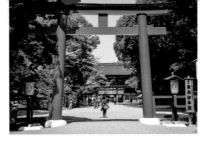

LEFT Priests enter the compound in single file to conduct one of the shrine's numerous ceremonies.

BELOW At midsummer, a circular wreath is placed in the entry gate as a means of purification for the remaining half of the year.

LEFT The approach is marked by an enormous *torii* gate in auspicious vermilion.

BELOW Japanese archery (*kyudo*) forms part of an ancient divination ritual held annually.

BOTTOM In May, horse archery skills are displayed in the ancient Tadasu woods.

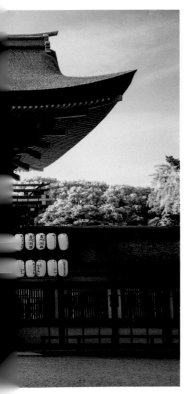

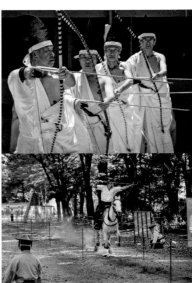

fronted by a large two-story gate. A natural spring known as the Mitarashi Stream runs through the grounds, retaining the same low temperature throughout the year and used for purification rites. Another feature of interest is Kawai Jinja, a subshrine which promotes women's beauty and houses a model of the 12th-century hut used by back-to-nature author Kamo no Chomei.

When Heian-kyo was founded, Shimogamo was chosen as a guardian for the new capital, and its privileged position is still evident at the annual Aoi Matsuri, when an imperial messenger comes bearing gifts. The elegance of former times is on display, too, at the autumn moon viewing, which is not only accompanied by *gagaku* court music but features a demonstration of how to wear the Heian court's sumptuous 12-layered kimono.

Access—10 mins walk from Demachiyanagi on Keihan line. 5.30–18.00/6.30–17.00 winter, free. (075) 781-0010 (shimogamo-jinja.or.jp/english/).

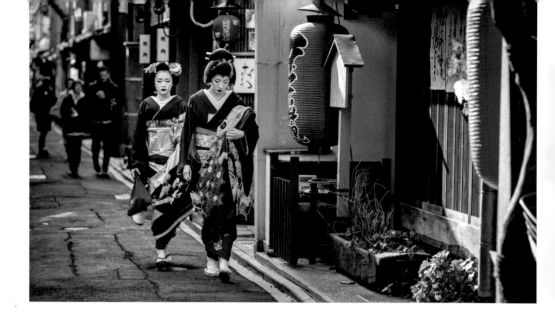

PONTOCHO ALLEYWAY
The Heart of Kyoto's Fabled Dining Scene

Walk down Pontocho in the daytime and you will find an empty lane of mostly closed shops. In the early evening, however, you will find it wall-to-wall crowded. As well as a popular eating area, it is one of Kyoto's five geisha districts. The well-preserved wooden houses give it the bustling feel of Edo times, with no cars, no garish signs and no ugly high-rises.

The alleyway dates back to the late 16th century, when it developed as a riverside entertainment area to rival Gion on the other side of the river. The theater at its northern end is where *maiko* train, and the public performances which take place in spring and

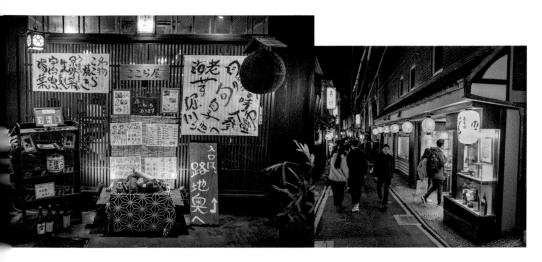

autumn once enchanted Charlie Chaplin on his world tour (p. 80).

On the east side of the alley, restaurants have views over the Kamo River, and in summer *kawayuka* platforms are put up to provide open-air dining in the summer heat. There are fine views of the Eastern Hills, and of the rising moon. In 1690, the poet Matsuo Basho wrote appreciatively of the scene (see p. 28). It is sometimes possible to see geisha entertaining guests, and occasionally a party atmosphere.

Dining in Pontocho used to be exclusive, with prices affordable only for those with expense accounts. But when Japan's bubble burst in the late 1980s, prices came crashing down. Now menus in English are available everywhere, and there is food of all sorts, ranging from Western and fusion to Japanese specialities. There are plenty of bars, too, for this charming alleyway is part of Kyoto's "water trade." Go with the flow, for you never know where you might end up.

ABOVE LEFT Most of the shops nowadays have English menus, while others put out sample food items. Sometimes you simply need to be adventurous.

ABOVE At peak times, the alleyway gets crowded, but if you go with the flow you are sure to come across something appealing amongst the many outlets.

Access—2 mins from Shijo stn on either Hankyu or Keihan lines. Dining varies but usually between 18.00 and 21.00. Yuka platforms May 1–Sep 30.

TAKASHIMAYA BASEMENT
A Department Store with Plentiful Surprises

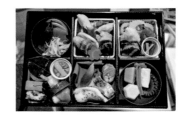

It is a rainy day and you are not in the mood for temple visiting. Or you are in the middle of town and want a bite to eat. Or you simply want some retail therapy. Kyoto's top department store might be just the solution, and you may be pleasantly surprised by what is on offer.

The basement is the place to start, for there is a plethora of food items unfamiliar to a Westerner. The stalls are colorful and closely packed, making the whole place a Wonderland for those with a fad for food: *bento* boxes and Asian delicacies; spices and sweets; modern concoctions and traditional fare.

If hunger is stimulated by this, take the elevator to the 7th floor where there are different types of Japanese restaurants, as well as French, Italian and Chinese. And that is not all; there is a post office, several ATMs and a travel agency. The eclecticism runs throughout the store; the 6th floor, for example, boasts an art gallery and Buddhist altars along with bedsheets, curtains and kitchenware.

For those feeling lost, the 1st floor has an information desk (and currency exchange) in addition to jewelry and makeup. Shopaholics might note that tax refunds are available for purchases over ¥5,000 and that souvenirs can be shipped abroad. Prices are slightly higher than elsewhere, but you can be sure of the quality

LEFT Some of the food is prepared in small portions and presented in appetising *bento* lunch boxes.

BELOW LEFT Looking the part is important, even if it is just for *kushikatsu* (skewered meat and vegetables).

of the product and its presentation. Arrive at 10.00 am and you will get to witness the bowing of staff to customers as the doors open—all part of the "Customer is God" tradition. It is an aspect of Japan that often elicits wonder but surely merits appreciation.

ABOVE Exploring the delicacies is recommended for rainy half-days, with prepared food vying with raw materials for attention.

LEFT Takashimaya competes with Daimaru as Kyoto's top food store. If browsing makes you hungry, head for the restaurants on the 7th floor.

Access—Shijo Kawaramachi (The rival Daimaru is at Shijo Karasuma.) Open 10.00–20.00, 7F restaurants shut 21.30. Closed Jan 1. (075) 221-8811 (takashimaya.co.jp/kyoto/store_information/index.html).

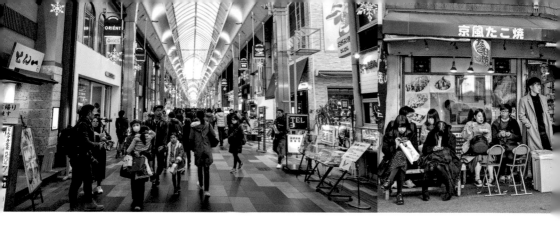

TERAMACHI SHOPPING ARCADE
A Covered Street with Antiques and Temples

In the heart of downtown is a shopping arcade popular with locals and tourists alike. It is a mix of the modern with the traditional, and you never know what will come next: a huge crab advertising a restaurant; a quality coffee shop; traditional crafts; an art gallery. Here, along with trendy clothes shops, can be found such revered delights as Horaido, one of the city's ancient green tea outlets.

Teramachi means "temple town," in reference to action taken by strongman Toyotomi Hideyoshi in the late 16th century. He ordered the east of the city to be lined with temples in order to better control them. Later, in the Meiji era, confectionery stores opened up alongside religious shops selling Buddhist altars and paraphernalia. Soon afterwards, all kinds of other shops followed.

Parallel to Teramachi runs another arcade known as Shinkyo-goku, which caters for younger tastes. Street fashion is to the fore, and people watching is as common as window shopping. It is

FAR LEFT The covered arcade is a useful refuge on rainy days, especially for families.

LEFT Eating while walking is frowned upon, and the people here are eating their fried octopus dumplings on seating in front of the shop.

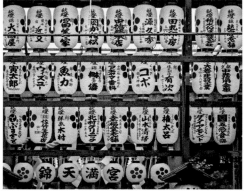

ABOVE Many of the shops sell souvenirs for foreigners, such as these *furoshiki* wrapping cloths for the bargain price of ¥500.

LEFT Along with all the shops are religious structures, such as Nishiki Tenmangu Shrine, strung with lanterns bearing the names of donors.

a place made for exploring, with escalators running up to hidden shops on high. You can pop into a *pachinko* parlor, cuddle in a cat cafe or read all night in a Comics and Capsule Hotel.

With their covered roofing, the arcades are just the place for a rainy day. There are even opportunities for a bit of traditional culture: the quirky shrine of Nishiki Tenmangu, for instance, near the southern end, or the temple of Honnyodo at the northern end, where samurai warlord Oda Nobu-naga committed *seppuku* in 1582. Small alleyways run between the arcades, making the whole district a maze of pedestrian pathways that veer entertainingly between the tacky and the traditional, between the present and the past.

Teramachi's arcade is at its best between Sanjo and Oike Street. Weekdays are less crowded than weekends. Some shops close on Wednesdays.

NISHIKI MARKET
"Kyoto's Kitchen" and Central Food Market

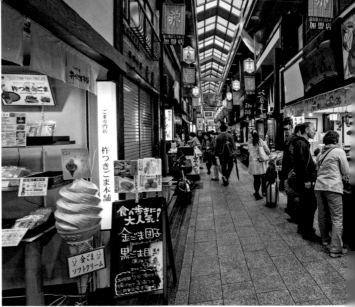

The covered arcade of Nishiki, five blocks long, is lined with over 120 stalls. Running parallel to Shijo, from Teramachi west to Takakura, it has been a market site for more than 500 years, and has a reputation for quality food that is fresh, seasonal and tasty. The vibrancy makes it one of Kyoto's most popular attractions for tourists, even as it continues to serve the local populace. Customers include Michelin-starred restaurants and *kaiseki* chefs.

A particularly striking aspect is the arrangement of food, displayed with meticulous care. The variety is astounding: here can be found green tea sweets, Kyoto-style octopus, *sashimi* on sticks, cinnamon *mochi* (rice balls), dried seafood, chocolate croquet, charcoal grilled eels, rice dumplings and pickles galore, including *kyo-yasai* (special Kyoto vegetables).

It is best to avoid the lunchtime crush, if possible. There are a few sit-down places, but the preferred option is to stand and snack, with some stalls offering free samples. Etiquette requires the customer to consume food in front of the stall, as eating while walking is frowned upon.

Though there are some modern shops, the market retains a traditional atmosphere. Some of the shops have been run by the same family for generations. As well as food, there are craft shops good for souvenirs, such as the high-quality knives of Aritsugu

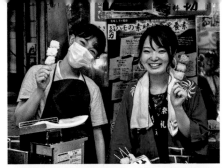

RIGHT AND BELOW RIGHT Several stores prepare delicacies on sticks, easy for eating, such as fried food or squid cooked in soy marinade.

BOTTOM Pickled vegetables are a Kyoto speciality, using simple ingredients in the process like salt, vinegar and rice bran mash.

on which you can have a name engraved. For those in a hurry, it is possible to breeze through the arcade in 20 minutes or so, but for those with time to spare Nishiki is just the place to linger a while and savor the true taste of Kyoto.

ABOVE The market is often packed at midday, but at other times it is fun to browse the selections of everything from pickles to souvenirs.

ABOVE LEFT Some of the snacks, such as octopus leg, take a bit of chewing.

Access—5 mins from Shijo stn on the subway or Kara-suma stn on the Hankyu line. Shop hours vary but generally 9.00–17.00. Some may shut on Wednesdays or Sundays. (075) 211-3882 (japan-guide.com/e/e3931.html).

KYOTO'S MANGA MUSEUM
A Contemporary Window on Japanese Culture

With more than 300,000 manga, ranging from the 19th century to the contemporary, Japan's first Manga Museum also serves as a vast reading resource. A joint project of Kyoto City and Seika University, it opened in 2006 in a converted elementary school. For the ancient capital, it is a refreshing dose of mod pop culture.

The books are nearly all in Japanese, but there is a small international section featuring classics such as *Barefoot Gen*. On the 1st floor, student artists draw manga-style portraits of visitors, which make fun souvenirs (add your name to the waiting list). There is also a room with hand molds of famous manga artists next to their drawings, and there are occasional events, such as the live projection of works in progress by professional cartoonists.

For many foreigners, the traditional story telling (*kamishibai*) is the highlight. It involves a succession of sketched drawings around which the narrator tells a story. The technique is seen as a forerunner of modern manga, and it dates back to the 12th century when monks used it to teach Buddhism to illiterate peasants.

For those tired of traipsing around temples, the Manga

RIGHT The three-story premises, previously an elementary school, include exhibition rooms, an entertainment space, a gift shop and a cafe.

CENTER RIGHT The museum contains the world's largest collection of manga, with some 300,000 volumes.

FAR RIGHT On display are signatures, self-portraits and plaster casts of artists' hands.

Location—Karasuma Oike subway stn, 2 mins walk. 10.00–18.00, ¥800. Closed Wednesdays. (075) 254-7414 (kyotomm.jp/).

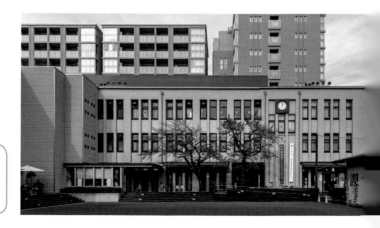

Museum offers something completely different, and for fans of the genre this is manga heaven. There is even a cafe with doodles by visiting celebrities, which you can admire while eating your sandwiches. And for those who would like to follow up with some manga tourism, try *Uchouten Kazoku* (Eccentric Family), set around Shimogamo Shrine, or *Inari*, *Konkon*, *Koi Iroha*, which is based on Fushimi Inari. In both cases, the shrines are portals into fanciful dimensions. Magical manga Kyoto—who would have thought it!

RIGHT The museum has dedicated areas where readers can peruse the manga of their choice.

BELOW A student artist does a portrait in manga style for a couple to take home as a souvenir.

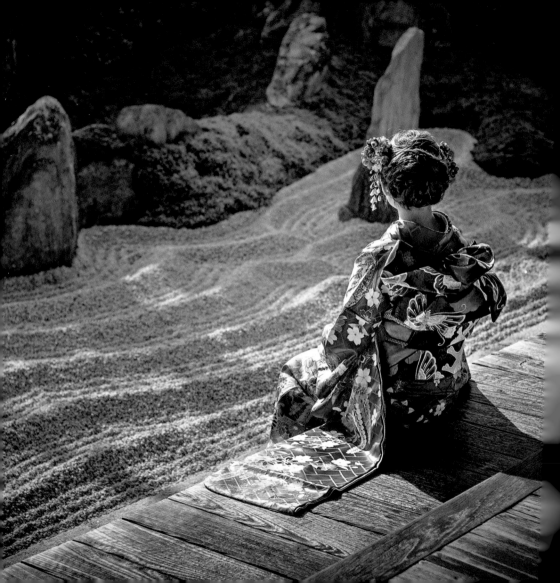

Exploring Northern & Western Kyoto

The north and west of Kyoto are large areas that embrace whole swathes of the city, stretching from the Takaragaike lake across to the river resort of Arashiyama. In tourist terms, the focal point is the World Heritage cluster comprising the Golden Pavilion at Kinkaku-ji, the rock garden of Ryoan-ji and the Shingon temple of Ninna-ji. Together they represent the striking accomplishments of Japanese aesthetics in garden design and architecture. The sites are reasonably close to each other, so it is possible to walk from one to the other. For many people, this will be the highlight of their visit.

LEFT Vying for attention: the brightness of the kimono stands in stark contrast to the natural hues of the rock garden.

Nijo Castle, another World Heritage site, combines samurai arts with upper-class refinement in its extraordinary collection of *fusuma* (sliding door) paintings. Several other sites in the area could have qualified for World Heritage if they had applied. Take Myoshin-ji, for instance, a medieval Zen monastery with 47 outstanding subtemples, or Kitano Tenmangu, a major shrine dedicated to a 9th-century statesman who played an influential role in Japanese culture. Another World Heritage candidate would be Daitoku-ji, a Zen monastery that was central to the development of the tea ceremony and has subtemples with design details that are of such historical significance that people fly to Japan from all over the world to study them.

The area offers much more than temples and shrines, though. For one thing, as the downtown city gives way slowly to hilly fringes and rice fields, grassland and open spaces become apparent. The Botanical Garden is a favorite of locals, and Kamigamo Shrine has meadowland used for festivities.

For those who wish to shake off the city dust altogether, there are activities such as rafting down the Hozugawa from Kameoka or boating by the picturesque Togetsukyo Bridge in Arashiyama. It is also possible to climb Mount Atago, Kyoto's highest mountain at 3,032 ft (924 m). A sacred mountain, it hosts a shrine known for fire-protection and offers fine views. It is steep at times, but there are steps. It takes about five hours to and fro.

As well as the outdoor activities, west Kyoto offers some more easy-going options: a monkey park, which children enjoy; a film star's second home (Okochi Sanso); souvenir and craft shops in Arashiyama; and the Toei Film Studio, where visitors can dress up in period costume or watch historical dramas being filmed. There is also Japan's most famous moss garden at Saiho-ji, and what for many experts is the most exquisite estate in the whole of Japan: Katsura Imperial Villa.

Altogether, the area is home to seven of Kyoto's 17 Unesco World Heritage sites, and there are many other attractions of different kinds. So head for the northern and western parts of Kyoto and enjoy exploring for yourself the rich variety and the chance to mix some nature with your culture.

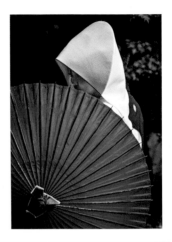

RIGHT At larger Shinto shrines such as Kamigamo, you may stumble upon traditional-style weddings with the bride in a white headdress to cover her "horns" of jealousy.

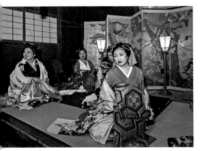

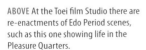
ABOVE At the Toei film Studio there are re-enactments of Edo Period scenes, such as this one showing life in the Pleasure Quarters.

RIGHT The placement of rocks in dry landscape gardens often provides a key to unlocking the meaning.

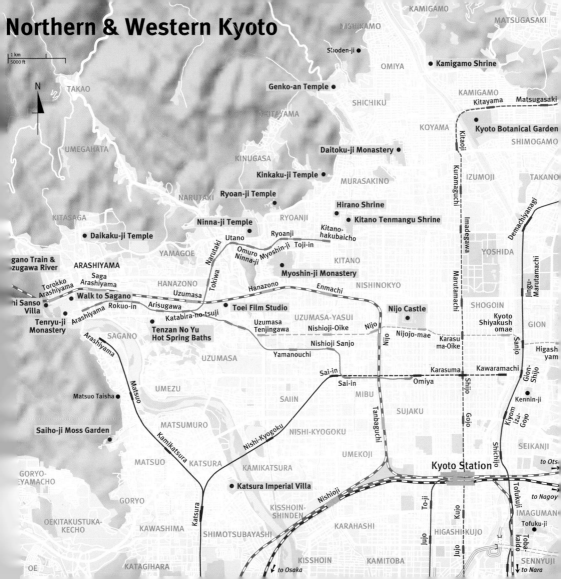

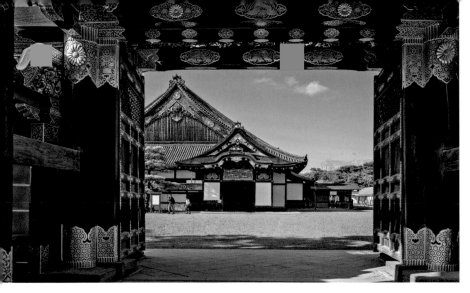

NIJO CASTLE
Samurai Architecture and Aesthetics

The moat and stone walls are immaculate, yet compared with castles elsewhere the dimensions are modest, and inside is a palace noted for its exceptional artwork. Founded in 1603, Kyoto's castle was not so much a show of might as a base from which the Tokugawa shoguns could keep watch over the emperor.

Visitors to the castle are steered through a magnificent Chinese-style gate to the Nino-maru Palace. It was built for a ceremonial visit by the emperor in 1626. It marked a coming together of imperial and shogunate factions, so the top artists of the day were employed to decorate the rooms. They were also intended to serve as the Kyoto residence of the shogun.

The palace comprises five connected buildings, arranged in hierarchical fashion. The outer rooms are for functionaries, followed by those for Outer Lords, then Tokugawa allies, and finally private rooms. Connecting them is a Nightingale Corridor which acts as an alarm system by squeaking when trodden upon. There is a wealth of artwork to protect: a total of 33 rooms with over 1,000 paintings, notable amongst which are sturdy pine

OPPOSITE The Ninomaru Palace is first seen framed by a Chinese-style gate with gold-embossed decoration.

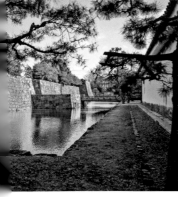

ABOVE Compared with other castles in Japan, the walls here are relatively small and suggest a shogunate residence more than a stronghold.

Access—2 mins walk from Nijojo-mae stn on Tozai line. 8.45–16.00 (grounds close 17.00), ¥600. Audio guide ¥500. Closed Tuesdays in Jul, Aug, Dec, Jan. Guided tours ¥2,000. (075) 841-0096 (www2.city.kyoto.lg.jp/bunshi/nijojo/english/).

trees with extensive branches, suggestive of Tokugawa power.

Next to the palace is a pond garden with rugged rocks that speak of military might. The path round the grounds leads past an old villa, a viewpoint and tea houses. There are a large number of cherry trees, popular in spring when they are illuminated. Together, castle and cherry blossom combine to evoke images of samurai and transience. Here at Nijo, one senses a closeness to the Japanese soul.

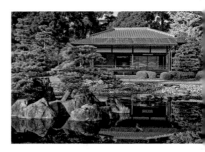

ABOVE The extensive grounds contain the Seiryu-en Garden, designed in the 1960s for public events.

BELOW The Ninomaru Garden, laid out in 1626 for an imperial visit, is remarkable for its rugged rocks.

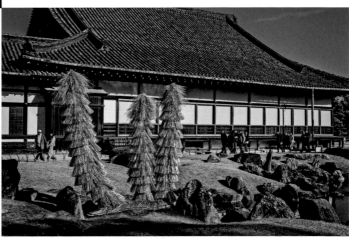

NINNA-JI TEMPLE
A Buddhist Temple Fit for an Emperor

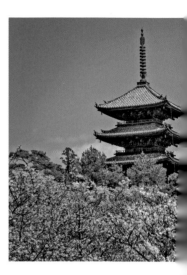

Although a Buddhist temple of the Shingon sect, Ninna-ji contains within it buildings more suited to the nobility. The founding abbot was a retired emperor, who in 888 converted his Omuro Palace into a temple. For nearly 1,000 years his successors were imperial princes who lived in the residence. Now it is a Unesco World Heritage site.

The palace reflects the leisurely refinement of Heian aristocrats. It was reconstructed in 1915 after a fire, but kept the original design. The Abbot's Quarters has rooms with paintings by acclaimed modern artists, and an altar room built on an incline offers a pleasing overview of the small estate, in which wooden buildings connected by corridors are set around a charming pond garden.

Visitors are welcomed by a huge floral display arranged by the

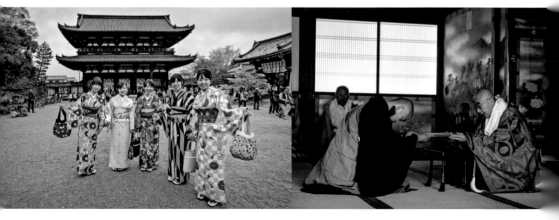

ancient Omuro School of *ikebana*, based at the temple. At the heart of the complex is a building with three adjoining rooms facing the pond. They are decorated with gorgeous gold-leaf paintings by modern artists, and the view of the pond with its rocks, tea houses and pagoda is delightful.

The temple's high status is reflected in the grandeur of the buildings, particularly the imposing Niomon Gate. Like most of Kyoto, the temple suffered destruction in the Onin War (1467–77), and what we see today is the subsequent reconstruction. The extraordinary woodwork of the pagoda dates from the 1630s, as does the nearby grove of cherry trees. They are famous for being late flowering and provide a photo opportunity after other sites have shed their blossom. "Heavenly Benevolence" is how the name of the temple translates, and after visiting you may understand why.

Access—10 mins walk from Ryoan-ji (from Kyoto JR stn bus to Omura Ninna-ji, about 40 mins). Open 9.00–17.00/16.00 winter. Grounds free, Omuro Palace ¥500.

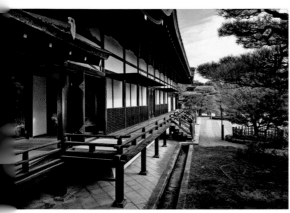

ABOVE The five-story pagoda, erected in 1637, stands near a famous grove of late flowering cherry trees.

FAR LEFT The spacious compound is entered through the magnificent two-story entrance gate, which like the other buildings was rebuilt in the early 1600s.

CENTER LEFT As well as being a World Heritage destination, the temple continues to function as a seminary for the Shingon sect.

LEFT From the end room of the Abbot's Quarters there is a magnificent view of the pond garden, where people sit to reflect upon the landscaped surrounds.

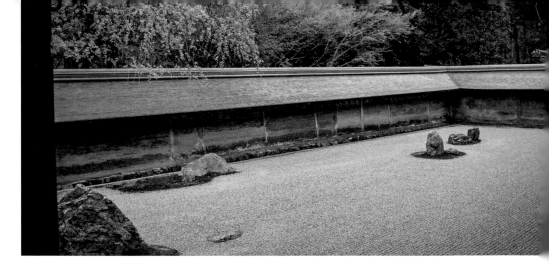

RYOAN-JI TEMPLE
Japan's Most Iconic Rock Garden

People fly across the world to see it, yet it is simplicity itself: 15 rocks in raked gravel with some touches of moss, enclosed by a wall blackened with age. The arrangement has aroused much puzzlement, giving rise to numerous theories. For some, it is the ultimate Zen riddle.

Contemplative viewing is said to evoke different ways of "reading" the garden. A sea of eternity with specks of time. Clouds pierced by mountain peaks. A yin-yang combination of water and rock. A key point seems to be that all 15 rocks cannot be seen at once, since in Buddhism the number 15 signifies enlightenment. (On the 15th day of the lunar cycle, the moon reaches completion.) The suggestion, therefore, is that the practitioner must continue striving in silent contemplation to see the full picture, as it were.

But there is more to Ryoan-ji than its rock garden. The Abbot's Quarters, for instance, that stand adjacent to the garden, have some excellent *fusuma* paintings, including some dramatic dragons, while the large pond garden is popular for its autumn colors. It was originally part of a Heian-era estate, and the path around it deliberately obscures the view until vantage points open up to picturesque scenes.

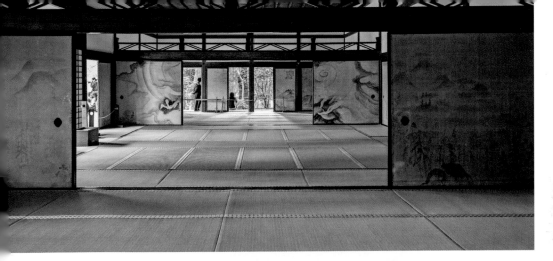

ABOVE The Abbot's Quarters adjacent to the rock garden have painted screens which slide shut to form three separate rooms.

LEFT One of the temple treasures is a standing screen with calligraphy of a Chinese poem.

BELOW The temple has an unusual washbasin with an inscription using the middle square so that it can be read vertically as well as horizontally.

Ryoan-ji became a Zen temple around the time of the Onin War (1467–77), after which the rock garden was laid out, possibly by famed artist Soami. Despite wide-spread damage to the temple, the garden survived intact, though it was unknown until the 1930s when it was "discovered" and hailed as a masterpiece. If you can get there early enough before the crowds, you might also fall under its spell.

Access—20 mins walk from Kinkaku-ji or bus from JR stn to Ritsumeikan Daigaku-mae, about 40 mins. Open 8.00–17.00/8.30–16.30 in winter, ¥500. (075) 463-2216 (ryoanji.jp/smph/eng/).

KINKAKU-JI TEMPLE
The Sublime Temple of the Golden Pavilion

Recognized as one of the most beautiful buildings ever conceived, it is an iconic image which photographers queue up to capture. Glistening in the golden rays of a deepening sunset, or sparkling in the winter snow, the Golden Pavilion is a dazzling sight, whose magnificence is doubled by reflection in the surrounding pond.

The pavilion was built in 1397 by Shogun Ashikaga Yoshimitsu as one of several buildings on his retirement estate. With statuary of Amida and a room for meditation, the pavilion was the religious heart of the estate.

RIGHT Seen across the pond by which it stands, the Golden Pavilion was intended to be a vision of a Pure Land paradise.

BELOW On sunny days, it is possible to believe that the glittering gold leaf does indeed have a purifying effect.

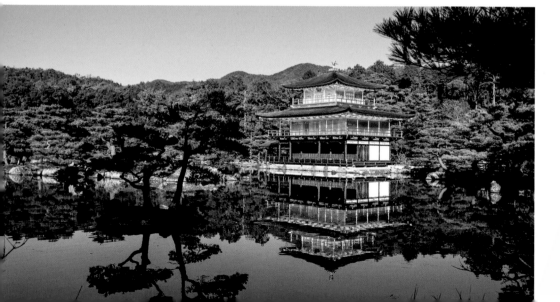

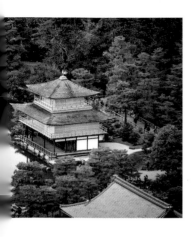

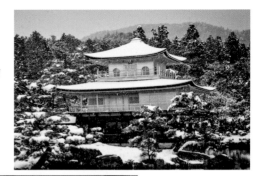

RIGHT The Golden Pavilion looks beautiful at all times, one reason why the trainee monk of Mishima Yukio's novel, *The Golden Pavilion*, develops such resentment that he burns it down.

LEFT As well as the pavilion, the temple grounds contain a number of other buildings, including the Sekkatei tea house located near the exit.

(Yoshimitsu combined belief in the Pure Land with practice in Zen.) After his death, the estate was turned into a temple, and today it belongs to the Zen monastery of Shokoku-ji.

The pavilion has three stories, which comprise an audacious mixing of design. The first floor uses the Heian aristocratic style, with unpainted wood, white plaster and veranda. The second and third floors are in a samurai-Zen style, lacquered and covered in gold leaf (the glow was thought to be spiritually purifying). The surrounding pond embeds literary references, such as a group of stones representing sailboats on their way to Horai, mythical Isle of the Immortals.

Beyond the pavilion, a stroll garden leads past a tea house and the former Abbot's Quarters. It brings to mind the novice monk of Mishima Yukio's novel, which was based on the real-life arson of 1950, following which the pavilion had to be completely rebuilt. Now it glitters brighter than ever, and viewed from across the pond it looks very much like a vision, one guaranteed to linger in the memory.

Access—Bus 101 or 205 to Kinkakuji-mae bus stop. Subway to Kitaoji then 10 mins taxi. Open 9.00–17.00, ¥400. (075) 461-0013 (japan-guide.com/e/e3908.html).

GENKO·AN TEMPLE
Two Views of the World

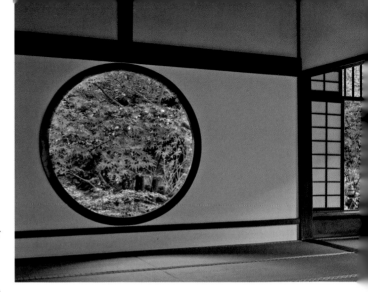

One of the windows is round, the other square. Both look onto the same garden but they shape perspectives in different ways. This pairing is part of a Zen exercise, for by sitting in front of the windows the viewer may draw nearer to realization of the true essence of the universe.

The square window, known as the Window of Confusion, offers a normal way of seeing things. The circular window, known as the Window of Enlightenment, shows a harmonious world in which all is connected. In both cases, the greenery beyond the window brings to mind transience, for change is the only constant in the seasonal round. It is a key teaching of Buddhism.

The temple originated as residence for a retired abbot of Daitoku-ji. Later, a reforming priest converted the temple from Rinzai to Soto, both branches of Zen (Rinzai makes use of *koan*

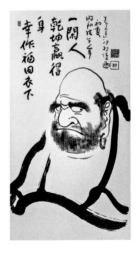

mental puzzles, Soto emphasizes just sitting). The temple's reception rooms contain ink paintings by 17th-century artist Yamaguchi Sekkei, showing the integration of humans in nature, while the nearby landscape garden exemplifies the aesthetic of *komorebi* (filtered sunlight through leaves).

In the Main Hall, Japanese people can sometimes be seen gazing up at the ceiling. This has to do with a massacre in 1600 at Fushimi Castle, when several hundred soldiers sacrificed themselves to gain time for

Tokugawa Ieyasu to raise troops. To pacify their souls, floorboards bearing their bloody stains were dispersed to various temples. More than 400 years have elapsed since then, but the outline of a handprint remains all too clear. Like the windows, it gives pause for thought on life's transience.

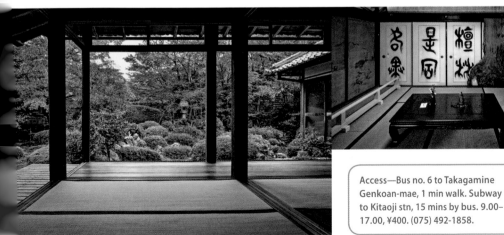

LEFT The circular and square windows both face the same way but offer different ways of framing reality.

BELOW LEFT The stern features of Zen founder Bodhidharma, known in Japan as Daruma.

ABOVE The temple started out as Rinzai Zen but converted to Soto Zen in 1694.

BELOW The temple's garden has a symbolic Turtle Island, but its Crane Island was destroyed.

BELOW The reception room has calligraphy in archaic style on a standing screen which has been made from the wood of fallen Yakushima cedar trees thousands of years old.

Access—Bus no. 6 to Takagamine Genkoan-mae, 1 min walk. Subway to Kitaoji stn, 15 mins by bus. 9.00–17.00, ¥400. (075) 492-1858.

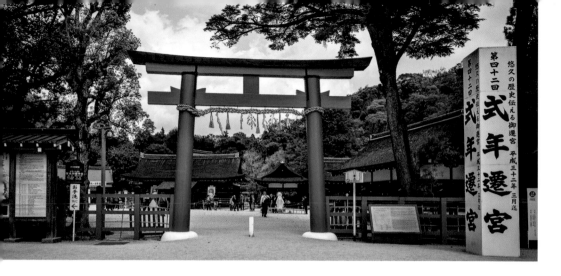

KAMIGAMO SHRINE

An Ancient Shrine in Open Meadowland

For many people, Kamigamo is the most pleasant of Kyoto's shrines because of its expanse of greenery. It lies upstream from its sister shrine, Shimogamo Jinja, and with its prehistoric origins has also been recognized as a World Heritage site. The deity worshipped here is Kamo Wake-Ikazuchi, *kami* of thunder featured in the founding myth (p. 146).

The shrine is approached through open fields used for grand occasions, such as the Aoi Festival. In spring there are horse races, and in autumn horse archery and a children's *sumo* contest. Adjacent to the park is a copse in which a Heian-era poetry contest is held in spring, with kimono-clad contestants sitting either side of a winding stream.

The outer compound has two mysterious cones of sand. These are said to be yin-yang representations of the shrine's sacred Mount Ko, onto which the kami first descended. The inner compound is fronted by a magnificent multistory red gate, in front of which is a graceful arched bridge. Unusually, there are two sanctuaries for the kami, one the permanent residence and the other a spare for use during renovations.

The shrine was run by the Kamo clan for much of its history, and descendants still live in the neighborhood. According to clan lore, their ancestor was a three-legged crow called *yatagarasu*, which may signify that in ancient times the

clan followed a crow shaman. Myth now serves the present, for the yata-garasu has been adopted as motif by the Japanese football team, for whom three legs would surely be a distinct advantage.

Access—Subway to Kitayama stn, then 15 mins walk, or bus 4 from Shimogamo Shrine, 30 mins. 8.00–16.00 (8.30 in winter). Free. (075) 781-0011 (kamigamojinja.jp/english). Handicraft market, 4th Sunday.

LEFT Young women working at the shrine are known as *miko*. In ancient times, they served as shamans but now mainly sell shrine goods and perform sacred dances.

ABOVE Shinto weddings are often held at the shrine, sometimes for foreigners, with bride and groom dressed in traditional style.

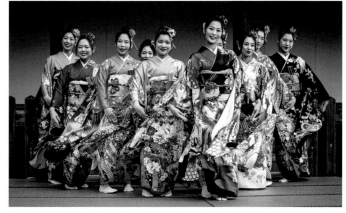

LEFT The inner compound containing the Worship Hall and Sanctuary is entered through a multistory red wooden gate.

ABOVE The shrine hosts occasional events, such as this kimono show by young single women in the formal *chuburisode* style.

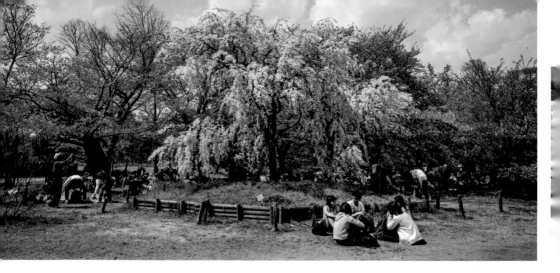

KYOTO BOTANICAL GARDEN
A Haven of Tranquility with 12,000 Plant Varieties

Kyoto was founded as Heian-kyo, "Capital of Peace and Tranquility." Faced with the hustle and bustle of downtown, visitors may be forgiven an ironic chuckle, but here in the Botanical Garden, located next to the Kamo River, is a retreat of sorts. It is particularly handy for families, and there is a playground for children. For rainy days, too, there is a canteen and conservatory, along with 12,000 different species of plants.

After the emperor left for Tokyo in 1868, Kyoto ran up a remarkable number of firsts. First elementary school, first power station, first cinema. First botanical garden, too. Founded in 1924, it is not only Japan's oldest but also the largest of its kind. The grounds are divided into sections: Japanese native plants, lotus pond, plum grove, bonsai, etc. Though the areas are signposted, it is a good idea to pick up the free English-language map at the entrance.

Spring and autumn are peak times. There are 500 cherry trees, comprising 100 different varieties, and maple trees mean that autumn colors are a popular draw. But such are the number of plants that any time of year brings a seasonal delight. For example, as spring blossom fades, waves of hydrangea are followed by lotus and sunflower.

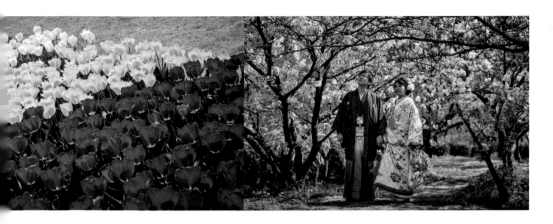

ABOVE The varied nature of the thousands of plants means there is a rolling round of flowers in bloom.

ABOVE The garden is popular for wedding photos, and couples in formal kimono are often found posing in picturesque spots.

BELOW Japan has over 100 varieties of cherry, one of the favorites being the multilayered *yaezakura*.

ABOVE Kyoto was once known as the "flowering capital," notable for its variety of cherry blossom.

A special feature is the conservatory. In summer, varieties of lily adorn the pond outside while the interior is divided into seven different sections housing 4,500 species of tropical plants, including succulents, orchids and savanna grasses. For those used to the modest hues of Japan, the exotic colors and fragrances are striking. Here, in the Botanical Garden, Kyoto lives up to its one-time epithet of "flowering capital."

Access—Kitayama stn (exit 3), subway, walk 1 min. 9.00–17.00 (greenhouse—16.00), ¥200. (075) 701-0141 (pref.kyoto.jp/en/02-02-10.html).

DAITOKU-JI MONASTERY
A Zen Universe with Splendid Subtemples and Gardens

Within the walled compound is an oasis of calm, with pathways that lead to large central buildings and secluded subtemples. The massive Buddha Hall, with its stone floor, stands in contrast to the homely *tatami* rooms of the priests' residences.

To walk the tree-lined paths is to step into history. This is the temple that Ikkyu Sojun, "the crazy man of Zen," reconstructed after the Onin War; here the subtemple where Takuan Soho taught "no mind" to master swordsman Miyamoto; over there

the subtemple where Ruth Fuller Sasaki became the first foreigner to be a Zen abbot, employing poet Gary Snyder as researcher.

Daitoku-ji has also played host to leading tea masters, including most famously, Sen no Rikyu. He not only regulated the form but promoted *wabi-sabi* aesthetics, and at Daisen-in is a room and water basin that he used when teaching Japan's ruler, Toyotomi Hideyoshi. The two men fell out over a statue placed in Daitoku-ji's Sanmon Gate, with the result that Hideyoshi ordered the tea master to commit ritual suicide.

LEFT Little lanes lead to the monastery's numerous subtemples, while the main buildings are served by wide avenues.

TOP The water basins for symbolic purification can sometimes seem an integral part of nature.

RIGHT The vigorous waves of Zuiho-in's dry landscape were created by celebrated designer Shigemori Mirei.

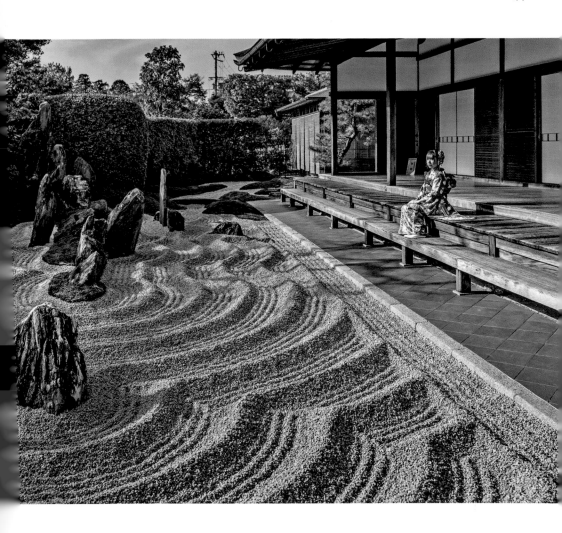

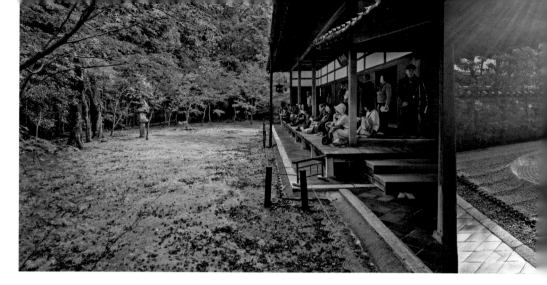

ABOVE One of the joys of temple visiting is sitting out on an open veranda, as here at Koto-in.

BELOW Daitoku-ji has long been synonymous with tea, and contains a large number of historical tea houses.

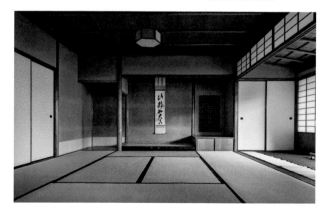

Daitoku-ji's subtemples have much to offer. Daisen-in houses a small but allegorical dry landscape garden, in which a river of life issues from mythical Mount Horai to flow round the main building and end in a sea of eternity. At Zuiho-in is a Hidden Christian rock garden, with rocks placed in the shape of a crucifix, and at Ryogen-in are Japan's oldest abbot's quarters. You can take a relaxing green tea at Koto-in, or have a *shojin ryori* meal at Izusen. One way or another, Daitoku-ji will provide you with a taste for Zen.

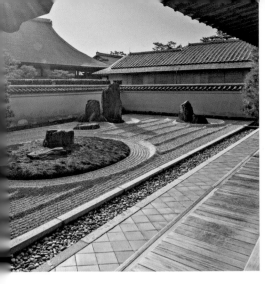

LEFT The dry garden of Ryogen-in is based on Horai, the Daoist mythical paradise. As is customary, there is a Turtle Island (round grassy area) and a Crane Island (standing stone with grass).

BELOW The dry garden of Hoshun-in also represents Horai (vertical rocks in the corner), while the two stones in the foreground suggest boats crossing the sea in order to reach it.

ABOVE The subtemple of Koto-in is known for its dazzling maple leaves, popular with photographers.

BELOW Korin-in, a subtemple founded in 1520, is entered through the kitchen building to the right of the main path.

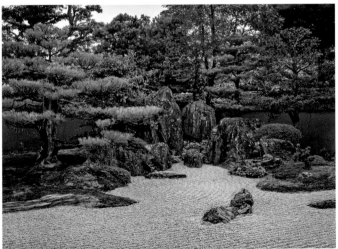

Access—Bus to Daitokuji-mae, 8 mins walk. Always open, free. (075) 491-0019 (zen.rinnou.net/head_ temples/07daitoku.html). Daisen-in 9.00–17.00, ¥400. (075) 491-8346 (b-model.net/daisen-in/syokai.htm).

MYOSHIN-JI MONASTERY
A Walled Compound with a Medieval Atmosphere

LEFT The temple complex offers an opportunity to enjoy a green tea set, here served with chestnut confectionery signaling an autumnal visit.

BELOW The Taizo-in subtemple has a pair of yin-yang gardens, the former having darker sand to denote night-time, shadows and the waning moon.

With over 3,400 branch temples, Myoshin-ji can claim to be the largest of Kyoto's seven Zen monasteries. It is also the most atmospheric, with its walled compound and winding lanes. Founded in 1342, it was destroyed in the Onin War, then rebuilt. Though much of the temple is closed to visitors, guided tours allow access to three of the buildings.

The Abbot's Quarters house an Amida statue over 1,000 years old together with Chinese ink paintings by 17th-century artist Kano Tanyu. The Lecture Hall, which holds 1,000 people, is supported by 18 massive pillars and holds Japan's oldest bell, dating back to 698. On the ceiling is a dragon by Kano Tanyu, the eye of which follows the observer around the room. The tour finishes with a visit to the communal steam bath, in use from 1656 to 1927.

There are two subtemples of note. Shunko-in has a deputy head priest, Kawakami Takafumi, who studied in America and has built up an international reputation for his work with mindfulness. Reservations can be made through the Shunko-in website for English-language talks, *zazen* meditation or overnight accommodation. (The subtemple is not normally open to the public.)

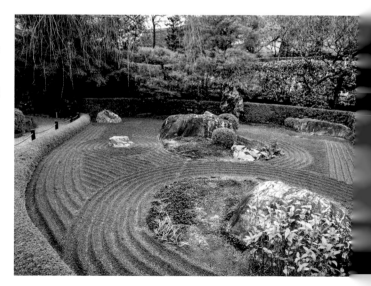

RIGHT The stroll garden of Taizo-in, created in 1956, evokes a mountain landscape with its carp pond fed by a waterfall in wooded surrounds.

BELOW Pathways are divided by formality into *shin-gyo-so,* with the formal shin style using regular square stone pieces with clear straight lines.

Access—5 mins walk from JR Hanazono stn or bus to Myoshinji-mae. Guided tours 9.00–16.00, ¥500. (075) 463-3121 (myoshinji.or.jp/english). Taizo-in 9.00–17.00, ¥500, green tea ¥500 (taizoin.com/en/). Shunko-in reservations (shunkoin.com).

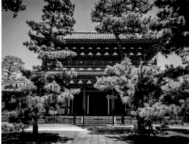

ABOVE The two-story Sanmon Gate was restored in 1599 but still retains the arrow holes used during the earlier Onin War.

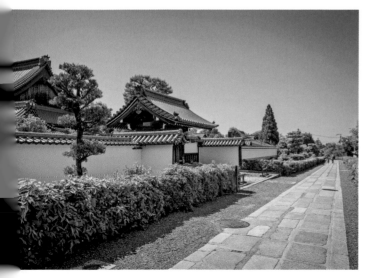

Nearby Taizo-in, founded in 1404, has an exceptional stroll garden, the approach to which leads through a yin-yang arrangement of white sand to one side and dark to the other. It suggests entry into a different dimension, and beyond is an enchanted world of waterfall, stream and landscaped grounds that flow towards a bower for rest and contemplation. The sub-temple's prized possession is the enigmatic Chinese ink painting by Josetsu, titled "Catching a Catfish with a Gourd" (1413).

KITANO TENMANGU SHRINE
A Shrine for One of Japan's Most Popular Deities

In 903, a statesman named Sugawara no Michizane died in exile. He had been falsely punished, and when a series of disasters hit the imperial palace, blame was ascribed to his angry spirit. To placate it, Michizane was awarded a posthumous pardon and deified at Kitano as the *kami* Tenjin. Today there are some 30,000 branch shrines, making him one of the most popular deities in Japan.

Tenjin shrines always feature three things: plum trees, prayers for exam success and statues of oxen. Michizane was fond of plum trees, as his poetry attests, and one of his trees supposedly flew into exile with him. As he was also a scholar, the kami is regarded as

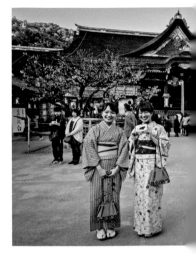

RIGHT Priests prepare for the Nagoshi no Harae Summer Purification in late June, which cleanses participants of the previous half-year's "pollution."

BELOW Wooden prayer tablets called *ema* carry a picture of an ox, thought to be the animal messenger of the shrine's deity, Tenjin.

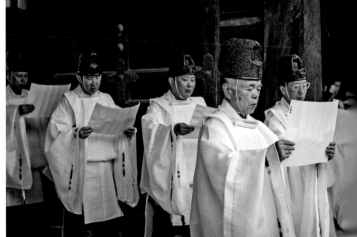

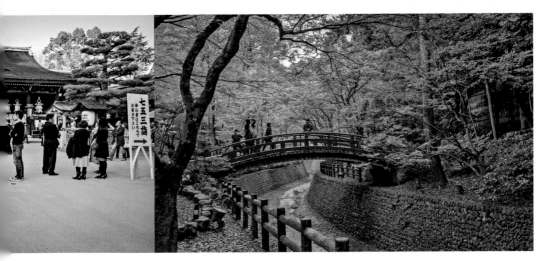

the patron deity of learning, and prayer plaques to pass exams are hung up in their hundreds.

The association with oxen comes from a legend concerning Michizane's funeral. The ox pulling his cart suddenly refused to move, as if to indicate the place of burial. That is why the animal is considered to be his messenger, and at Kitano, as elsewhere, statues of oxen are rubbed by worshippers for good health.

The shrine buildings are in the extravagant style of the Momoyama Age, typified by the magnificent, ornately carved two-story

entrance gate. There is a plum grove of 2,000 trees where every spring on February 25, the day of Michizane's death, a festival is held with *maiko* from the nearby geisha district serving tea under the blossom. In Michizane's time, the worst fate possible was to be exiled from the glittering capital. The elegant beauty of this event illustrates why.

ABOVE LEFT The Worship Hall exemplifies the exuberant Momoyama style of the late 16th century.

ABOVE The wooded area in the small valley alongside the Kamiya River contains some 250 maple trees.

LEFT During the Mitarashi Festival, people wade along the river with candles to offer to the shrine's deity.

Access—Bus 50 or 101 to Kitano Tenmangu-mae. Open 5.00–18.00/17.30 Oct–Mar. Free. Plum grove Feb–Mar, maple leaves Nov–Dec 9, ¥700. (075) 461-0005 (kitanotenmangu.or.jp/top_en.php).

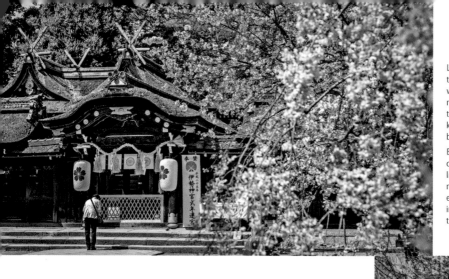

LEFT Hirano dates back to the founding of Kyoto and was one of the capital's most prestigious shrines, though now it is mainly known for its cherry blossom.

BELOW The spirit of celebration pervades the lively picnic area, where merrymakers gather to eat, drink and breathe the intoxicating fragrance of the spring blossom.

HIRANO SHRINE
Kyoto's Premier Spot for Cherry Blossom Viewing

Ask Kyoto people about cherry blossom, and they will likely think of Hirano. It is one of the oldest and most popular places for *hanami* (blossom viewing), and in the evenings the trees are illuminated and the grounds covered with happy picnickers. The sound of *gagaku* court music mixes with the merry chatter of celebrants, and photographers with extended lenses hover around blossoming branches.

Cherry trees were first feted here in 985, by order of Emperor Kazan. Previously, plum blossom had been the favored tree, as in China, but the shorter duration of the cherry won the nation's heart. The shrine now houses 500 trees of 60 different varieties. Its cherry blossom festival takes place on April 10, when the *kami* is carried to the mausoleum of Emperor Kazan, accompanied by men in warrior outfits.

The shrine originated in Nara, but was relocated to Heian-kyo when the capital was transferred. The buildings date from the 17th century. One interesting feature is a large rock located in front of a 400-year-old tree. It has a strong magnetic force, attributed to supernatural power, and people rub it in the hope of absorbing some of its energy.

ABOVE The main entrance is marked by a large *torii* gateway through which visitors flood in spring to see some of the shrine's 500 cherry trees.

LEFT Until Heian times, Japanese celebrated plum, but switched to cherry because of the greater beauty and transience.

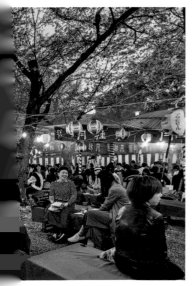

Access—bus to Kinu-gasa-ko-mae, 3 mins walk, or Keifuku train to Kitano Hakubaicho stn, 10 mins walk. 6.00–17.00. Free. (075) 461 4450 (hiranojinja.com/home/english-page).

The amulets sold here use a blossom motif, and in spring there are special red bean sweets with a sugar coating. There are charms, too, with magnetic force, like the rock. The shrine is said to be favorable to women, and has a reputation for fostering love relationships and pregnancy. The joys of spring are evidently not confined to cherry blossom viewing!

WALK TO SAGANO
A Pleasant Hillside Path through a Traditional Village

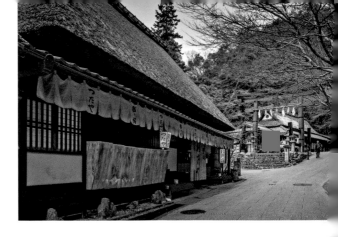

Sagano, or Saga, lies to the north of Arashiyama and is less crowded than its famous neighbor. Narrow streets and traditional buildings nestle against wooded hills. With its attractive shops and offbeat temples, it is perfect for walking or cycling (rental bikes are ¥1,000 for the day).

Saga-Toriimoto is a preserved area with a feel of Japan in the past. Latticed townhouses are set amongst thatched farmhouses. Many have been converted into restaurants, and some serve expensive *kaiseki* meals. There are two places of note. One is the small but picturesque Gio-ji Temple, with its thatched hall and carpet of moss. The other is the rustic Rakushisha hut where the poet Matsuo Basho stayed when visiting one of his followers.

The Adashino Nenbutsu-ji Temple is known for its bamboo grove and autumn foliage, but is most famous for its 8,000 statues. The temple was built on a burial site for paupers, and the statues are of Jizo, guardian of the dead. On August 23 and 24 each year, the statues are lit by candles to mark the return of ancestral spirits.

Fifteen minutes walk away is Otagi Nenbutsu-ji. It was hit by a typhoon in 1950, following which the sculptor-priest in charge decided to help worshippers carve their own *arhat* (disciple of Buddha). The result is some 1,200 statues, done mostly in the 1980s and 1990s. The faces are individualized, with humorous depictions that contrast with those at Adashino. As you head home, it will surely put a smile on your face.

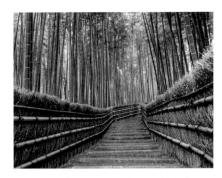

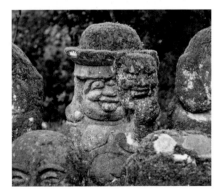

FAR LEFT The area of Saga-Toriimoto is designated a Traditional Architecture Preservation District, with famous restaurants such as Hiranoya specializing in *ayu* fish.

LEFT Traditional-style lanterns bear the name of Enmei Jizo Daibosatsu, a bodhisattva favored by farmers and peasants thought to assist those in Hell.

LEFT One of the converted *machiya* in the Preservation District, gives something of the feel of a Meiji-era merchant town.

ABOVE RIGHT The bamboo grove at Adashino Nembutsu-ji is less crowded than its more famous cousin near Tenryu-ji, enabling photographers to capture the atmosphere.

RIGHT At Otagi Nembutsu-ji are some very bizarre faces, which may appear to be purely satire but are, in fact, saintly figures known as *arhat*.

Access—JR to Saga-Arashiyama or Randen train to Arashiyama stn or City bus 28 or Kyoto bus 73, 76 to Arashiyama bus stop. Walk north away from the river. For map, see (jnto.go.jp/eng/pdf/pg/pg-503.pdf).

SAGANO TRAIN & HOZUGAWA RIVER
A Historic Railway and White Water Boats

Too many Kyoto temples? A "romantic" train ride coupled with open-air boating might be the perfect antidote. "Get away and give yourself up to the flow," says the publicity, and the three-hour round trip transports visitors into an entirely different world.

The departure point is Saga Torokko Station with its Diorama Kyoto, a curioso that exhibits miniatures of the city's famous places as well as model trains. The trip to Kameoka follows a forested ravine, and there are large windows to maximize the views. The old-fashioned carriages have wooden benches (the name of the line, Torokko, derives from "truck").

On arrival at Kameoka, a bus shuttles passengers to the river station. The flat-bottomed boats steered by men with bamboo poles take two hours to make their way along the gorge. Though the publicity plays up the white water, the rapids are mild and the

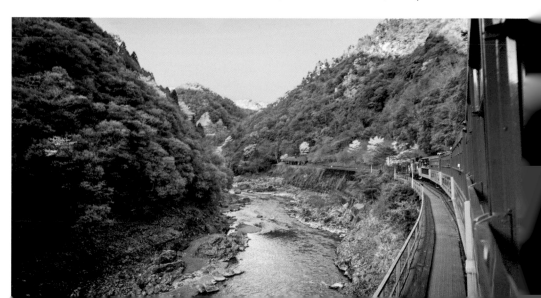

boats comfortable. In winter they are heated, and there is plastic covering should it rain.

The river was first used during the construction of Heian-kyo, when timber was sent downstream. In the Edo Period, boats transported charcoal and food items, but the introduction of trains made them obsolete. Later, they were reintroduced as a sightseeing attraction, and today they are so popular that in spring and autumn reservations should be made in advance. It is the job of the boatmen to entertain passengers, and the joke-filled commentary provokes frequent laughter. It is an enjoyable atmosphere, even if you don't understand a word.

Access—From Saga-Arashiyama stn on JR line, take the Torokko to Kameoka, 25 mins, ¥600. Bus to boat stn, ¥310. Rafting 2 hrs to Arashiyama, ¥4,100. Hourly Mar–Nov, every 90 mins in winter. (0771) 22-5846 (hozuga-wakudari.jp/en).

OPPOSITE ABOVE The Sagano Romantic Train has been running since 1991, using 19th-century narrow gauge tracks and retro carriages. (Trains don't run in January or February.)

OPPOSITE BELOW The train from Saga to Kameoka takes 25 minutes and follows the Hozugawa River, at one point slowing down so that passengers can admire a ravine.

BELOW LEFT At Kameoka, a shuttle bus connects the train station with the embarkation point for boats, which ferry passengers back to Kyoto.

BELOW In summer, the river breeze is pleasant, and when it turns cold in autumn the boats are heated. They can also operate in light rain using a plastic sheet covering.

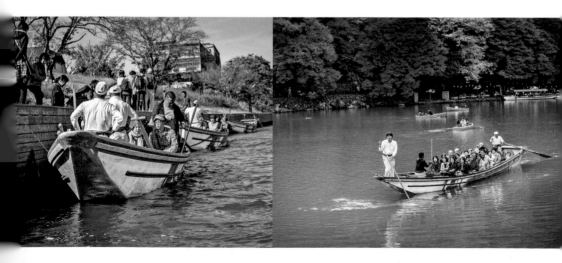

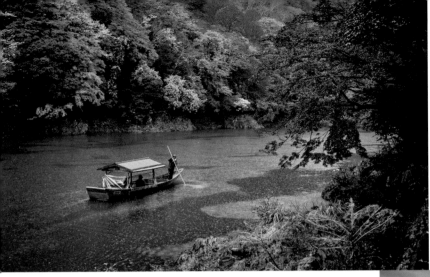

LEFT For those looking to escape the crowds, boating on the Katsura River offers a pleasant diversion and is a favorite with children (¥1,400 per hour).

BELOW The 508 ft (155 m) long Togetsukyo Bridge spanning the Katsura River, has been Arashiyama's iconic image for over 400 years. It is also a popular place for feeding carp or watching cormorant fishing in summer.

ARASHIYAMA
A Riverside District for Leisure and Sightseeing

Aristocrats once came here on outings to enjoy the beautiful surrounds. They boated on the Katsura River while watching dance and listening to music. They wrote poems about moon viewing. Something of these Heian-era refinements can be seen in May every year in the colorful Mifune Festival.

These days, Arashiyama is filled with crowds of pleasure seekers, and there are activities for everyone. The main street is lined with shops of all kinds, from delicacies and nibbles to souvenirs and restaurants. For families with children, there are boats for hire and rental cycles. Next to the river is Iwatayama, a small hill with about 120 monkeys roaming free in an open compound.

At the heart of the district is a bridge: Togetsukyo, the Moon

Crossing Bridge. Originally built in Heian times, it was last reconstructed in the 1930s. To its north is the charming Nonomiya Shrine, of historical interest since it is mentioned in the world's oldest novel, *The Tale of Genji* (c.1005). Nearby is what many consider the area's highlight: a bamboo grove.

Arashiyama's bamboo is particularly popular with photographers. The improbably tall trunks sway like a troupe of dancers, and

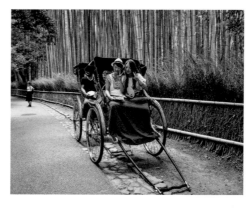

LEFT Jinrikisha are hand-pulled carts first introduced after 1868 and used till the 1920s. Now they are pulled by young men, often students, who act as guides (20 mins, ¥4,000).

BELOW On Iwateyama Hill are 120 snow monkeys, aka Japanese macaque, which roam relatively free. Have fun interacting but don't look them in the eye for they seem tame but remain wild.

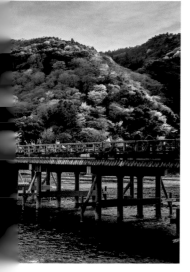

though bamboo is known for its sturdiness and flexibility, here one is most aware of its beauty. Two of Arashiyama's major sights lie nearby, one the delightful Okochi Sanso Villa (p. 194) and the other the Zen monastery of Tenryu-ji (p. 192). There is much more, but if you can fit all that in, you will have a good idea of what makes this corner of Kyoto so popular.

Access—JR train to Saga Arashiyama or Randen line to Arashiyama. Bus to Keifuku Arashiyama. Monkey Park 9.00–17.00/16.30 winter, ¥550. Nonomiya Shrine 9.00–17.00, free.

TENRYU-JI MONASTERY
A Zen Temple with a Celebrated Garden

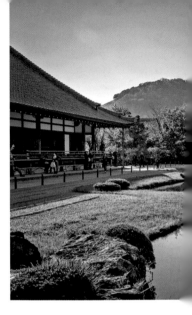

It is spacious, it has cherry and maple trees, and it is a Unesco World Heritage site. It also has a restaurant serving high-end Zen food. Located in the midst of popular Arashiyama, Tenryu-ji is not short of visitors, but such are the dimensions that it can cope with the crowds.

Founded in 1339, Tenryu-ji was set up by Shogun Ashikaga Takauji to appease the spirit of the man he betrayed, Emperor Go-Daigo. Subtemples line the approach, their open gates allowing sight of the immaculate front gardens. In the middle lies a Lotus Pond, which draws admirers in July when the flowers bloom (a symbol of enlightenment). The Lecture Hall (Hatto) is a 1900 reconstruction, with a ceiling dragon among swirling clouds and a statue of Shakyamuni, the Japanese name for the historical Buddha.

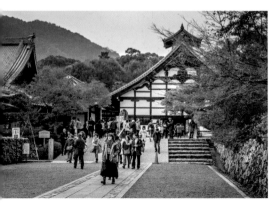

LEFT The entrance to Tenryu-ji, with its two principal buildings, the Hondo (Main Hall, with object of worship) and the Hojo (Abbot's Quarters, with pond garden).

Pride of place belongs to the Sogenchi Pond in the shape of the Chinese character *kokoro*, or "enlightened heart," sole survivor from the original temple. It was designed to be viewed from the veranda of the Abbot's Quarters, and is laid out like a 3D composition. Waterfall, peninsula and rocky coastline combine to represent a seascape, behind which is the first known use of "borrowed scenery." This involves incorporating the background hills into the garden by use of a layering effect.

Access—JR train to Saga-Arashiyama or Randen line to Arashiyama or bus to Keifuku Arashiyama, then 5–10 mins walk. Open 8.30–17.30, ¥500/600. Zazen second Sun 9.00–22.00. (075) 881-1235 (tenryuji.com).

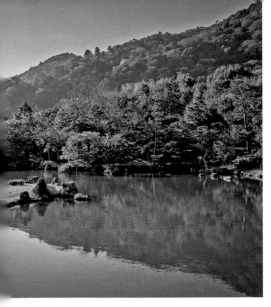

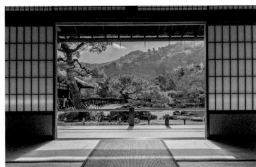

ABOVE The famous Sogenchi Garden, laid out by temple founder Muso Soseki (1275–1351), leads the eye up towards the hills behind in the earliest example of "borrowed scenery."

On the far side of the pond, a stroll path leads past shrubbery carefully positioned to obscure views of the pond and focus the mind on the flora. For the designer, Muso Soseki, first abbot of the temple, the garden was a vital means of realizing one's Buddha nature. Through contemplation lay the way to salvation.

ABOVE RIGHT The World Heritage garden was deliberately designed as a kind of 3D composition, and the open sliding screens of the Abbot's Quarters create a perfect picture frame.

RIGHT In the center of this aerial shot can be seen the Abbot's Quarters and pond, next to which is a wooded incline with stroll path.

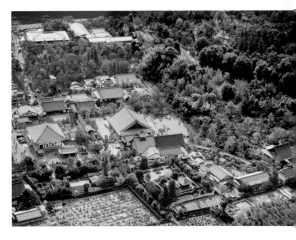

OKOCHI SANSO VILLA
A Film Star's Stylish Retreat

RIGHT The villa is relatively free of the crowds elsewhere, such that the beauty of the architecture can be admired at leisure.

Kyoto was once "the Hollywood of Japan," with studios and film stars concentrated in the Uzumasa district. At its peak in the 1930s, over 500 films a year were produced. One of the top stars was Okochi Denjiro (1898–1962), who made his name acting a samurai with scarred eye and missing arm. His fame brought him wealth and he spent it on a retreat into which he poured his money—and soul.

As a Buddhist, Okochi wanted his villa to reflect the importance of learning from nature. The loca-

tion was carefully chosen on the ridge of a hill, with views on one side over the Hozugawa Gorge and on the other towards holy Mount Hiei. Here, he built a house that utilized traditional styles. No film ostentation, but a pleasing simplicity and naturalness.

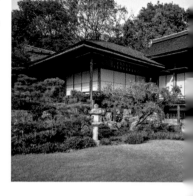

BELOW The estate is notable for its elegant use of tradition, here exemplified by a Middle Gate framing a stone path that leads to a world unseen.

Access—15 mins from Keifuku Arashiyama stn through the bamboo grove. Open 9.00–17.00, ¥1,000 (includes matcha tea set). (075) 872-2233 (insidekyoto.com/okochi-sanso-villa-arashiyama).

The core of the estate is the inner garden, to which a "middle gate" allows access. The winding path leads from one feature to another, from rustic tea house to viewpoint, and then on to a small Buddhist shrine. The immaculate shrubbery and "borrowed scenery" speak to the best of Japanese gardening arts.

Okochi spent 30 years finalizing the details of his estate. He was concerned to highlight the annual round through flowers and shrubbery that bloom in each season. Following his death, the grounds were opened to the public and an open-air museum built to show-case his career. The high entrance fee deters most visitors, but it means relative peace in which to drink the complimentary *matcha* tea set while enjoying the surrounds: a film star's home with a touch of Zen.

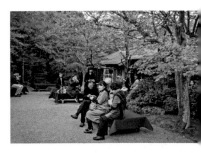

TENZAN NO YU HOT SPRING BATHS
A Genuine Onsen at a Reasonable Price

Hot water soaking has long been a Japanese indulgence, and it comes in two forms: a public bath (*sento*) or a hot spring (*onsen*). The latter, being full of minerals, is considered better for the health. Tenzan no Yu, a short distance from Arashiyama, has water rich in calcium and sodium, good for removing impurities and softening the skin.

Over the centuries, many famous hot spring resorts have been set up, but they can be expensive and involve an overnight stay. Tenzan no Yu offers Kyoto visitors an accessible alternative. The water bubbles up under its own power from 4,000 ft (1,200 m) below ground, and as well as large baths there are jet massages, footbaths and outdoor tubs. For an extra fee, Korean rubs are available.

House rules state no tattoos (worn by *yakuza*), no photos, no mobiles and no swimsuits in the bathing area. After putting your shoes in a locker, hand the key to the receptionist in order to get a numbered key for the changing

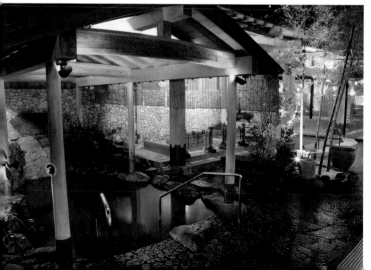

room. Take the small "modesty towel" to wash with in the shower. Etiquette dictates that you keep the towel with you, but refrain from immersing it in the bath water; either leave it on the side or arrange it on your head.

After bathing, head for the Japanese-style dining area where there are meals and drinks at a reasonable rate. By the end of the visit, the strains and stresses of tourism will have melted away, and you will understand why the Japanese are so addicted to their indulgent long soaks.

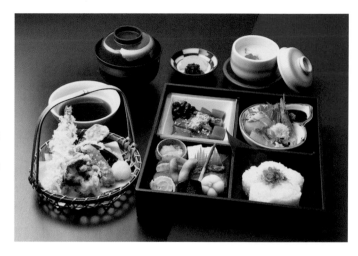

OPPOSITE ABOVE On the way to the pools, there is a footbath with ticklish little fish that nibble away dead skin.

ABOVE The restaurant offers wholesome set meals of Japanese food at very reasonable prices.

FAR LEFT Amongst the different baths is one with an open roof, giving the feel of an outdoor pool known as *rotenburo*.

LEFT The entrance to the *onsen* has attractive clean lines and subdued lighting.

ABOVE Amongst other services are massages, Korean body scrub, esthetics and carbonated spring bathing.

Access—Randen line to Arisugawa, 5 mins walk (past a convenience store, turn right and 100 m on the left). 22.00–1.00, ¥1,050. Rental towel set, ¥200; take own for free (one big, one small). (075) 882-4126 (ndg.jp/tenzan/en/).

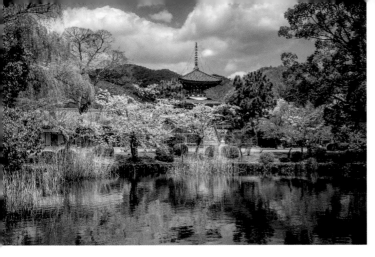

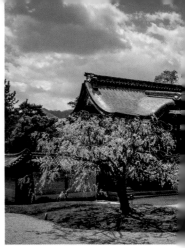

DAIKAKU·JI TEMPLE
A Royal Villa Dating from the Heian Period

ABOVE LEFT The two-tiered pavilion is a modern addition but integrates perfectly into the picturesque scene.

The aristocrats of the Heian Era enjoyed refined leisure pursuits. These included poetry writing, full moon viewing, outings to nature, listening to insect song and cultivating sensitivity to incense. To this end they built exquisite estates, with ponds on which to go boating and gardens that were idealized miniatures of landscape scenes.

Daikaku-ji is a rare survivor from those times. It was originally built in the early 800s as a villa for Emperor Saga, son of Kyoto's founder. He took a keen interest in the arts, more than in governance. He even initiated a school of *ikebana* still in existence today (Soga Goryu), when he made an arrangement of chrysanthemums which had bloomed on an island in the garden pond.

Thirty years after Saga's death, the villa was converted into a Shingon temple. It kept its imperial connections, and the architecture preserves the aristocratic *shinden* style. Elevated walkways run between wooden buildings, some of which were relocated here from the imperial estate. The *fusuma* sliding doors were painted by members of the illustrious Kano School, and the English audio guide gives a full description.

The centerpiece of the garden was the Osawa Pond, used for fishing and moon viewing. The two-tiered pagoda, a modern addition, is a photographer's dream, with its reflection shimmering in the water. Because of its relatively remote

ABOVE The temple still retains the elegance of the aristocratic estate with which it originated in the 9th century.

RIGHT Daikaku-ji is made up of several connected buildings, and featured here is the entrance to the 8th (there is a useful audio guide for ¥500, 40 mins).

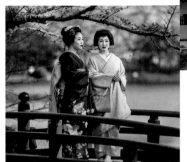

LEFT Osawa Pond, with its gracefully arched bridge, was once used for boating, especially for moon viewing and winter snow parties.

BELOW Sliding screen paintings give an opulent feel with their gold background, featuring nature scenes from the four seasons.

location, the temple is not as crowded as elsewhere, even at peak times, and with its air of refinement it calls for leisurely engagement. Immerse yourself in appreciation of nature here, and it is as if the Heian times never left.

Access—15 mins walk from JR Saga-Arashiyama stn or 25 mins north of Keifuku Arashiyama stn. 9.00–17.00, ¥500. (075) 871-0071 (daikaku.or.jp/english).

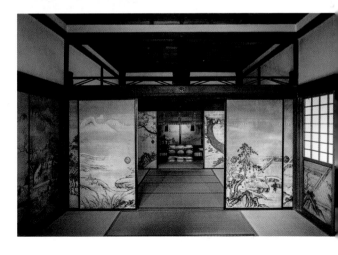

TOEI FILM STUDIO
A Movie Set Theme Park

In 1897, a businessman named Inabata Katsutaro used a Lumiere machine to project a film, and thereby Kyoto became the birthplace of Japanese cinema. It was Kyoto, too, that fostered Japan's equivalent of the Western: the *jidaigeki* (period drama). It made the city "the Japanese Hollywood," and Kurosawa's masterpiece *Rashomon* (1950) was filmed here. Contemporary films were left to Tokyo, where film making has now concentrated.

Toei is the great survivor from Kyoto's Golden Age. Its studio, built in 1975, features Edo Period streets and is used for historical movies and television programs. There is a retro feel to the park, with none of the glamor of Universal or Disneyland, though in recent years the studio has upgraded and added to its attractions.

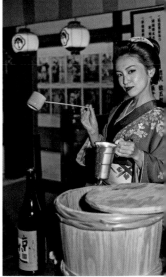

Depending on scheduling, there is the possibility of seeing a movie being shot, but if not there are plenty of alternatives: an Edo-style street performance, a Trick Art Museum, a show of super-heroes, a 3D theater and a rental costume shop for samurai, ninja, or geisha. There is even a demonstration of *seppuku*!

For those who want some action themselves, there is a "samurai experience" where, for a fee, you can try your hand against professionals. In recent years, ninja have soared to popularity, and there is a Mystery House where, after a talk on ninja tricks, visitors are invited to escape from the building. A Ninja Training Dojo offers such activities as walking on logs, climbing castle walls or descending from roofs. By the time you leave, you may have acquired a new set of skills.

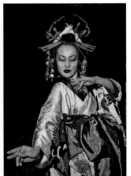

FAR LEFT Ninja have been mythologized as secret assassins in recent years, but for samurai they were furtive mercenaries lacking honor and openness.

LEFT Glamorous courtesans known as *oiran* were skilled entertainers who tied their *obi* at the front, the sooner to undo them, it was said.

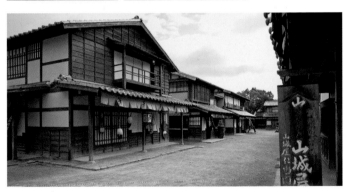

FAR LEFT Visitors to the Studio Park get to see a sword fight in historical costume between a samurai hero and "a baddie."

LEFT One of the costumed staff members pours saké during a special evening event.

ABOVE The studio set evokes the atmosphere of Japan in the Edo Period, when townhouses and lifestyles were strictly regulated.

Access—5 mins from Uzumasa-Koryuji on Keifuku line. Bus to Eigamura-mae or Koryu-ji mae. Open 9.30–16.30, ¥2,200, children ¥1,000. Tel 0570 064 349 (toei-eigamura.com/en/). Samurai experience, see (samurai-do-toei.com).

ABOVE The upper garden overlooking the pond consists of a dry landscape representing a waterfall and mountain stream.

SAIHO-JI MOSS GARDEN
A Zen Temple with Gorgeous Grounds

ABOVE The pond garden was laid out by Zen abbot Muso Soseki (1275–1351), with the moss probably a later development.

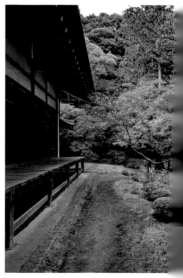

With its high humidity, Kyoto has fertile soil for moss. It makes an attractive addition to the city's gardens, though nowhere as strikingly as at Saiho-ji, which is known familiarly as Kokedera (Moss Temple). It is also one of Unesco's World Heritage sites. Admission is designed to limit numbers and protect the delicate plants, but by general agreement the experience is well worth the extra effort involved.

Visits provide a rare opportunity to experience a Zen atmosphere. In the Main Hall visitors are invited to trace out the Heart Sutra, a form of spiritual exercise. This is accompanied by chanting from the father and son priests who run the temple. Afterwards, visitors are free to enter the grounds.

The estate was laid out in 1339 by the abbot of Tenryu-ji, Muso Soseki, who conceived a pond

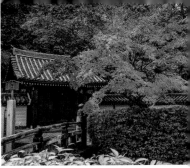

ABOVE The moss garden is perfectly suited to the stepping stone style of footpath known as *tobiishi*, which here leads to a secluded tea room.

LEFT Autumn colors reach out across the garden path towards the Kannon Hall.

ABOVE RIGHT The limited number of visitors, together with the temple ritual, helps deepen appreciation of nature.

Access—Matsuo Taisha stn on Hankyu Arashiyama line, then 20 mins walk, or city bus to Kokedera michi. Reservation in advance, ¥3,000, 90 mins visit. (saihoji-kokedera. com/en/about.html).

garden overlooked by an upper dry landscape. There are said to be 120 different kinds of moss, which in their variegated greens lie like a carpet over the undulating surrounds of the pond. Streams add the sound of running water, and a protective canopy provided by trees gives shelter from direct sunlight.

In the upper garden, a dry waterfall represented by rocks lies next to a tea house. There is also a Meditation Rock, where Soseki would sit. Interestingly, credit for the garden may not be entirely his, for it is thought that the pond surrounds were originally covered with white sand, and that only when flooding occurred in the 19th century did the moss take over. Man and nature thus happily combined in creation of a masterpiece.

KATSURA IMPERIAL VILLA
A Masterpiece of Japanese Garden Arts

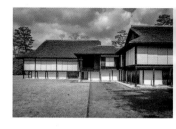

Experts rate the Katsura estate as the finest in Japan. Not only is the stroll garden a masterpiece, but the buildings exemplify the highest standards of Japanese craftsmanship. House and garden here combine in perfect union. They were conceived by Prince Toshihito (1571–1629), who wanted an estate in which to entertain his artist friends.

The main feature is a pond garden with a "conceal and reveal" technique, whereby views are withheld until a twist in the path opens up an unexpected vantage point. At the start, strategically planted trees and shrubbery obscure an overview of the pond, but later there comes clear sight of the elaborate shoreline, the connecting bridges and the references to famous literary scenes.

As a practitioner of tea, Toshihito was fond of *wabi-sabi* aesthetics and introduced rustic elements into the garden, such as water basins and stone lanterns. There are four tea houses in all, each with its own special character. One is set on an incline as if a mountain retreat, while another seems to float on the water.

The main buildings, completed by Toshihito's son, are simple in appearance but sophisticated in detail, exemplified by doorbells shaped as flowers. There is even

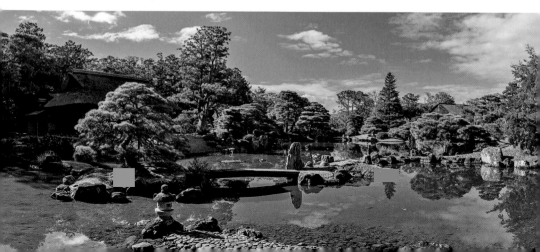

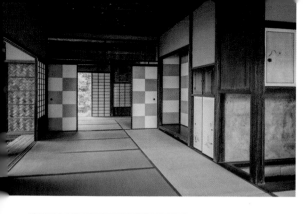

a set of shelves with 18 different kinds of wood. Such was the delight of Toshihito's son in the estate that he largely refrained from going, so as not to dull the pleasure. Each visit gave him a sense of Paradise Regained, and if you visit you will understand his feelings.

Access—Katsura stn on Hankyu Arashiyama line, walk 15 mins, or bus 33 to Katsura Rikyu-mae. Apply online in advance or first come first served on the day, ¥1,000. Closed Mondays. (sankan.kunaicho.go.jp/english/guide/katsura.html).

OPPOSITE ABOVE The estate buildings are in the *shoin* style and comprise four staggered structures which are interconnected.

BELOW LEFT Katsura has one of the earliest examples of a stroll garden, in which the visitor is directed around a pond to enjoy different views.

ABOVE The interior of the buildings exemplifies the very finest craftsmanship which the Japanese tradition has to offer.

BELOW Picture postcard scenes occur throughout the estate, such as this view of a rustic tea house.

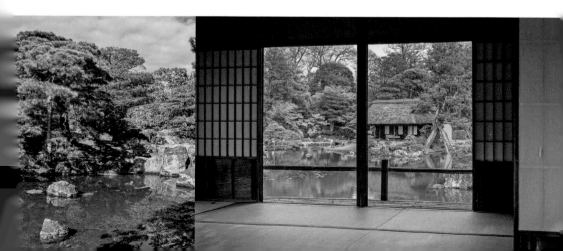

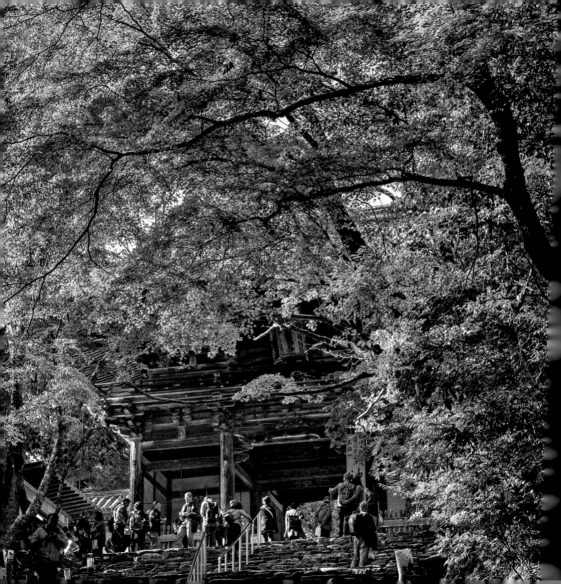

Excursions Around Kyoto

There is so much to see in Kyoto that many people never make it beyond the city confines. This is a pity because the peripheral areas are part of Kyoto's charm. Half an hour by local bus can take you into another world, free of crowds and full of woods and hillside streams. Because the city huddles up against its eastern, northern and western hills, there is a strong sense of *rus in urbe* (countryside in town). Arashiyama and Daimonji are examples, at opposite ends of the city.

To escape the heavy air of downtown Kyoto is therefore not at all difficult, and in this section are opportunities for something

LEFT Takao in Kyoto's northwest is popular for outings, with Jingo-ji offering a gateway to the rural atmosphere and spectacular views.

ABOVE RIGHT Mount Hiei hosts more than a temple, rather a whole complex of historical sites and buildings.

different. It begins appropriately enough with the shrine of Fushimi Inari, now Kyoto's no 1 tourist spot, and by some accounts no. 1 in Japan. It offers the city's most magical portal, giving access to a hillside world of *torii* tunnels and fox statues. Continue up the hill, and as the air thins the crowds thin, too. Continue further, and you will find yourself all alone on the back of the hill. Such is the appeal of these outlying sites.

Those in search of some serious hiking need look no further than Mount Hiei, with its spectacular views over Lake Biwa. There are several routes up the mountain, which take from an hour and a half to three hours depending on the starting point. Alternatively, a shorter 50-minute hike at Daigo takes one through wooded surrounds, from the lower to the upper parts of an ancient temple.

For residents of Kyoto, the hillside walk from Kurama to Kibune is a favorite excursion, not too rigorous but challenging enough to feel you have done some exercise. It begins and ends in a couple of attractive villages. Another favored village is Ohara, a little further north, which is notable for supplying wholesome *kyo-yasai* (distinctive Kyoto vegetables).

To the south of the city lies the shrine of Jonan-gu, famous for its

gardens. Beyond it is the open plain through which rivers flow to Osaka and the sea. It is a reminder of the geomancy with which Kyoto was first conceived by Emperor Kammu and his advisors. For the nobility of Heian-kyo, the outlying areas were distant entities which demanded long expeditions and careful planning. A thousand years later, ease of access may have lessened the mystique but they still remain reinvigorating spots for Kyoto citizens. The immersion in nature, the higher ground, the sense of getting away from it all, here in this section are opportunities to take a break from the city crowds.

BELOW Kibune has an attractive hillside shrine, the stone steps to which are lined with lanterns.

BOTTOM LEFT Fushimi is known for its production of saké, and the area offers abundant opportunities to sample local brands.

ABOVE The hillside behind Fushimi Inari is covered with fox statues. Inari is a rice god, and the liminal fox appearing at dusk was thought to flit between this world and the unknown. Now, the animal serves as mediator between humans and Inari.

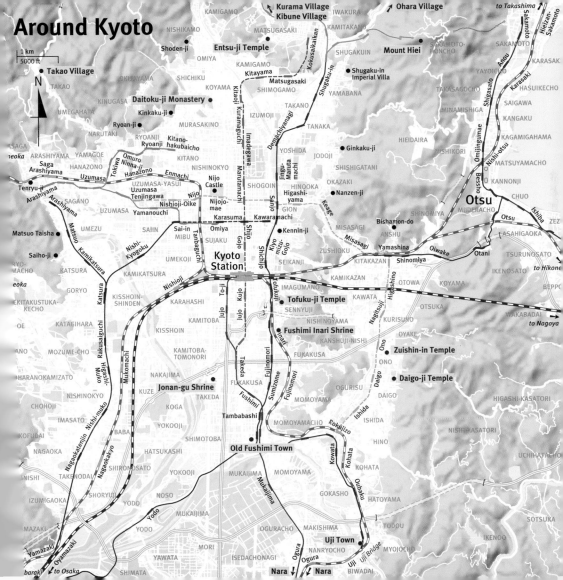

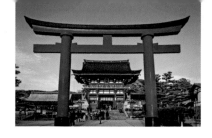

FUSHIMI INARI SHRINE
A Hillside Covered in 10,000 Torii Gates

Fushimi Inari Shrine was founded even before the city of Kyoto came into being. It combines spirituality with a Disneyland quality, and it is Kyoto's no. 1 tourist destination, mostly due to its 10,000 spectacular *torii*. Despite the crowds, it does not disappoint. It is simply magical.

Fushimi is the name of the area, Inari is a *kami* of rice. The two came together in 711 when a member of the immigrant Hata clan had a mystical experience and established a shrine backing onto the Eastern Hills. Etiquette requires paying respects at the Worship Hall before heading up

the sacred hill. The torii tunnel, popular with photographers, represents passage into a spiritual dimension, and the return symbolizes rebirth, thanks to the restorative power of nature.

Since rice was formerly used as currency, Inari became seen as a kami of business. It is therefore

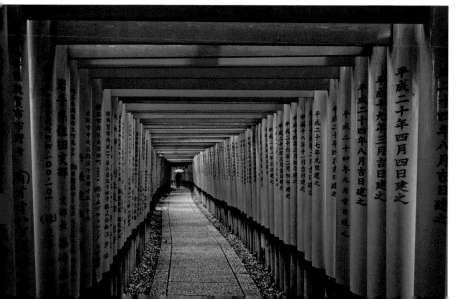

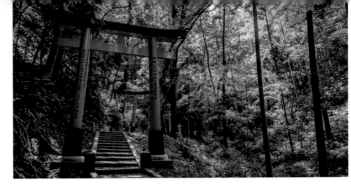

patronized by companies, which donate the colorful red torii covering the hillside. As for the fox statues, in Shinto kami are served by animal messengers, and since foxes are liminal creatures that flit between rice field and woodland, they were seen as mediating between this world and the other.

OPPOSITE BELOW The famous *torii* tunnel leading up the hillside presents a symbolic passageway into a spiritual domain.

BELOW CENTER The tunnel of torii winds its way up the hillside, each wooden torii sponsored by a company in the Kansai region.

ABOVE As one ascends the hill, the number of torii becomes fewer, as does the number of people.

BELOW Priests carry out rituals throughout the year, including a fire ceremony when prayers are sent up to heaven.

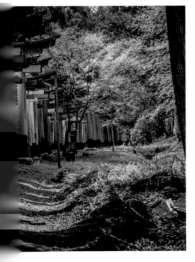

Those who reach the top of the hill will find that along the way there are countless altars, which were erected after individual visions of Inari by devotees. There are also traditional stores selling noodles and religious items. There is a viewing point over the southern side of Kyoto, a waterfall for cold water austerities and a spiritual wonderland of shrines and statues. With its many fox statues, the hill combines a strong sense of the sacred with the playful. There is magic in the air and that is why Fushimi Inari is Kyoto's no. 1.

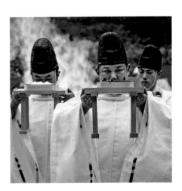

Access—Fushimi Inari stn on the Keihan line. Open all day, free. (075) 641-7331 (inari.jp/en/).

OLD FUSHIMI TOWN
A Preserved District and the Home of Saké

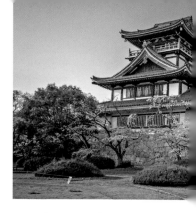

There is a sense of times past about the back streets of Fushimi. The historic district is noted for the purity of its water, and the confluence of rivers means that in former times it was a major locus of water transport between Kyoto and Osaka. The ease of movement is why strongman Hideyoshi built a retirement castle here on the hill of Momoyama.

Nowadays, the boats serve tourists, and the flat-bottomed *jikkokubune* carry passengers down to a small harbor, where there is a museum with pictures of Fushimi in the past. Willows and cherry trees line the banks, which means high demand in spring for the 50-minute tours.

Throughout Fushimi are underground wells, and this, together with access to top-quality rice, meant that in the past saké breweries were concentrated here (80 at the peak, these days around 20). One of the most famous is Gekkeikan, which has a museum with over 6,000 artefacts tracing its history and the saké process. Fushimi saké is the perfect complement to Kyoto food, and the Kizakura brewery offers a restaurant as well as an entertaining exhibition of *kappa*, a mythical water-based creature.

Those with an interest in history will head for Teradaya, an inn famous for its association

LEFT The Fushimi area is full of saké shops offering a wide range of options. The brand of rice, water quality, production technique and type of yeast can all affect the final taste.

RIGHT Sakamoto Ryoma, one of the most popular figures in Japanese history, made a famous escape over the rooftops from Teradaya Inn, which still cherishes his memory.

FAR LEFT Fushimi-Momoyama castle, built in the 1590s, was destroyed in 1600 and reconstructed in concrete in 1964 as part of an entertainment park.

LEFT The Gekkeikan saké company has been going for 318 years, run by the same family for 14 generations.

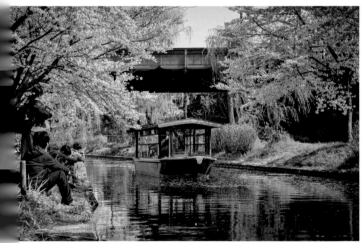

ABOVE Barrels of saké by Fushimi's Kizakura company, founded in 1925, which runs the intriguing Kappa Country restaurant.

LEFT Flat-bottomed canal boats called *jikkokubune* once ferried rice and saké to the river junction for delivery to Kyoto or Osaka.

Access—Keihan line to Chusho-jima or Fushimi-Momoyama. Boat cruise, ¥1,000. Gekkeikan Museum 9.30–16.00, ¥300. Teradaya Inn 10.00–16.00, ¥400. For a saké guide to Fushimi, see (fushimi.or.jp/sake_guide/).

with Meiji Restoration hero Sakamoto Ryoma. He stayed there in 1866 and escaped over the rooftops after being warned by a servant girl that shogunate assassins were about to kill him. Later, he married the servant and the pair ran off to Kyushu where they are said to have enjoyed Japan's first ever honeymoon.

TOFUKU·JI MONASTERY
Modern Zen Gardens and a Maple-studded Gorge

BELOW The Southern Garden of the Abbot's Quarters was created by Shigemori Mirei in 1939 to represent the sacred Horai Isles of the Immortals.

Founded in 1236, Tofuku-ji is one of Kyoto's earliest and largest Zen monasteries. It is set in attractive grounds against the Eastern Hills. There is still a medieval feel about the compound, which is famous for two features: a gorge filled with 2,000 maples and a 20th-century garden.

The temple layout is in classic Zen style, with the main structures set along a central axis. The buildings are mostly modern reconstructions, following a devastating fire in 1881. The Sanmon ceremonial gate is the largest of its kind, next to which is a "100 man toilet," with perfectly aligned circular openings in padded earth. On the other side are washrooms that once catered for up to 340 monks, using a sauna system.

The Founder's Hall, which requires a fee to enter, is accessed by a roofed bridge over a ravine. In autumn, the gorge is heaving

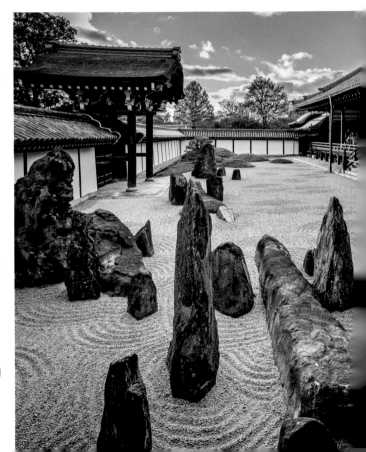

LEFT The Founder's Hall has a busy garden of shrubbery and rocks arranged on a slope, at the base of which is a pond spanned by bridges.

BELOW The Northern Garden of the Abbot's Quarters is laid out in squares, which taper off as they approach a bush-lined ravine.

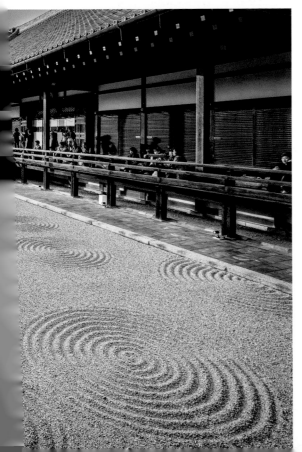

with people drawn by its maples. For garden lovers, however, it is the Abbot's Quarters on which attention is focused, for the building is surrounded by the celebrated four-part Hasso Garden by Shigemori Mirei. It is said to have catapulted Zen garden design into the modern age.

The Southern Garden has rocks representing the Isles of the Immortals and, unconventionally, mossy mounds symbolizing the top five Gozan zen temples. The

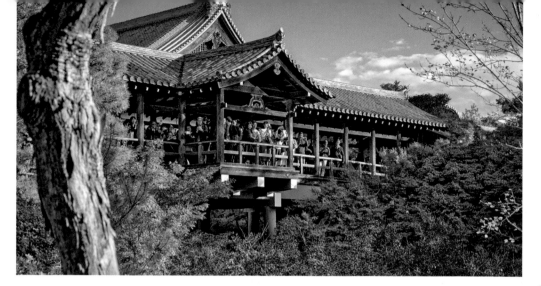

ABOVE The Tsuten Bridge has a viewing gallery, which offers a panorama over the 2,000 maples in the ravine below.

Western Garden has raked gravel in squares, not normally used in Zen, while the Northern Garden has a checkered pattern that uniquely fades into the distance. The Eastern Garden recycles old pillars in innovative fashion to represent the Big Dipper, sacred in Daoism. In this way, myth and modernity combine to smash through the constrictions of traditional design.

BOTTOM LEFT When the maples in the Sengyokukan ravine reach their peak in autumn the grounds are tightly packed with eager sightseers.

BELOW Raking the gravel into precise forms requires practice and a lot of patience.

BELOW The Zendo Hall for meditation is an enormous affair, able to accommodate up to 400 monks, which makes it the largest as well as the oldest in Japan.

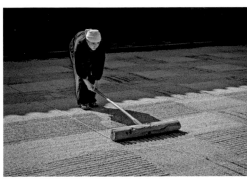

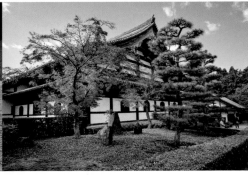

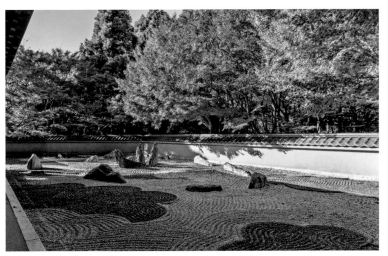

LEFT At the subtemple of Ryogin-an is a dry landscape by Shigemori Mirei, representing a coiled dragon half covered in cloud. The three rocks at the back indicate the dragon's head.

Access—Keihan line to Tofuku-ji stn, 10 mins walk. Open 9.00–15.30, Founder's Hall, ¥400. Abbot's Hall, ¥400. (075) 561-0087 (tofukuji.jp/english).

DAIGO-JI TEMPLE
A World Heritage Site with Kyoto's Oldest Pagoda

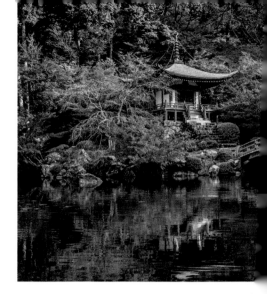

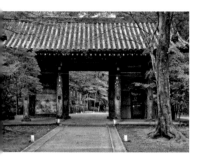

LEFT The Niomon entrance gate, with its welcoming lights, beckons the visitor into a world of spectacular autumn colors.

RIGHT The Benten Pond, with its maple tree surrounds, is one of the most picturesque spots in all of Kyoto.

Daigo-ji has an outstanding garden, a picturesque pond, a villa of exquisite arts and Kyoto's oldest standing pagoda. There is an impressive museum, too. What's more, a 50-minute hike uphill leads to a set of wooden buildings with the austere atmosphere of mountain asceticism. It was here that this Shingon temple was founded in 874.

The magnificent buildings of Lower Daigo derive from the patronage of the 16th-century ruler Toyotomi Hideyoshi. The showpiece is Sambo-in, not so much a subtemple as an upper-class villa. There are top quality paintings, a Noh stage and tea houses. The much praised garden has an opulent feel, with three islands, several bridges, a dry landscape and a staggering array of 700 rocks.

The temple has special connections with cherry blossom because of a grand public outing that Hideyoshi made in 1598. It is also popular in autumn when the picturesque Benten Pond is ablaze with fiery colors reflected in the water. With its gracefully arched

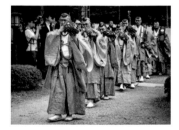

bridge and perfectly proportioned vermilion shrine, the pond is a photographer's dream come true.

Apart from the seasonal peaks, the expansive grounds of this World Heritage site are surprisingly quiet. The uphill hike leads

into another world altogether, through woodland with the occasional old building or place of worship. For those not inclined to hiking, Lower Daigo offers more than enough to warrant a visit. By the Benten Pond is a small restaurant offering seasonal cuisine, a feast for the stomach as well as the eyes.

BELOW The garden at Sambo-in is remarkable for its incredible display of more than 700 boulders assembled from around Japan.

BELOW The five-story pagoda is Kyoto's oldest surviving structure and houses some rare religious paintings (not open to the public).

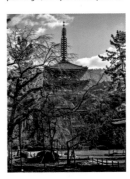

LEFT The temple has strong connections with Shugendo (mountain asceticism), and plays host to practitioners (*yamabushi*), who blow conch shells in their rituals.

Access—Tozai line to Daigo stn, 15 mins walk or shuttle bus 4. Lower Daigo 9.00–17.00/16.00 Dec–Feb, ¥800, ¥1,500 at peak times. Upper Daigo, ¥600. (075) 571-0002 (daigoji. or.jp/index_e.html).

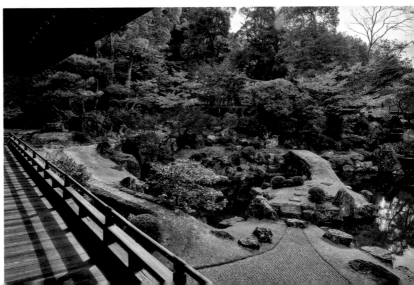

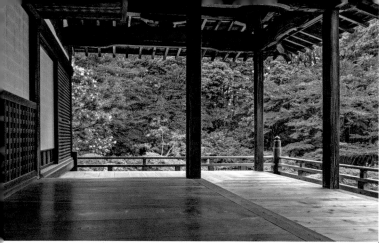

ZUISHIN-IN TEMPLE
A Peaceful Retreat for a Poetic Beauty

There are spacious grounds, with 230 plum trees, a carp pond and a moss garden at Zuishin-in. It is a temple that exudes peace and calm. Historically, it is associated with the 9th-century poet Ono no Komachi, a court lady famed for her beauty. Her family may well have lived in the area, called Ono, hence her name.

The temple was built after Komachi's time, but the association with the poet is used for promotion and there are references to her throughout the precincts. According to folklore, unrequited love led to her becoming a nun, and she lived in a cottage in the temple's bamboo grove. Inscribed on a stone is her famous poem.

The colors of my flowers
Already faded
Vainly did I spend my life
In watching
The long rains falling

In front of the altar is a panel depicting Komachi's life. There is a Jizo statue onto which her love

FAR LEFT The temple is relatively quiet because of the location, but its large platform offers space for contemplation of the surrounds.

LEFT The romantic associations of the poet-beauty Ono no Komachi mean that the temple is a favorite site for wedding photos.

BELOW Plum blossom recalls the early Heian Age when Komachi lived, for it was more celebrated even than cherry.

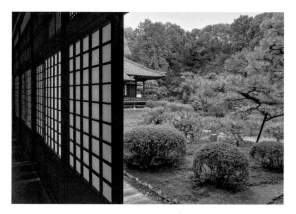

LEFT The garden is kept in immaculate condition, as are the *shoji* paper screens, making for a pleasing combination of garden arts and architecture.

BELOW Red maples in autumn, plum blossom in spring—the temple also has a bamboo grove where Ono no Komachi supposedly had her cottage in the 9th century.

letters are lacquered, and in the grounds are memorial stones and a mound of letters from her many admirers. There is also a Well of Beauty, where she supposedly did her morning ablutions.

The most famous story about Komachi concerns an admirer called Prince Fukakusa. Reluctant to give herself, she asked him to make the long journey to visit her for 100 successive days. He accepted, but tragically on the 99th day he was overcome by a snowstorm and died. Here in autumn, when maples attract visitors, it is hard not to be touched by the tone of melancholy that pervades the poet's tragic life.

Access—Tozai line to Ono (one stop before Daigo-ji). 9.00–16.30. Sutra copying or Buddhist image copying, ¥2,000. (075) 571 0025.

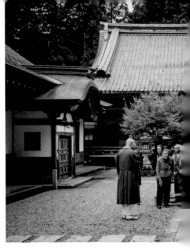

ABOVE LEFT On the far side from Kyoto lies Japan's largest lake, Biwako. It is also one of the world's oldest, with a remarkably diverse ecosystem.

MOUNT HIEI
Kyoto's Holy Mountain with Spectacular Views

More than just a mountain, Hiei also refers to a monastery that was once amongst the biggest in the world. It even had its own army, and when it was attacked in 1571 over 3,000 buildings were destroyed and 25,000 people killed. It was rebuilt, but not on the same scale. The mountain today boasts a ski slope, a cable car and a garden museum. Secularism competes with the sacred.

The temple-monastery, called Enryaku-ji, is head of the Tendai sect, introduced in the early 9th century by a monk named Saicho. It guards the "Devil's Gate" in Kyoto's northeast, through which demons were thought to enter. For over 1,200 years, asceticism has been practiced here in the harsh conditions, 3 degrees colder than in the valley below.

A cable car runs up both sides of the mountain, with a ropeway in between. The circuit is a popular option. On the way there are exhilarating views of Lake Biwa. The temple is so extensive that it spreads over three different pre-

cincts, each with massive buildings. Pride of place goes to the unusual main building of Konponchudo, which enshrines a Healing Buddha image. From a

LEFT A priest explains the mountain's spiritual history and all the important people who at one time or another studied there.

RIGHT A short ropeway connects the Yase cable car with the mountain top (2,756 ft/840 m), offering spectacular views en route.

Access—Eizan line to Yase, then cable car and ropeway. Direct buses also but not in winter. 8.30–16.30/ 9.00–16.00 winter, ¥700. (077) 578 0001 (hieizan. or.jp/_att/english.pdf).

BELOW LEFT A cable car runs up both sides of Mount Hiei, one of which starts from the village of Yase, easily accessed by the Eizan railway.

BELOW The temple complex has three main areas. In the West Precinct is the Shakado Hall, moved from Lake Biwa in 1595.

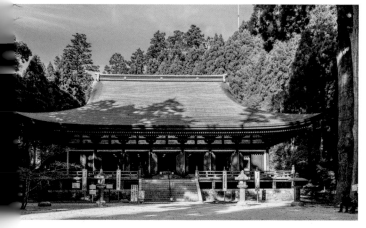

raised platform, visitors can look down on the priests below.

From Konponchudo, a path leads through woods to the West Precinct and the huge Shakado Hall, relocated to Hiei in 1595. For the energetic, there is the option of hiking down to Kyoto (60–120 minutes), and on the descent one may hear the chanting of priests in training. It is a reminder that Kyoto's holy hill, "mother of Japanese Buddhism," continues to foster religious tradition even in a secular age.

ENTSU-JI TEMPLE
A Garden with Magnificent Borrowed Scenery

Entsu-ji is Kyoto's finest example of the garden technique known as "borrowed scenery." This is often thought to simply refer to a backdrop, but proper use of the technique involves integration into the composition. This takes vision and foresight in terms of planting. Entsu-ji provides a perfect model.

The temple began life as a villa for retired emperor and aesthete Go-Mizunoo. When he completed his estate at Shugakuin, he no longer needed the villa and it was converted, in 1678, into a Zen temple. It houses an 11th-century Kannon by famed sculptor Jocho Busshi, and a Study Room relocated from the imperial palace. The chief treasure, however, is the "borrowed scenery."

The garden is a post-war restoration, best seen sitting on the veranda. Moss encircles the low-lying rocks and azalea bushes form the foreground. At the back of the garden runs a manicured hedge, behind which towering cedar trunks draw the eye upwards. In the middle ground is a line of bamboo tops swaying in the wind, their light green a contrast to darker hues around them.

The centerpiece is distant Mount Hiei, aloof and serene, framed between tree trunks. Rocks, bush and foliage combine in a 3D display that lends the mountain depth of perspective. Sit for an hour and the shifting clouds and angle of the sun cast the mountain in a different light, as if to emphasize that all is change. Here, on the veranda, enjoying a green tea set, "the mother of Japanese Buddhism" provokes thoughts of life's transience. Nothing is permanent, not even Mount Hiei.

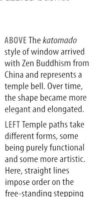

ABOVE The *katomado* style of window arrived with Zen Buddhism from China and represents a temple bell. Over time, the shape became more elegant and elongated.

LEFT Temple paths take different forms, some being purely functional and some more artistic. Here, straight lines impose order on the free-standing stepping stones.

RIGHT Entsu-ji dates back to the 17th century, when it was converted from an aristocratic villa into a Zen temple.

BELOW From the veranda, the framed view of the garden scenery is both multilayered and multi-textured, leaving much to ponder.

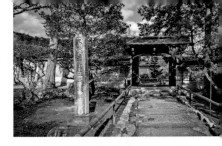

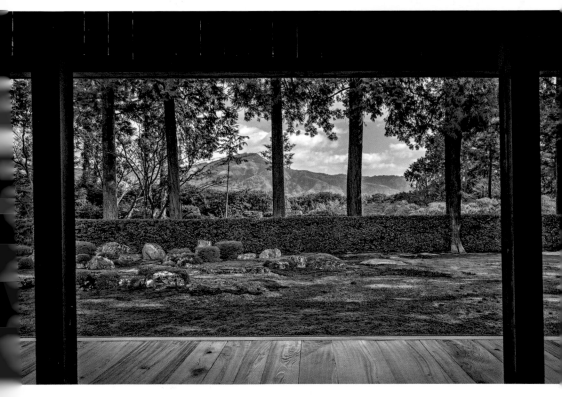

OHARA VILLAGE
A Rustic Village with a "Paradise Garden"

Of the villages on Kyoto's fringes, none can compete for charm with Ohara. Situated between mountains, it has the feel of the past: rice fields and vegetable plots set amongst streams. The air feels fresher, the food more delicious, the people more relaxed. It is a bit colder, too, such that in autumn the maple leaves change color a week earlier than in Kyoto.

Most visitors head for Sanzen-in, a Tendai temple founded in the 9th century. In the reception area is space to sip tea and admire the carp pond. The high point is a moss-covered garden with sky-scraping cedars, amongst which stands a building displaying a stunning triad of Buddhist deities. It is not difficult to understand why it is classified as a "paradise garden."

There is a cluster of small temples nearby, with green tea sets available at Jikko-in and Hosen-

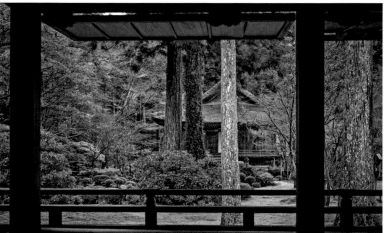

ABOVE The pond-viewing veranda at Sanzen-in's Guest Hall allows for contemplation of a verdant garden called Shuheki-en, set on an incline that rises up from the water.

LEFT At Sanzen-in, a paper screen opens upwards in the Heian style to reveal a hall entitled "Rebirth in the Western Paradise," set amidst a moss carpet and giant cedar trees.

LEFT There are various souvenir and food shops dotted round Ohara, the village being particularly famous for its vegetables.

RIGHT The Hosen-in temple boasts a magnificent 700-year-old pine tree which dominates the garden. There is also a *suikinkutsu*, where one can hear drops of water falling.

BELOW RIGHT Several temple gardens, Sanzen-in in particular, have cute Warabe Jizo statues guaranteed to put a smile on your face.

in. The latter boasts a 700-year-old pine tree and a *suikinkutsu*, a device by which drops of water are amplified underground. The path back down through the village leads past little cafes, vegetable stalls and the occasional craft shop.

Over in the west of the village is Jakko-in, a small nunnery with literary associations through the tragic account in *The Tale of Heike* of the empress-nun Kenreimon'in.

Her grave lies up the steps next to the temple. The Ohara Sansou opposite has a cafe with a foot bath in which to soak tired feet, and for those who would like to linger longer, there are hot spring inns for staying overnight.

Access—bus from Kyoto JR (60 mins) or Sanjo (40 mins) or Kokusai Kaikan (20 mins). Sanzen-in 8.30–17.00/16.30 in winter, ¥700. (075) 744-2531 (sanzenin.or.jp/en). Hot spring accommodation (seryo.co.jp/english) or (ohara-sansou.com/english/index.htm).

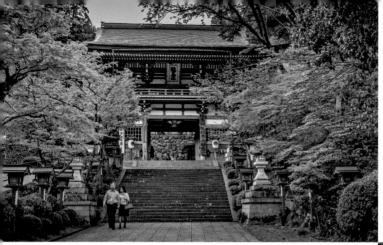

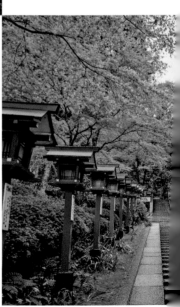

KURAMA VILLAGE
A Hillside Temple and Hot Spring Resort

Kurama has long been a favorite of Kyotoites. It has got the feel of the countryside, yet it is just 30 minutes away by a charming local train. The village is compact, but boasts Kyoto's best outdoor hot spring. What's more, the prestigious temple has unspoilt surroundings and the walk over the hill to Kibune provides "forest bathing" and the healing touch of nature.

Passengers arriving by train are greeted by an enormous long-nosed *tengu*, a mythical creature said to inhabit the woods around Kurama. One of Japan's greatest heroes, Minamoto Yoshitsune (1159–89), is said to have learnt sword fighting from the tengu while apprenticed to the temple in his youth.

The winding uphill path to the temple leads past Yuki Shrine, with its astonishingly tall cedar trees. The temple itself is unusual in several ways, one of which is worship of a deity called Mao-son, who "fell to earth many thou-

FAR LEFT Entry to Kurama Hill is through a two-story gate. One can either walk up to Kurama Temple or continue over to Kibune (90 minutes).

LEFT Legend has it that long-nosed demons known as *tengu* lived in the Kurama woods and practiced martial arts.

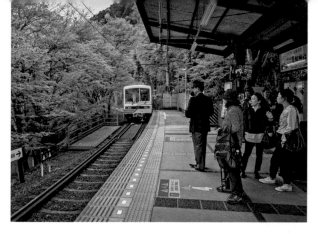

LEFT Access to Kurama is by the small private Eizan railway, which offers pleasant views on the 30-minute journey from Demachiyanagi (¥430, 5.5 miles/9 km).

BELOW The evening meal at Kurama Onsen consists of small portions pleasingly presented, with seasonal ingredients prepared so as to bring out their natural taste.

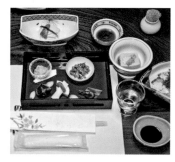

sands of years ago." It also has a reputation as a "power spot" that gives off energy, and it was on the slopes of Mount Kurama that, in 1922, Usui Mikao received a vision of *reiki*, a form of massage.

After returning from the temple, visitors might wish to soothe their aching limbs. Fortunately, Kurama Onsen is just 10 minutes away. Here, one can relax outdoors in hot water while taking in the crisp mountain air and contemplating the wooded slope opposite. For some, this is the perfect form of "immersion in nature."

LEFT The walk to the temple takes about 30 minutes. Alternatively, one can use a small funicular carriage.

Access—Eizan Densha from Demachiyanagi, 30 mins, ¥430. Kurama Temple 9.00–18.30, ¥200. (075) 741-2003. Kurama Onsen 10.30–21.00, ¥1,000 for outdoor bath, ¥2,500 all facilities. (075) 741-2131 (kurama-onsen.co.jp/index_e.html).

KIBUNE VILLAGE
Dining by a Fresh Mountain Stream

Located just 30 minutes north of Kyoto, Kibune lies in a forested valley, with streams of fresh mountain water gushing out of the steep sides. On the far side of the hill lies Kurama, and the pair of tranquil villages make for an excellent day outing with a two-hour walk between them.

Like medieval towns in Europe, Kibune developed around the nucleus of a sanctified site. According to folklore, a princess from Osaka followed the rivers upstream as far as she could, and the Kifune Shrine marks the place where her boat came to rest. It has an attractive hillside setting,

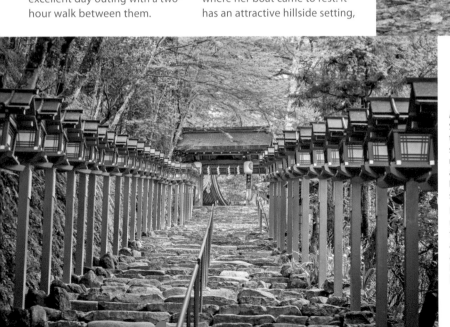

ABOVE From June to September, river dining takes place on platforms set just above the rippling water, a perfect antidote to the humid heat of the Kyoto summer.

LEFT Kifune Shrine nestles against a tree-covered hillside, and is approached up an attractive set of steps bordered by vermilion lanterns.

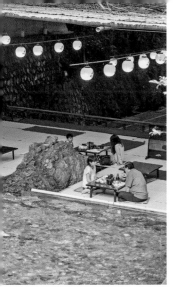

RIGHT The Ohitaki Festival at Kifune Shrine is an ancient sacred fire ritual to drive away bad spirits and cleanse those attending of impurities.

LEFT The shrine is dedicated to a water *kami* and promotes gratitude for its life-giving qualities. Closeness to nature is evident everywhere, such as here at the water basin.

BELOW Wooden plaques known as *ema* contain written wishes, ranging from health for the family to success in exams. Kifune, unusually, has some *ema* shaped like leaves.

and the picturesque entrance steps lined by lanterns are popular with photographers. Dedicated to the *kami* of rain, it has fortune slips that can only be read by being placed in water.

Kibune has one other attraction: *kawadoko*, or dining platforms built over the rushing waters of the Kibune-gawa, the village stream. The seating is just above the surface, so one can enjoy the sound of water while sampling high quality food. (Meals can be pricey, and weekends are best avoided.)

From Kibune, some people head back to the Eiden Station, to return to Kyoto or continue to Kurama. For hikers, there is a small bridge in the village which gives access to the forested footpath to Kurama. The walk takes one into the realm of Japanese spirituality. Both Kibune Shrine, with its concern with water, and Kurama Temple, with its woodland preservation, have a strong attachment to nature. The many shrines and sacred trees reflect this, and the walk is imbued with a strong sense of the divine.

Access—Eizan line to Kibune-guchi, 30 mins, ¥400, then 25 mins walk or shuttle bus. Kibune Shrine 6.00–20.00/18.00 Dec–Mar. (075) 741-2016. Dining options (kibunesou.com/en/).

TAKAO VILLAGE
Fiery Maples, Temples and Scenic Hiking Trails

In autumn, the thoughts of Kyotoites turn to Takao, tucked away in hilly woodland in the northwest, thick with maples, in amongst which are three temples of note. And for those looking for exercise, there is one of the city's best walking routes.

The temples lie not far from the bus stop. Jingo-ji is the largest temple, founded in 824 and boasting calligraphy by the multi-talented Kukai (d.835). The main compound is reached via a stone staircase of 350 steps that stretches from the Kiyotaki Valley to the temple's main gate, which opens onto a breathtaking view over the valley far below. The custom is to write one's name on an earthenware plate before flinging it into the plunging depths to rid oneself of impurities.

Nearby Saimyo-ji is small but picturesque, typified by the charming Shigetsukyo Bridge.

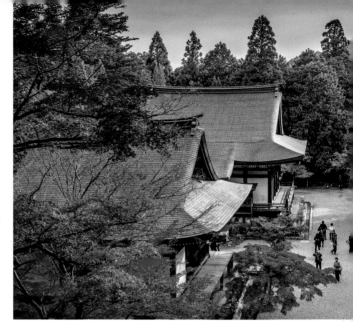

ABOVE Jingo-ji is Takao's biggest temple, with spacious grounds. It stands on the edge of a cliff offering dramatic views over the surrounding landscape.

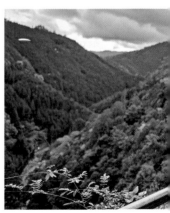

Kozan-ji, also small, is surprisingly a World Heritage site whose prize possession is the 12th-century *Chojujigiga* (Animal Person Caricatures). There is a small field of tea to commemorate the first such plantation in Japan, and the beautifully proportioned building of Sekisui-in nestles

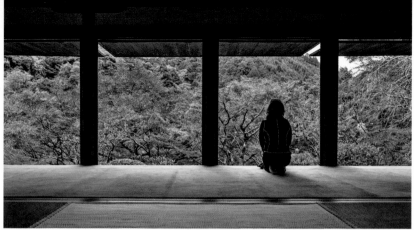

BELOW LEFT Throwing plates off the edge of the ravine at Jingo-ji is a great way to release accumulated "impurities" and cleanse yourself for the coming months.

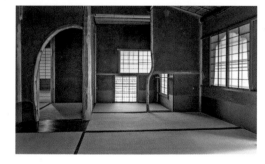

harmoniously into the verdant surroundings.

From the village of Takao it is a 90-minute hike to Kiyotaki, with its wonderful waterfall, or two or three hours to endpoints around Mount Atago. In summer, there are restaurants for outdoor eating. The massive cryptomeria alone make the walk worthwhile. The autumn maples may be the star attraction, but for a breath of fresh air Takao is a delight in all seasons.

TOP The beautifully proportioned Sekisui-in at Kozan-ji started life as an emperor's study room, where the shutters open outwards and upwards.

ABOVE The first tea to be planted in Japan was at Kozan-ji, and its tea room exemplifies the use of natural materials.

Access—Bus from Kyoto JR stn 50 mins. Jingo-ji 9.00–16.00, ¥500. (075) 861-1769. Saimyo-ji 9.00–17.00, ¥500. (075) 861-1770. Kozan-ji 8.30–17.00, ¥600. (075) 861-4204 (bit. ly/2RRJ2CZ).

JONAN-GU SHRINE
Guardian of Kyoto's Southern Flank

In Heian times, directions played an important part in fortune telling, and traveling in an inauspicious direction was avoided where possible, resulting in long detours. The concern to prevent directional misfortune extended to the capital, and Jonan-gu was set up to protect the southern entrance of Heian-kyo.

At one time, the shrine became part of a huge imperial estate, and because the capital was aligned to the south, emperors would come to pray for protection. It was customary also for visitors to the capital to first pay respects here, a practice which continued up to the Meiji Period. The shrine's importance led to it being used as a military base in the Battle of Toba-Fushimi in early 1868 between pro- and anti-shogunate forces.

Something of the grandeur of former times is still evident in the shrine's architecture. The reconstructed buildings exemplify the graceful style of the Heian Period, complemented by shrine maidens (*miko*), who perform refined *kagura* dances for the *kami*. The full elegance of the Heian Period is on display twice

RIGHT Jonan-gu has three gardens created after World War II, including a pond garden in the Heian Period style, with island and waterfall.

BELOW The shrine once held high standing as guardian of the capital's southern side and enshrines the deity of direction.

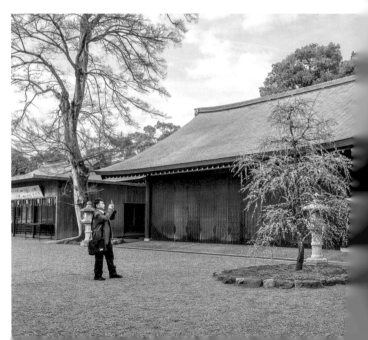

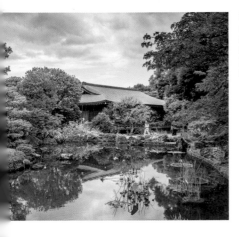

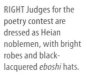

BELOW Once a year the shrine recreates the elegance of Heian times in a poetry contest known as Kyokusui no Utage.

RIGHT Judges for the poetry contest are dressed as Heian noblemen, with bright robes and black-lacquered *eboshi* hats.

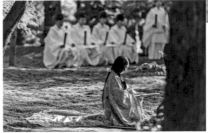

BELOW A dance for the *kami* performed by a shrine maiden called *shirabyoshi*, backed by musicians playing *gagaku* court music.

yearly at poetry contests, when robed participants sit by a stream and compose short verses known as *tanka*.

The shrine is also known for its 150 plum trees, which flower in late winter and early spring. The blossoms of the plum were once regarded as superior to cherry because they start earlier. The trees belong to the Raku-suien Garden, which is divided into sections covering different historical eras. From aristocratic ponds, through the symbolism of Zen, to the expansive Momo-yama Age, the gardens offer a walk through time. Just be sure to head in the right direction!

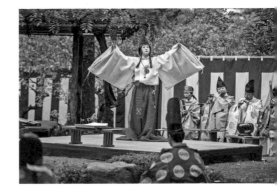

Access—from Takeda stn on subway or Kintetsu line, 20 mins walk. 9.00–16.30, ¥600 for gardens, green tea set ¥300. (075) 623-0846 (jonangu. com/english.html). Apr 29, Nov 3 poetry contest at 14.00.

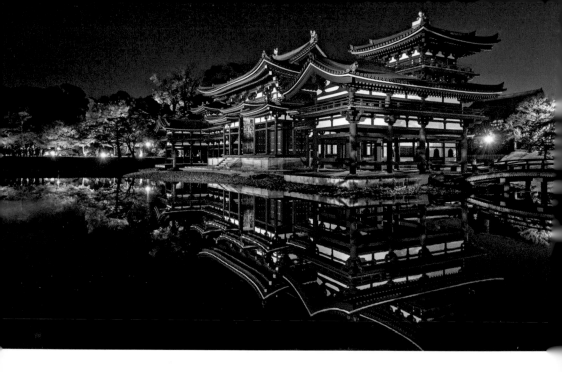

UJI TOWN
Green Tea, *The Tale of Genji* and a Vision of Paradise

Look at the back of a ¥10 coin and you will see a building considered the most beautiful in Japan. It is known as the Phoenix Hall, and is the centerpiece of the World Heritage temple of Byodo-in. Built in 1052, the hall was inspired by belief in Amida, who promised salvation in his Pure Land (paradise) to all who call on his name.

Byodo-in owes its location to the preference of Heian aristocrats for rural retreats not too far from the center of Kyoto. One of the favored places was along the Uji River, and it was here that the last section of the world's earliest novel, *The Tale of Genji* (c.1005), is

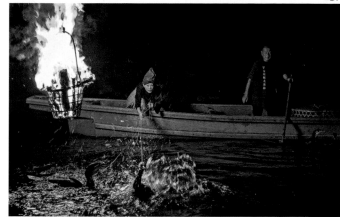

In summer, cormorant fishing is carried out in traditional style, which dates back to Heian times when aristocrats enjoyed watching from specially built elegant boats.

set. The city today boasts a Genji Museum and a literary trail.

The celebrated Phoenix Hall is set on the far side of a pond, as if in a different realm. There are long corridors on either side, like the outstretched wings of a bird, and inside the central building is a huge statue of Amida surrounded by celestial cherubs. It represents the descent of the deity to collect the souls of the dead.

Uji has long had a reputation for the high quality of its green tea, and in the Edo Period the first tea of the season was sent to the shogun in the kind of procession accorded a feudal lord. Nowadays, Uji tea has become a brand name and is available at shops along the street to Byodo-in, together with delicious accompaniments. Genji, tea and a vision of paradise, what more could you want from an outing?

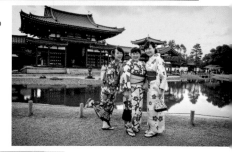

RIGHT Chinese tourists in rented kimono pose before the famous Phoenix Hall, pictured on the back of Japan's ¥10 coin. Inside the hall is a huge statue of Amida, 9.5 ft (3 m) tall.

BELOW The approach to Byodo-in is lined with shops selling green tea in various guises, from *matcha* powder to matcha ice cream. Uji has long been known for the quality of its tea.

Access—JR Nara line or Keihan line to Uji stn, 10 mins walk. Genji Museum (0774) 39-9300. Byodo-in 8.30–17.30, ¥300. (0774) 21-2861 (byodoin.or.jp/en/).

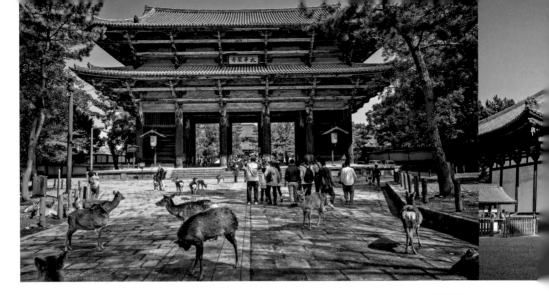

DAY TRIP TO NARA
A Deer Park, a Bronze Buddha and an Ancient Shrine

ABOVE LEFT In Nara Park, deer wait in front of the entrance gate to Todai-ji for the next group of tourists willing to give them a treat.

Nara is older than Kyoto, and has eight World Heritage sites. It also has a large open park with 1,200 deer, and one of the wonders of the world in a massive Buddha in an enormous wooden building. Less than an hour from Kyoto, Nara makes for an excellent day out.

When Nara was the capital from 712 to 794, Buddhism was a powerful force. Nothing represents the era better than the giant seated Buddha of Todai-ji. Constructed in 752, it is an amazing 50 feet (15 m) tall. The building around it is absolutely massive, yet it is only two-thirds of the original size after having been rebuilt in the 17th century following a fire.

Not far away is Kasuga Shrine, established in 768 to protect the capital. It is known for its lanterns, donated by worshippers. A total of 2,000 stone lanterns line the approach, and there are a further 1,000 hanging lanterns inside. Twice a year they are all lit, illuminating the red, white and green colored buildings to spectacular effect. Beyond the shrine is a primeval forest, untouched since 841 when it was officially declared sacred.

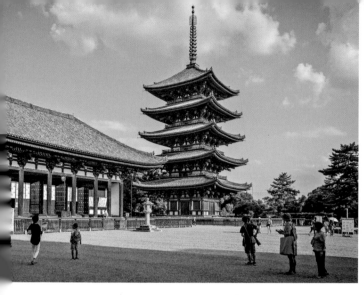

Access—Nara Park, 5 mins from Kintetsu Nara stn, 20 mins from JR Nara stn. Todai-ji 7.30–17.30/ 8.00–17.00 Nov–Mar, ¥600. (0742) 22 5511 (todaiji.or.jp/ english/). For map and details (japan-guide.com/e/e4103.html).

ABOVE Kofuku-ji's pagoda, a symbol of Nara, was first erected in 725 and is the second tallest pagoda in Japan after Kyoto's To-ji.

BELOW The seated gilt bronze Buddha of Todai-ji is an enormous 50 ft (15 m) tall, and the ears alone are taller than a human being.

The deer that roam the park are considered messengers of the Kasuga *kami*. They are surprisingly tame, though cheeky (watch your pockets and bags). For those not keen on deer, Nara has more to offer, such as the world's oldest wooden buildings at Horyu-ji. Kyoto may be the soul of Japan, but it built on the heritage of Nara, which makes it special.

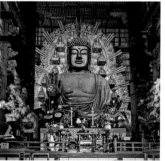

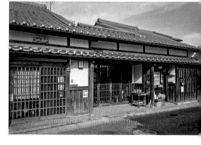

TOP Deer have been seen as messengers of the *kami* since ancient times and, unusually for Japan, are allowed to roam freely wherever they want.

ABOVE Merchant townhouses known as *machiya* evoke the atmosphere of Edo times. Like Kyoto, another "ancient capital," the city treasures its past.

Published by Tuttle Publishing, an imprint of Periplus Editions (HK) Ltd

www.tuttlepublishing.com

Copyright © 2020 Periplus Editions (HK) Ltd
Photos pages 196 bottom left and 197 right top and middle, courtesy of Tenzan no Yu (ndg.jp/tenzan/en/).

ISBN 978-4-8053-1542-2

25 24 23 22 21 20
10 9 8 7 6 5 4 3 2 1

Printed in Malaysia 2003VP

TUTTLE PUBLISHING® is a registered trademark of Tuttle Publishing, a division of Periplus Editions (HK) Ltd.

Distributed by

North America, Latin America & Europe
Tuttle Publishing
364 Innovation Drive
North Clarendon, VT 05759-9436 U.S.A.
Tel: 1 (802) 773-8930
Fax: 1 (802) 773-6993
info@tuttlepublishing.com
www.tuttlepublishing.com

Japan
Tuttle Publishing
Yaekari Building 3rd Floor
5-4-12 Osaki
Shinagawa-ku
Tokyo 141-0032
Tel: (81) 3 5437-0171
Fax: (81) 3 5437-0755
sales@tuttle.co.jp
www.tuttle.co.jp

Asia Pacific
Berkeley Books Pte. Ltd.
3 Kallang Sector #04-01
Singapore 349278
Tel: (65) 67412178
Fax: (65) 67412179
inquiries@periplus.com.sg
www.tuttlepublishing.com

RIGHT Summer purification at Shimogamo Shrine (p. 146), when paper doll cutouts are thrown over a sacred pond as men compete to grab one of 50 lucky arrows.

THE TUTTLE STORY
"Books to Span the East and West"

Our core mission at Tuttle Publishing is to create books which bring people together one page at a time. Tuttle was founded in 1832 in the small New England town of Rutland, Vermont (USA). Our fundamental values remain as strong today as they were then—to publish best-in-class books informing the English-speaking world about the countries and peoples of Asia. The world has become a smaller place today and Asia's economic, cultural and political influence has expanded, yet the need for meaningful dialogue and information about this diverse region has never been greater. Since 1948, Tuttle has been a leader in publishing books on the cultures, arts, cuisines, languages and literatures of Asia. Our authors and photographers have won numerous awards and Tuttle has published thousands of books on subjects ranging from martial arts to paper crafts. We welcome you to explore the wealth of information available on Asia at **www.tuttlepublishing.com**.